STEAMPUNK STYLE 2
GOGGLES, GAS MASKS AND AVIATOR STYLES

STEAMPUNK STYLE 2

GOGGLES, GAS MASKS AND AVIATOR STYLES

cover:
Photo|Hironobu Onodera
Digital Painting|Toshiyuki Kimura
Model|ARISA
Aviator Style|Mitsuji Kamata (Kamaty Moon)

Contents

Gallery

Antiquarian and Wunderkammer

Making of Steampunk Creations

DIY Antique Interiors 2

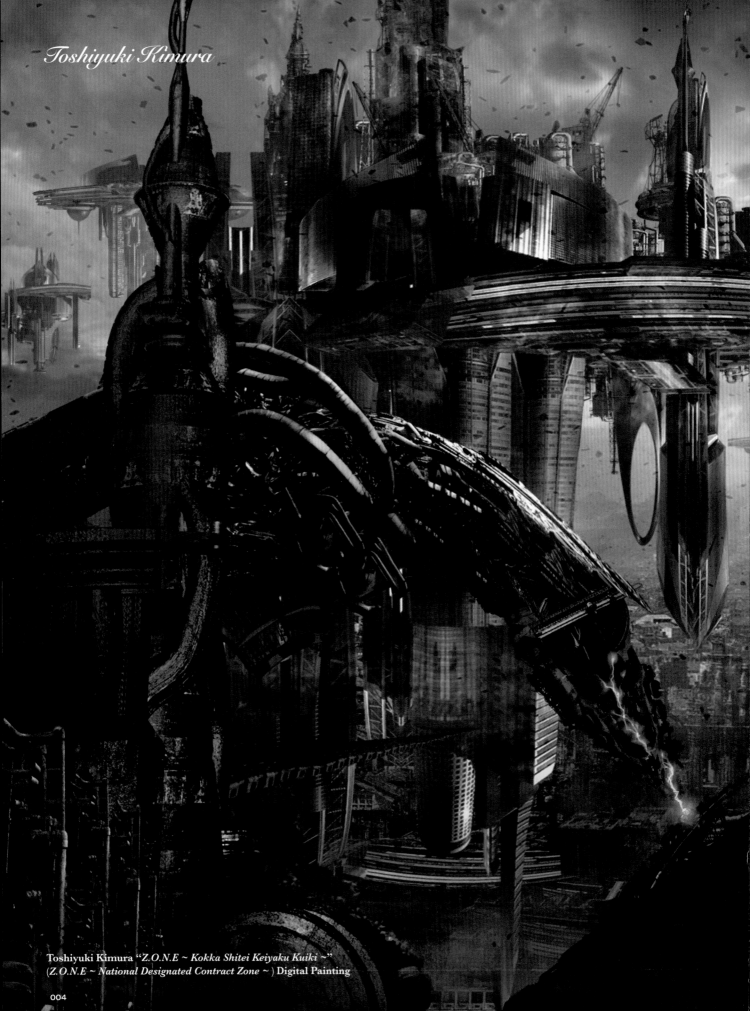

Toshiyuki Kimura

Toshiyuki Kimura "Z.O.N.E ~ Kokka Shitei Keiyaku Kuiki ~"
(*Z.O.N.E ~ National Designated Contract Zone ~*) **Digital Painting**

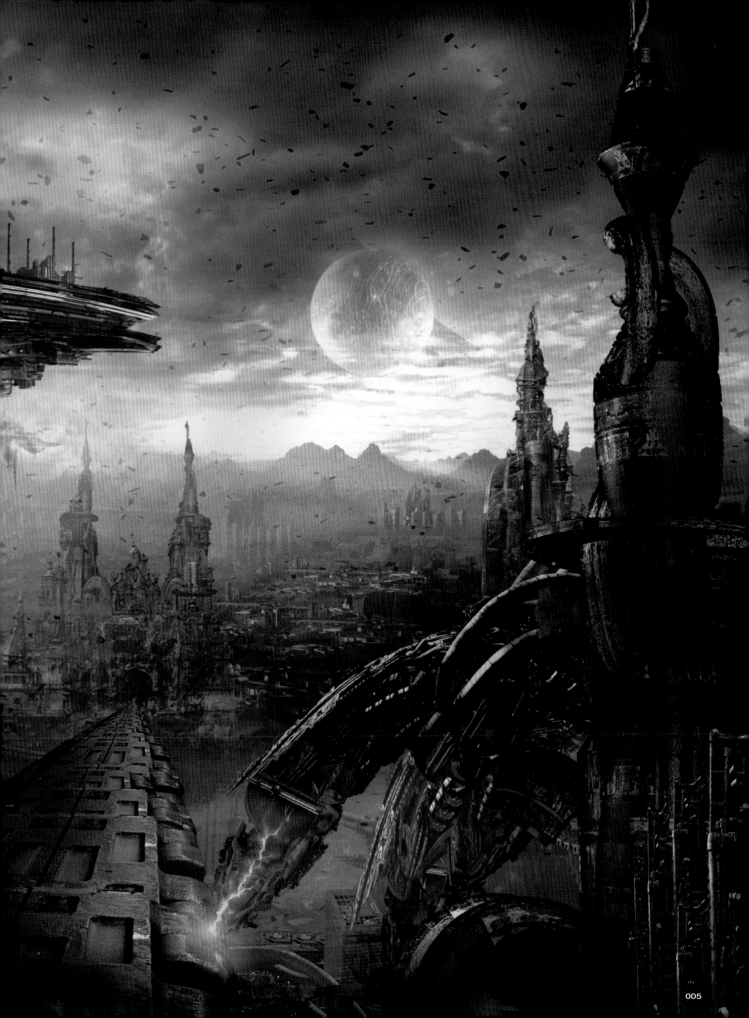

Toshiyuki Kimura

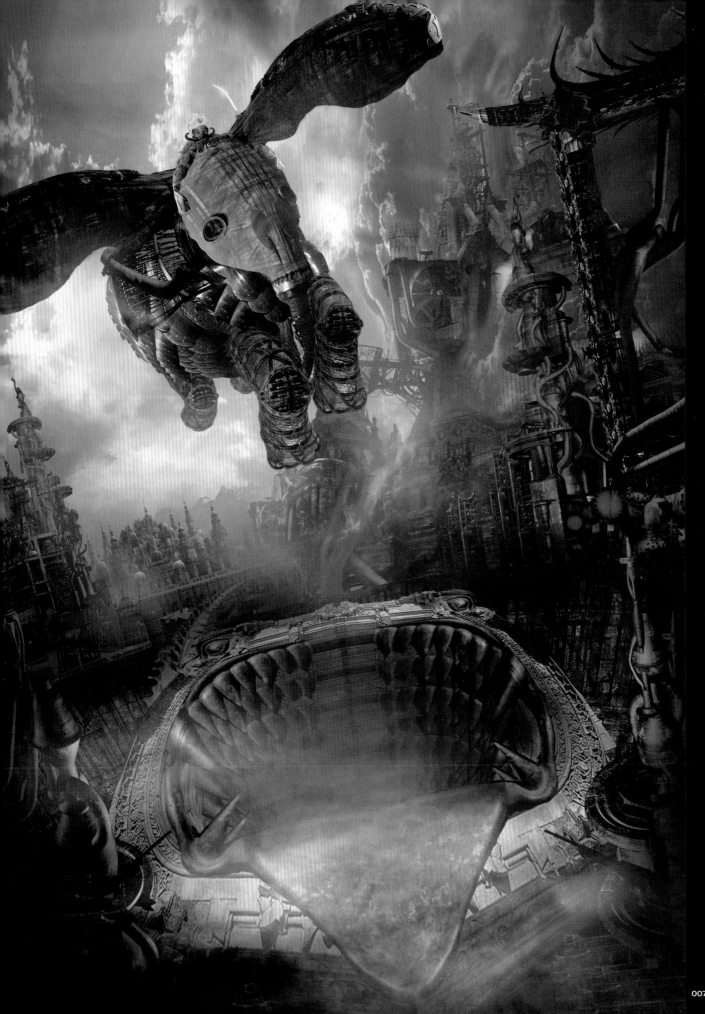

Naoto Nishiwaki
(TOO.N.M.ART)

Naoto Nishiwaki TOON MART "*Genba Kensho*"
(*On-scene Investigation*) Headgear, Gas Mask
PHOTO: Susumu Miyawaki
MODEL: Keaki Watanabe

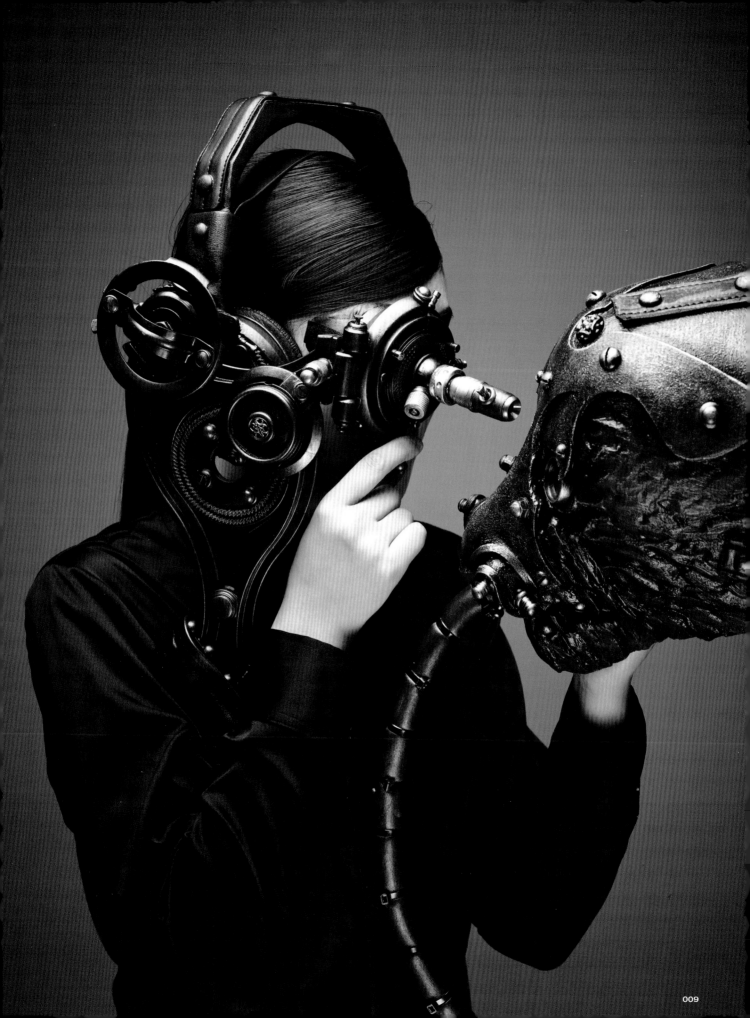

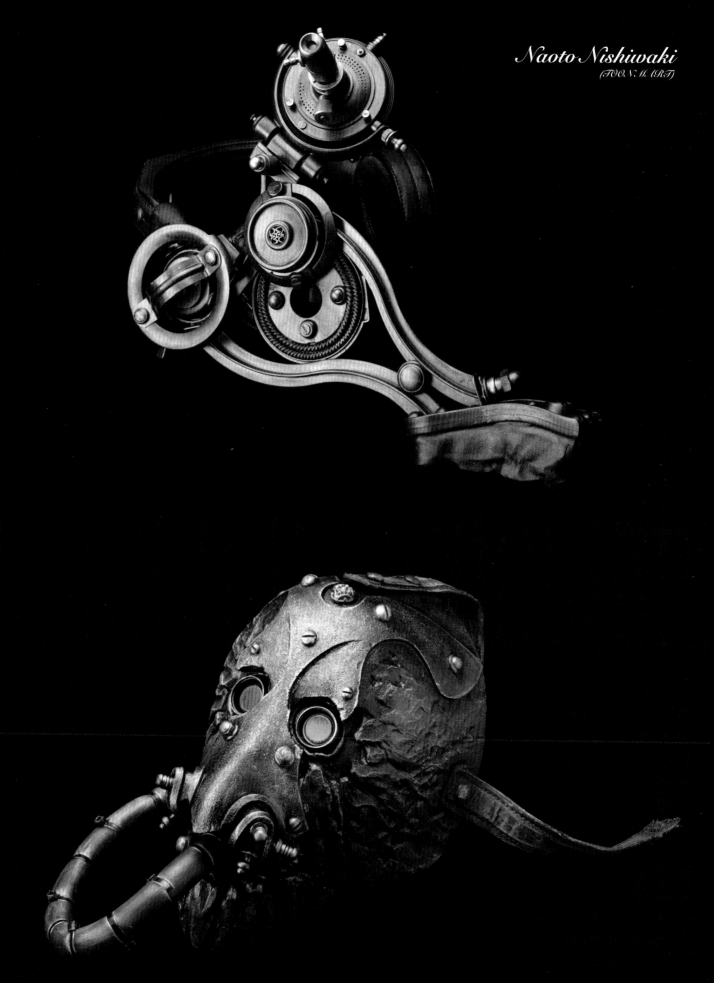

Hatohiro Mikami

Hatohiro Mikami "*Shiro Shokkaku Gear*"
(*White Antennae Gear*) **Mask**
PHOTO: Susumu Miyawaki
MODEL: Sahara

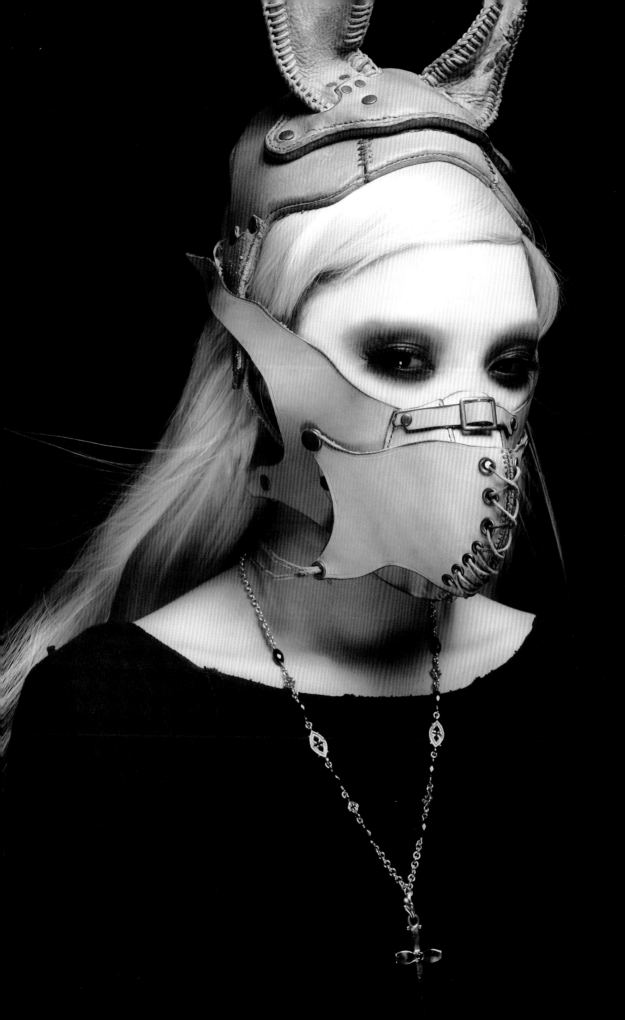

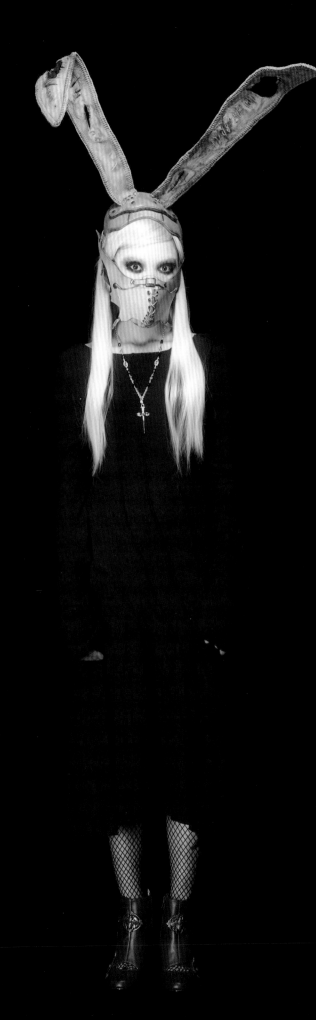

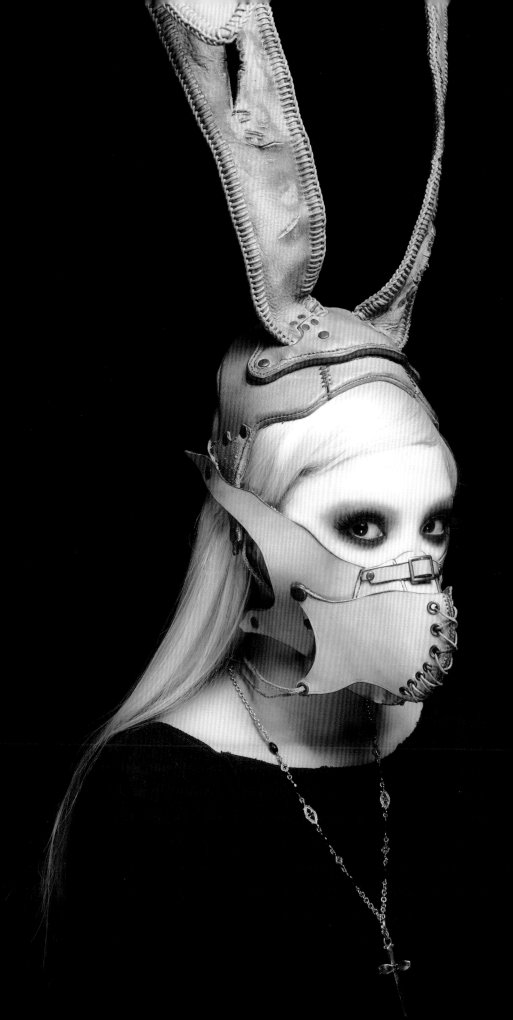

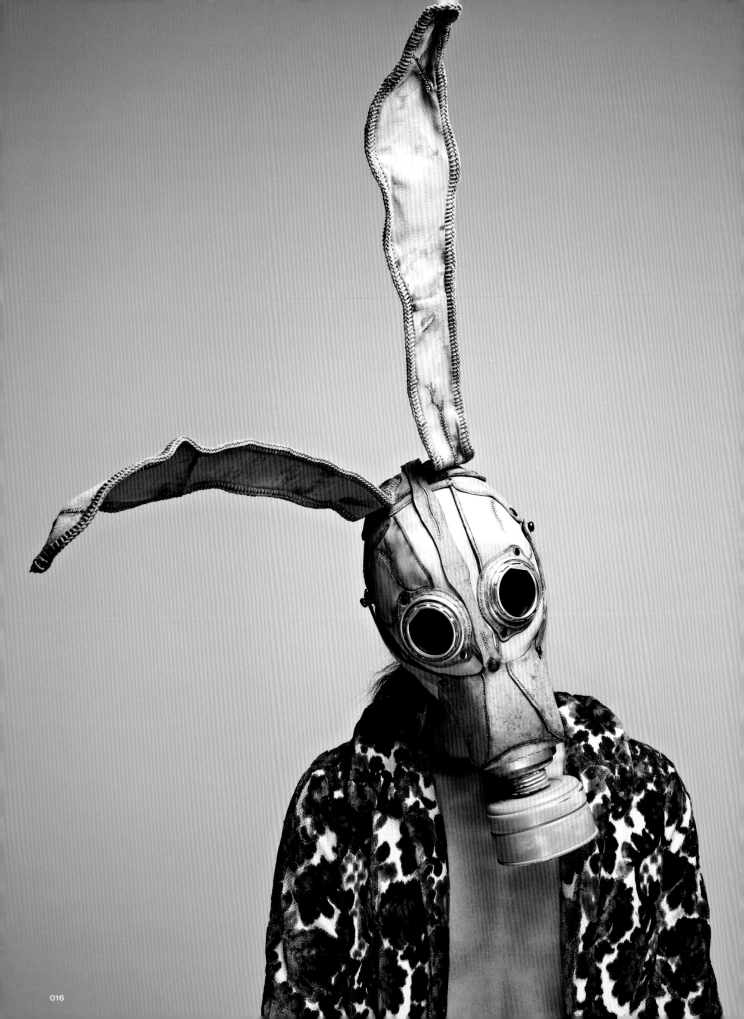

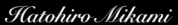

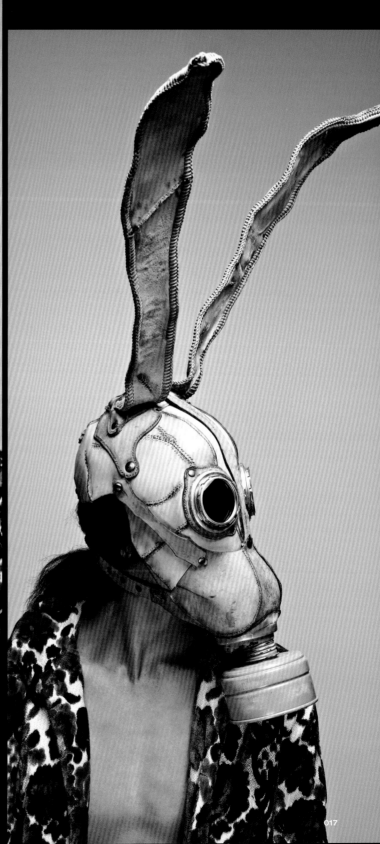

Hatohiro Mikami *"eureka"* Gas Mask
PHOTO: Susumu Miyawaki
MODEL: Shinjiro Saito

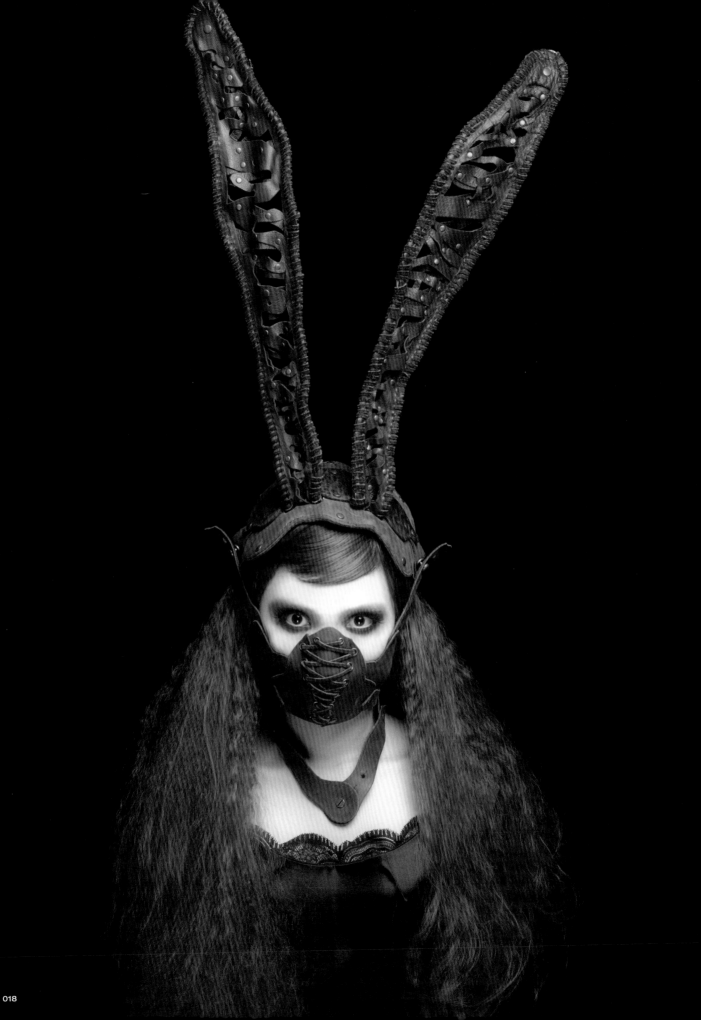

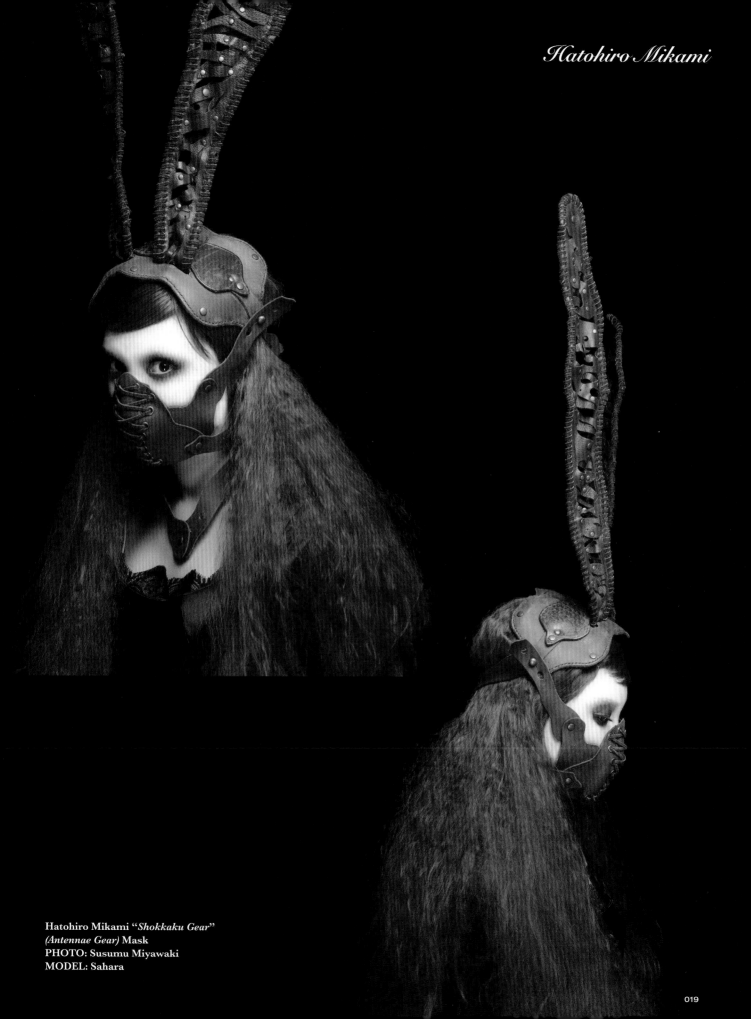

Hatohiro Mikami "*Shokkaku Gear*"
(*Antennae Gear*) Mask
PHOTO: Susumu Miyawaki
MODEL: Sahara

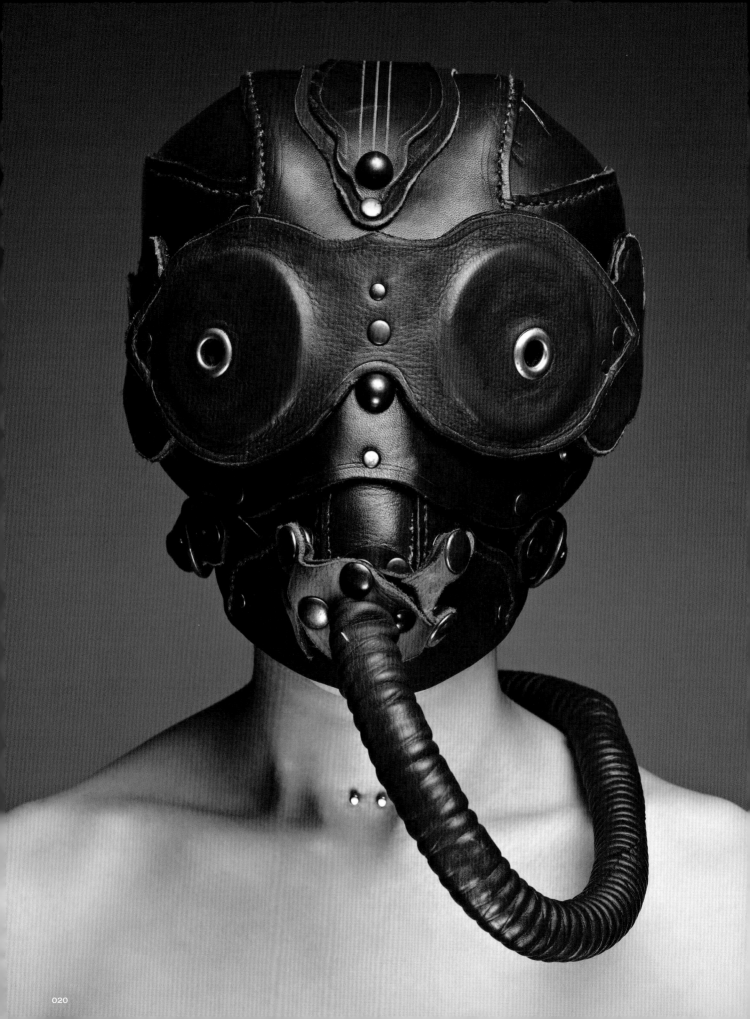

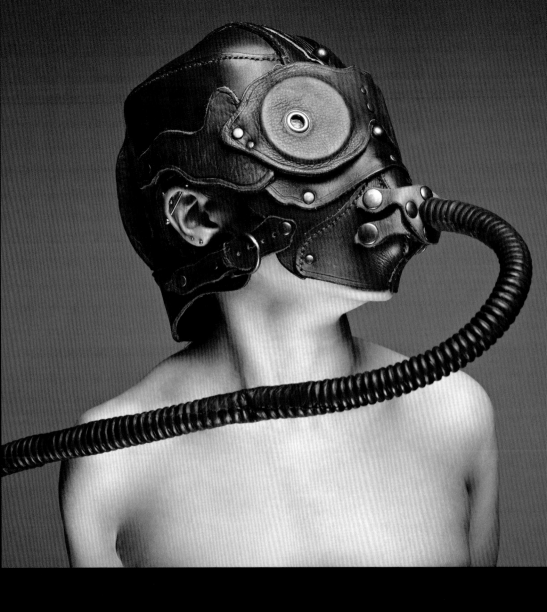

Hatohiro Mikami "*Miffy*" Gas Mask
PHOTO: Susumu Miyawaki
MODEL: Hatohiro Mikami

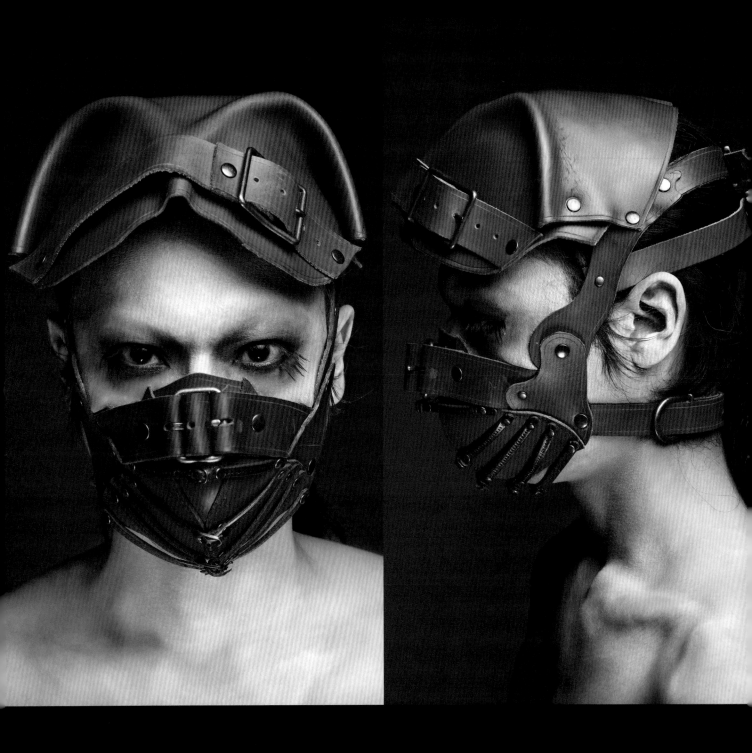

Hatohiro Mikami "*Belt Leatherface*" Mask
PHOTO: Susumu Miyawaki
MODEL: Hatohiro Mikami

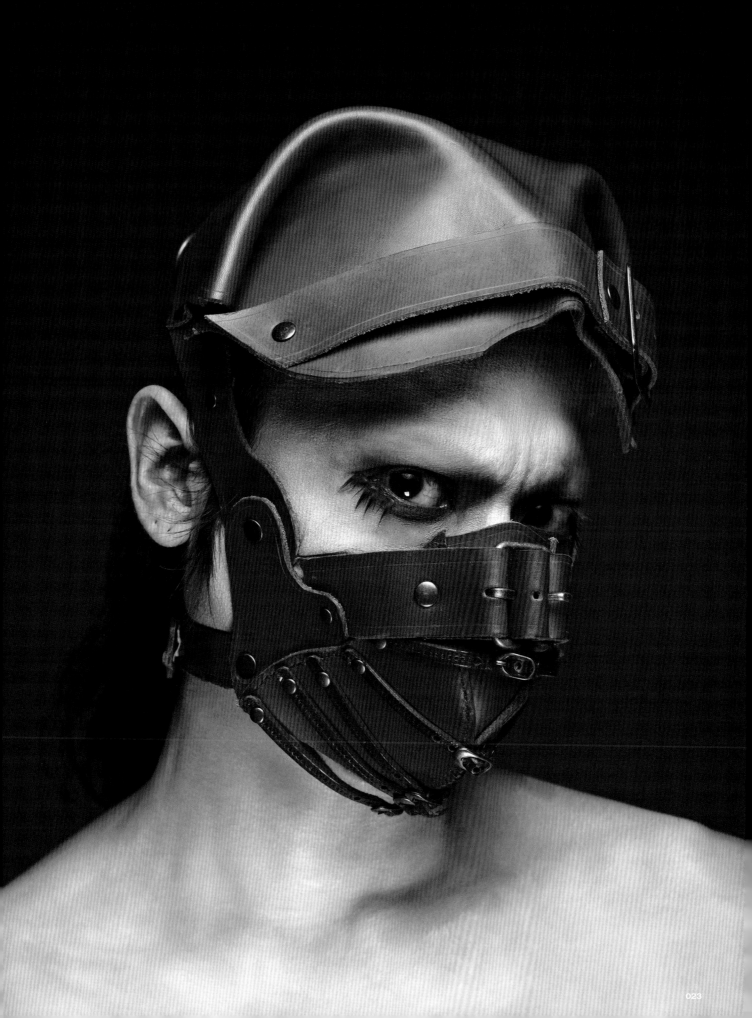

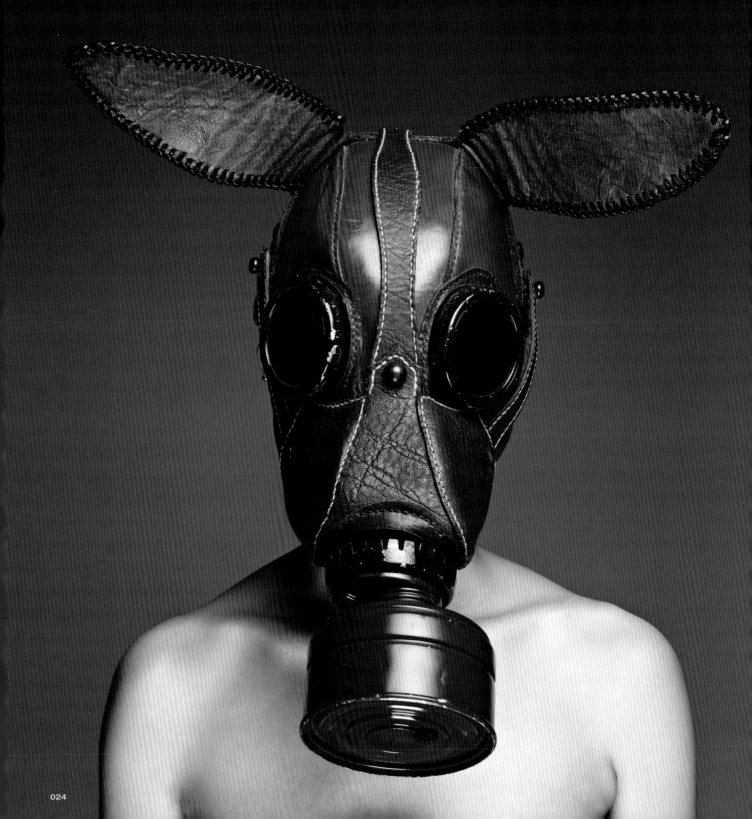

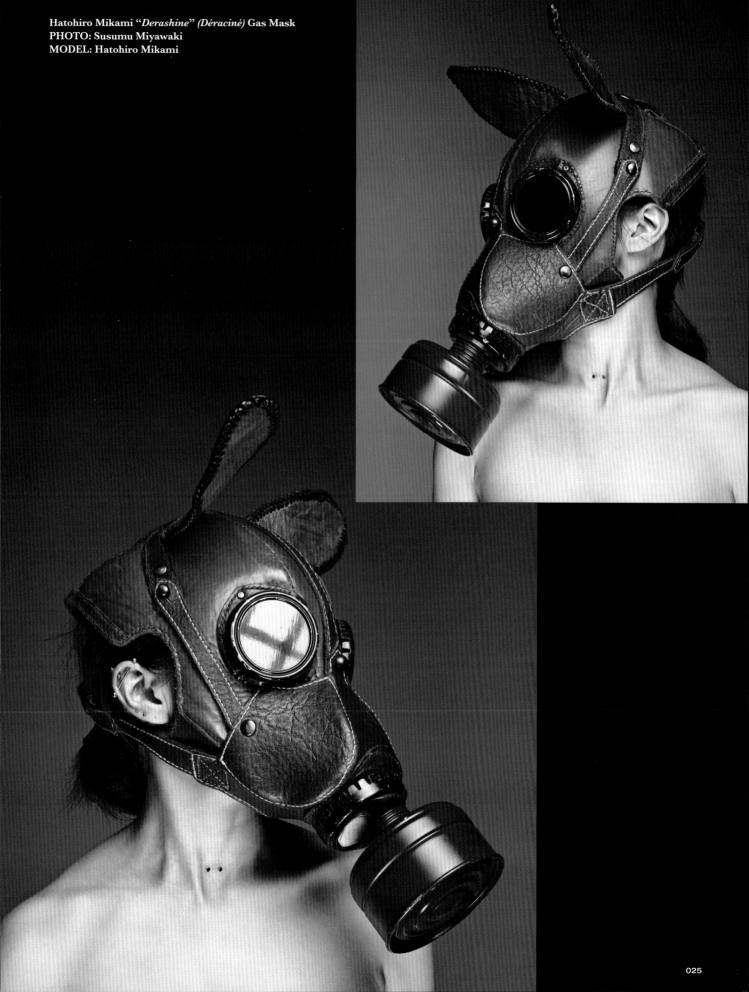

Hatohiro Mikami "*Derashine*" *(Déraciné)* Gas Mask
PHOTO: Susumu Miyawaki
MODEL: Hatohiro Mikami

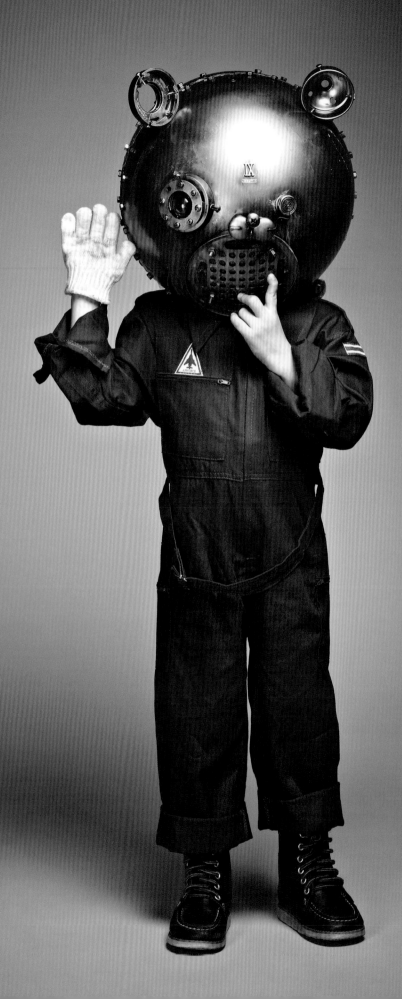

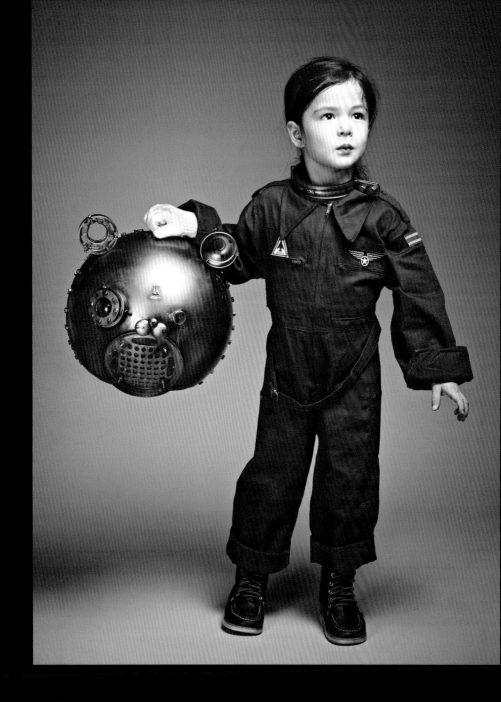

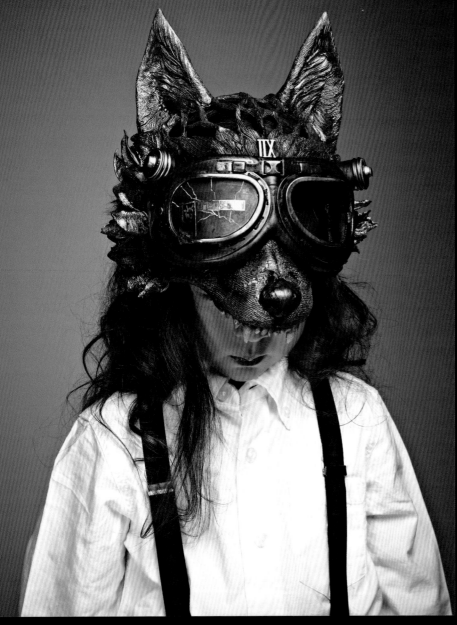

TOMO *"Wolf Boy"* Goggles
PHOTO: Susumu Miyawaki
MODEL: Giulio

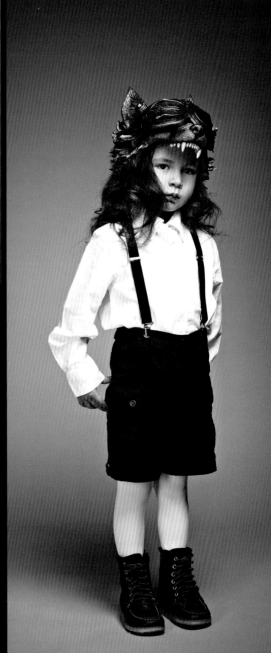

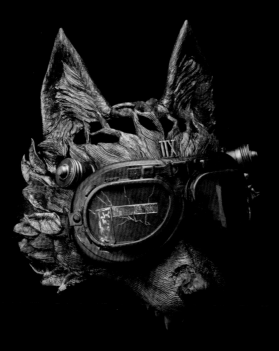

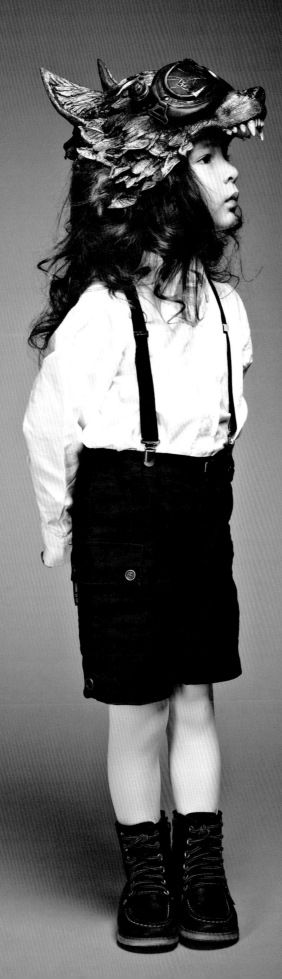

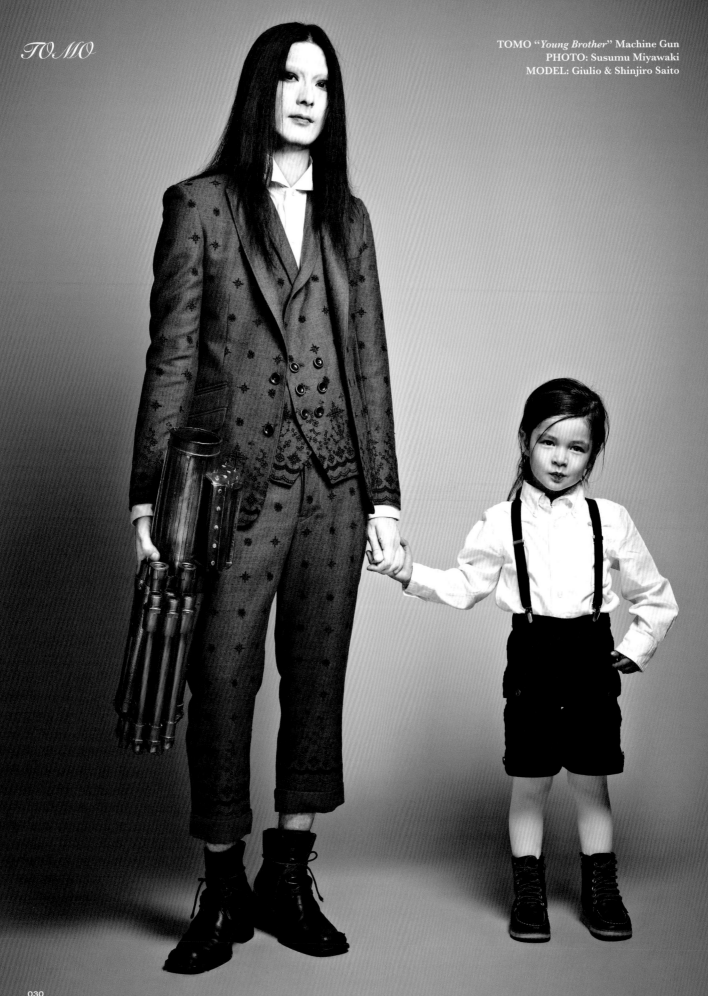

TOMO *"Young Brother"* Machine Gun
PHOTO: Susumu Miyawaki
MODEL: Giulio & Shinjiro Saito

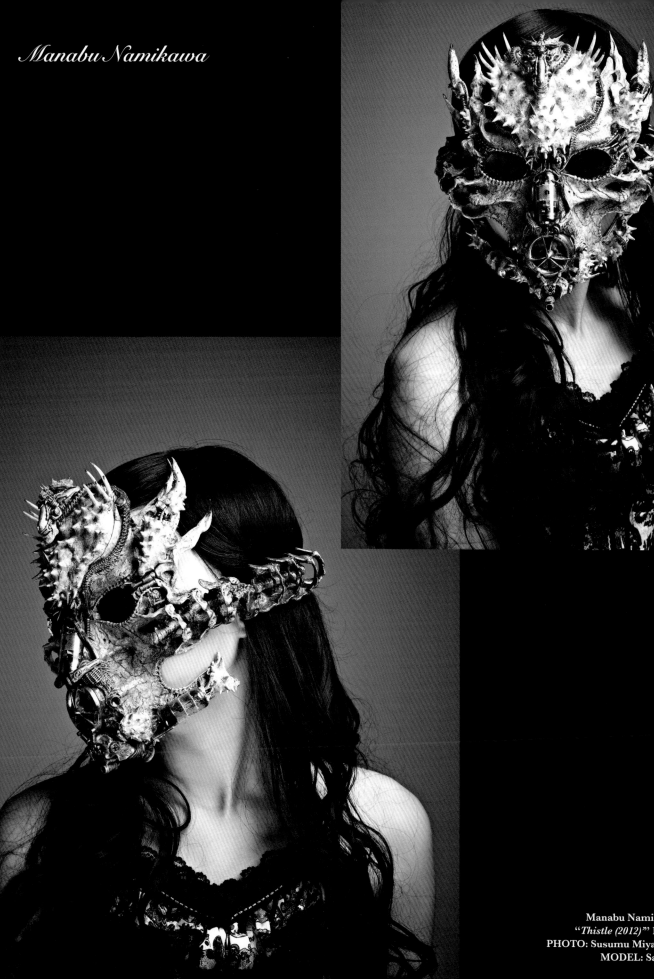

Manabu Namikawa

Manabu Namikawa
"Thistle (2012)" Mask
PHOTO: Susumu Miyawaki
MODEL: Sahara

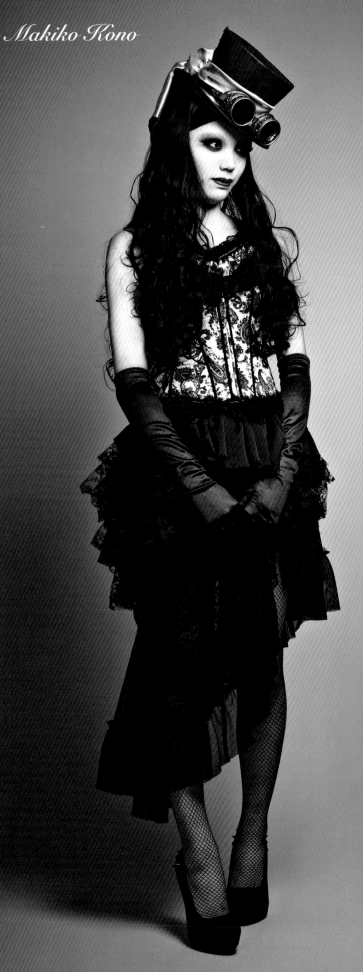

Makiko Kono

Makiko Kono *"Mary's top hat with goggles"*
Hat with attached Goggles
PHOTO: Susumu Miyawaki
MODEL: Sahara & Shinjiro Saito

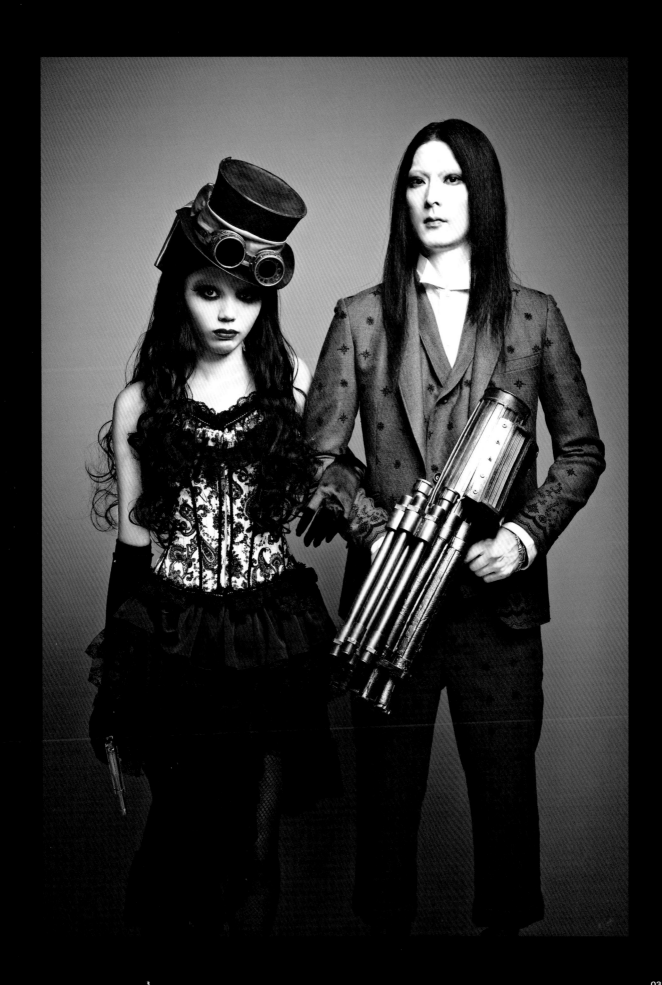

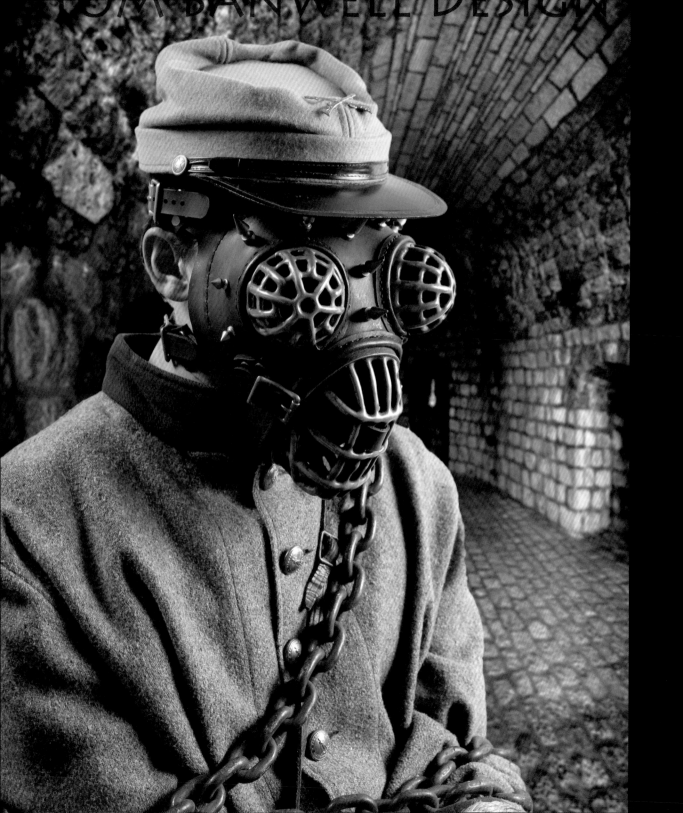

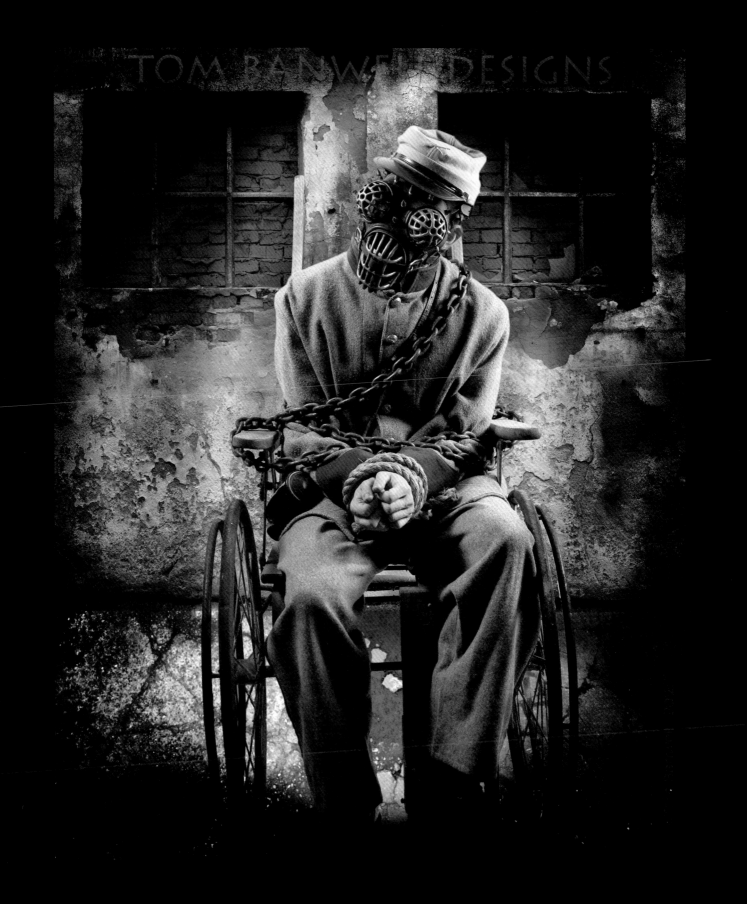

Tom Banwell
"Crixus in wheelchair" **Gas Mask**

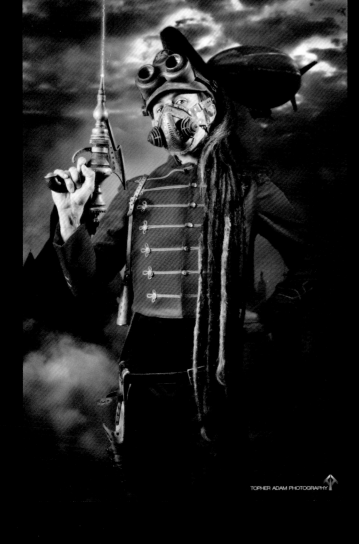

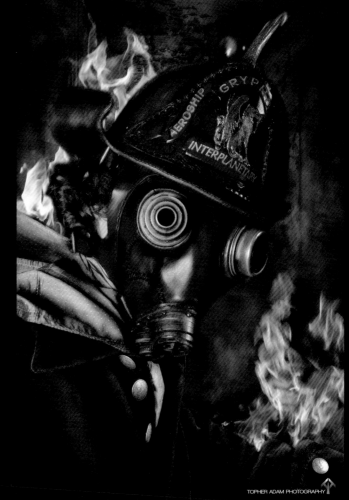

Tom Banwell
Left: *"Aero Field Sargent"* Gas Mask
Right; *"Aero Fighting"* Gas Mask

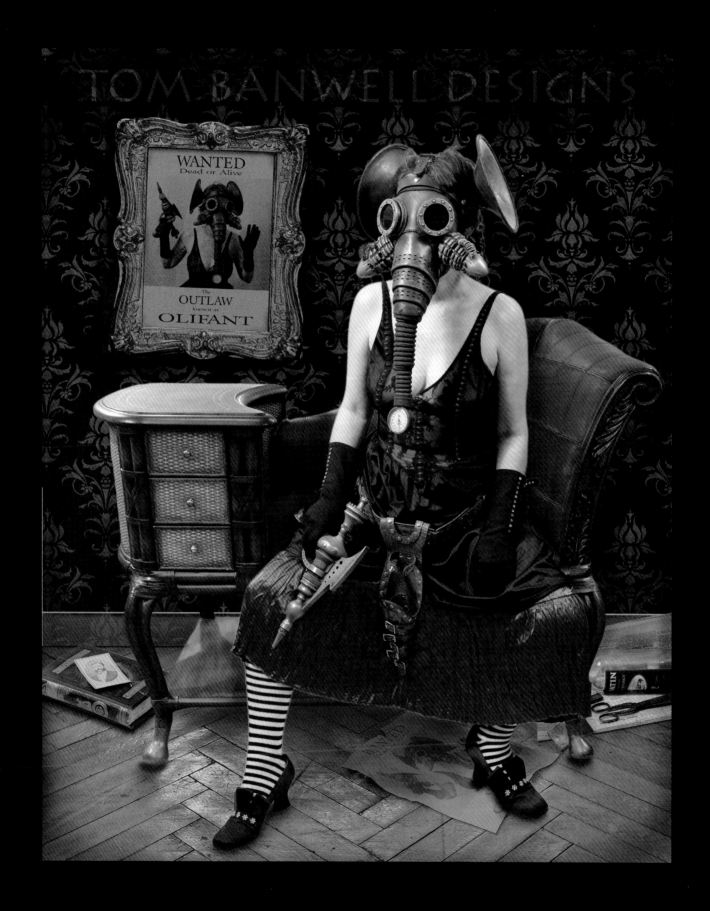

Tom Banwell
"Olifant Outlaw" Gas Mask

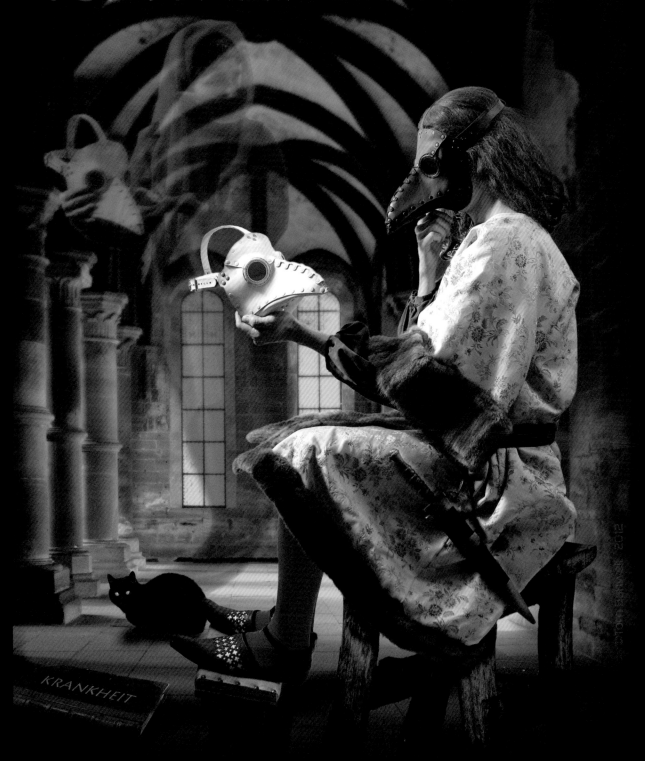

Tom Banwell

Tom Banwell
"Krankheit Medieval" Mask

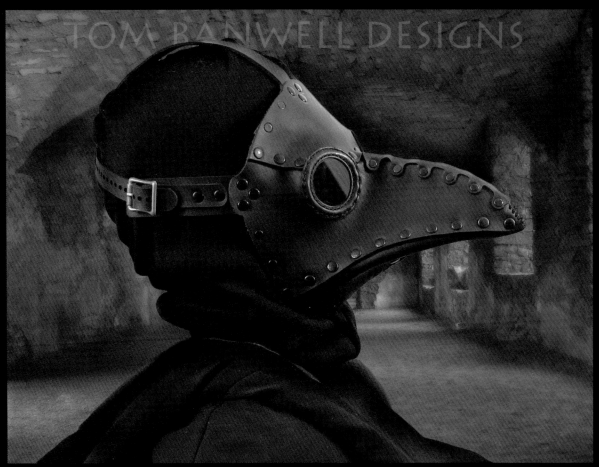

TOM BANWELL DESIGNS

Tom Banwell *"Black Krankheit"* **Mask**

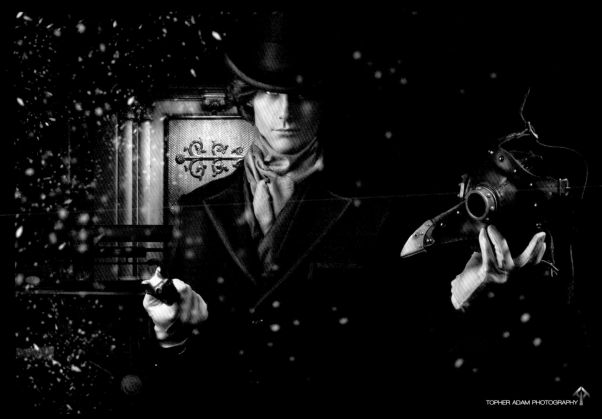

TOPHER ADAM PHOTOGRAPHY

Tom Banwell *"Stone Cold"* **Mask**

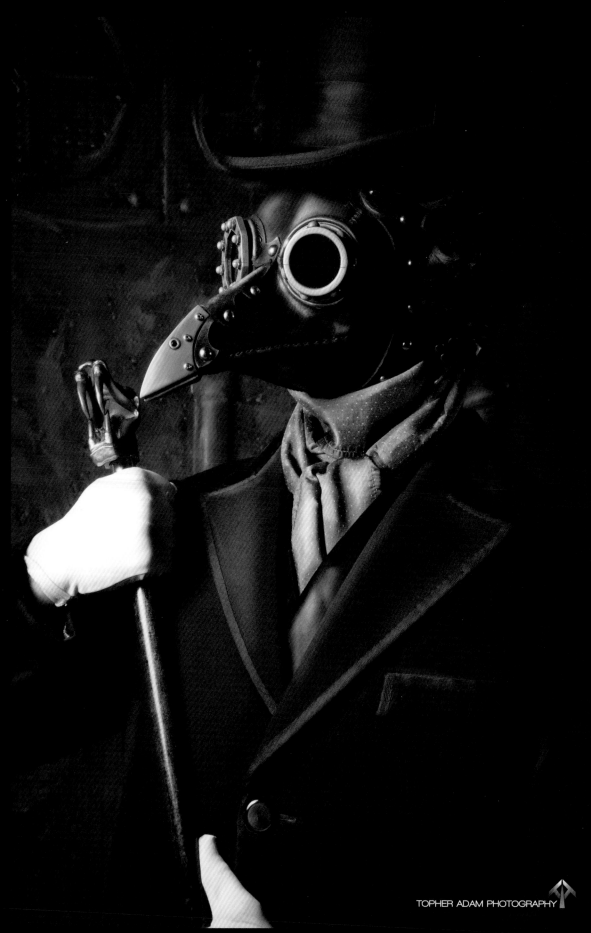

Tom Banwell *"Dr. Beulenpest"* Mask

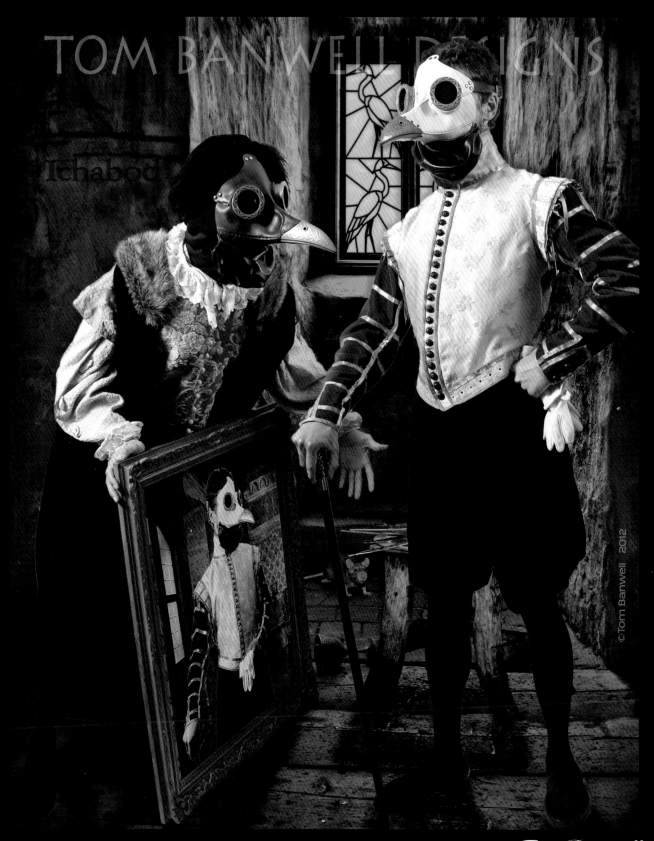

Tom Banwell

Tom Banwell "*The Displeased Patron Ichabod*" Mask

041

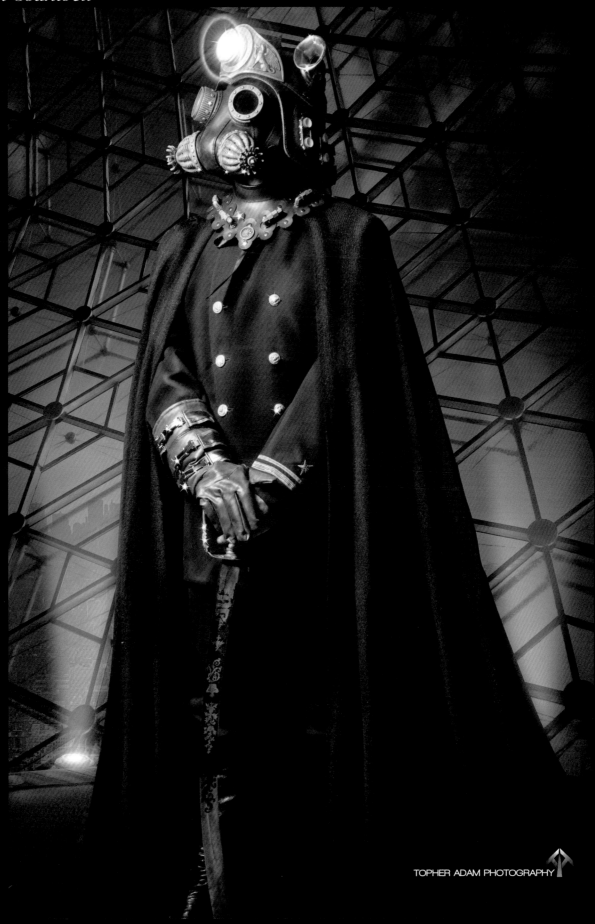

Tom Banwell *"Dark Air Lord"* Mask

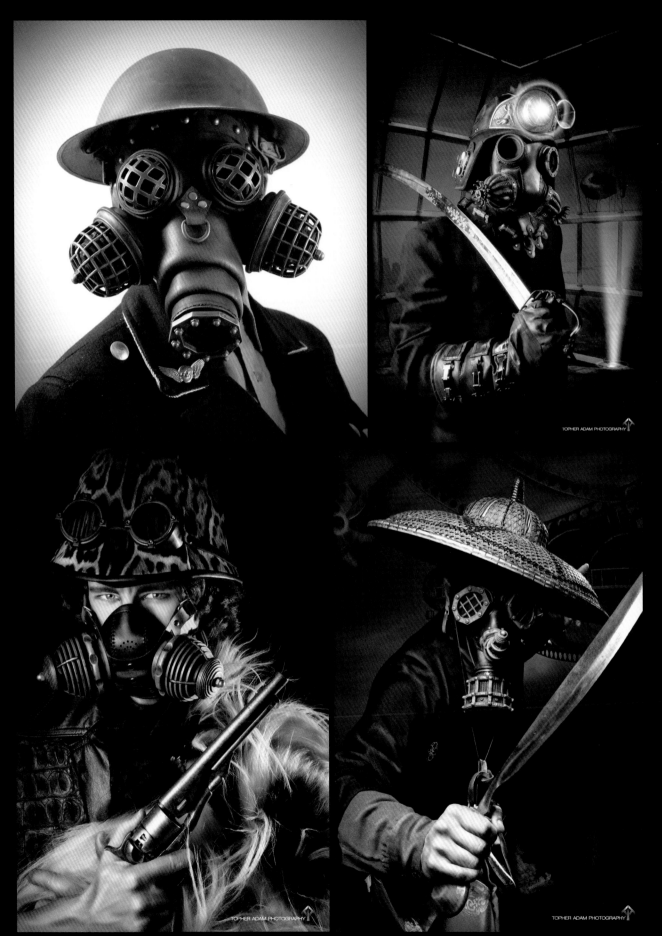

Tom Banwell Top left: "*Ragnarok Soldier*" Gas Mask Top right: "*Sentinel*" Gas Mask
Bottom left: "*Transmutator*" Gas Mask Bottom right: "*Invasion*" Gas Mask

Tom Banwell

TOPHER ADAM PHOTOGRAPHY

Tom Banwell *"Olifant"* Gas Mask

Tom Banwell Top left: *"Firemaster"* **Gas Mask Top right:** *"Trophy Hunter"* **Goggles**
Bottom left: *"Dark Explorer"* **Helmet Bottom right:** *"Underground Explorer"* **Helmet**

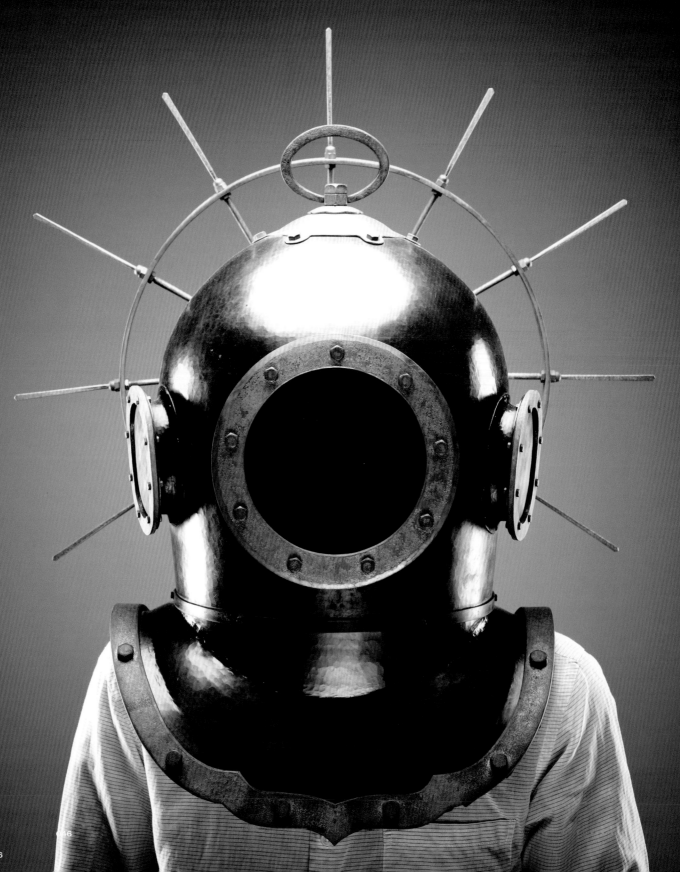

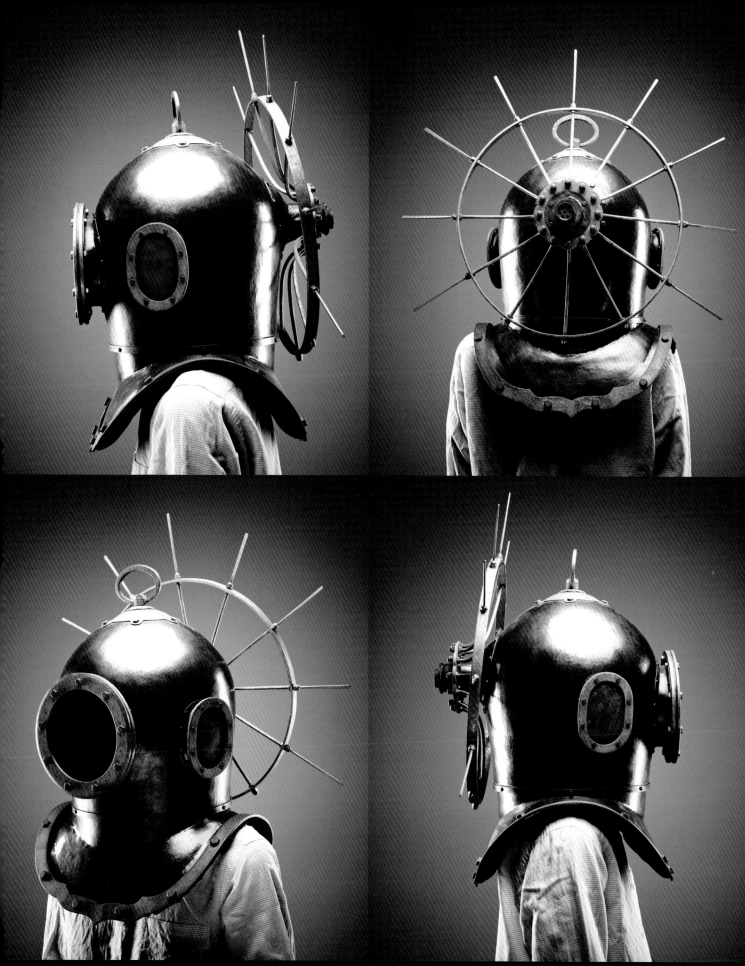

Kozo Saito "Senshin" (Mind that Dives) Mask PHOTO: Susumu Miyawaki MODEL: Kozo Saito

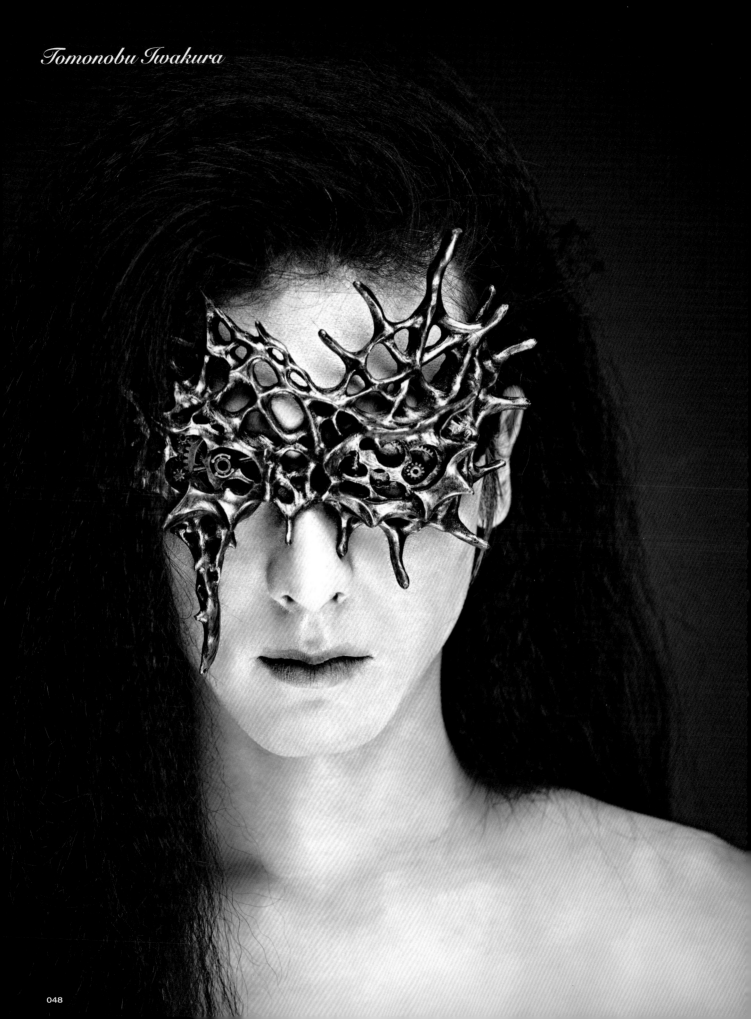

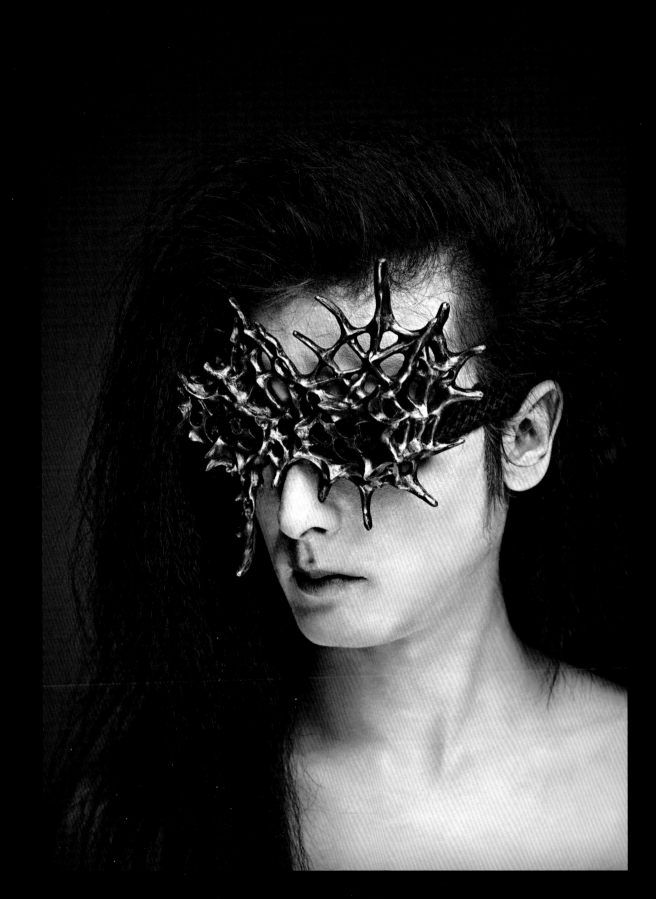

Tomonobu Iwakura "*BLACK SPIDER*" *(Mind that Dives)* Googles PHOTO: Susumu Miyawaki MODEL: Shinjiro Saito

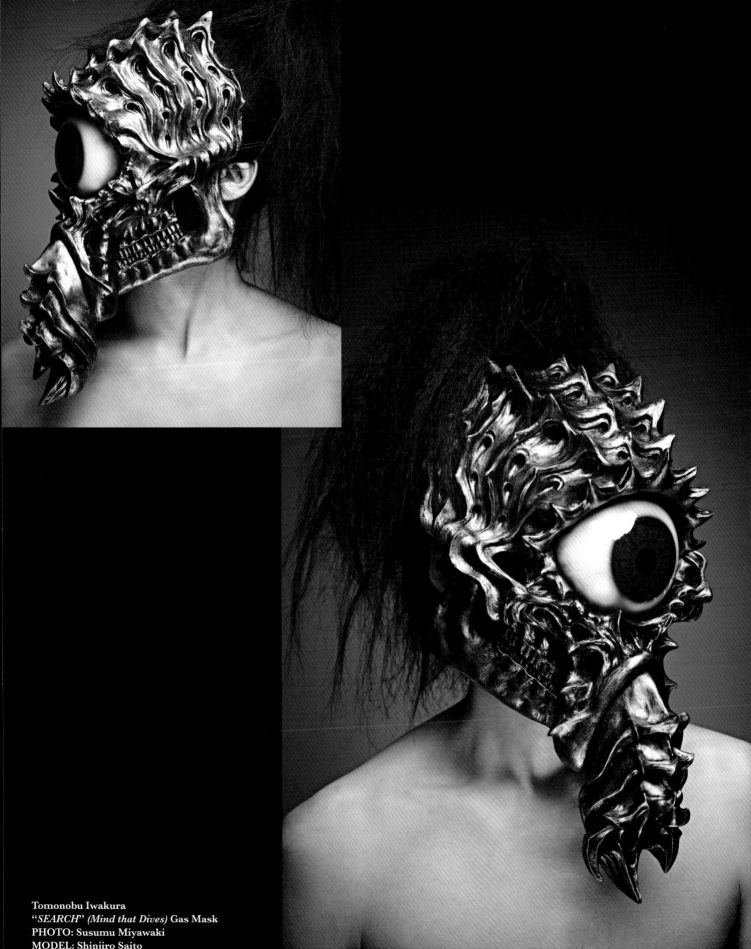

Tomonobu Iwakura
"*SEARCH*" *(Mind that Dives)* Gas Mask
PHOTO: Susumu Miyawaki
MODEL: Shinjiro Saito

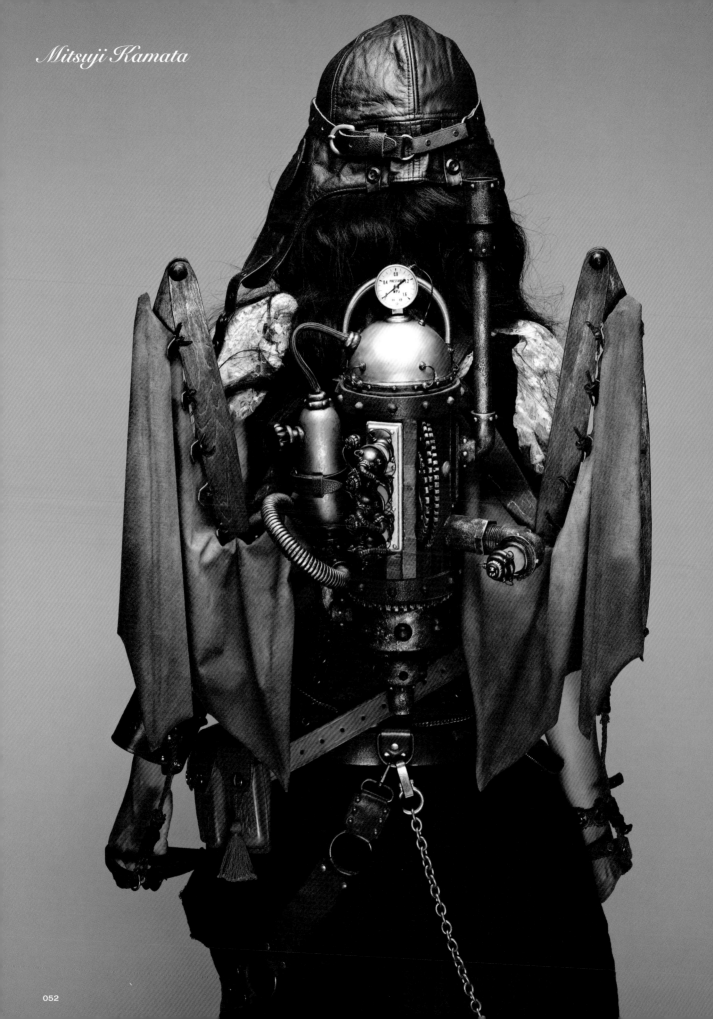

Mitsuji Kamata
"*Steam Flying Machine*" *(Mind that Dives)* Flying Machine *Objet*
PHOTO: Susumu Miyawaki
MODEL: Mary

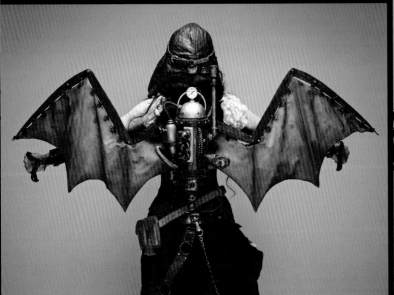

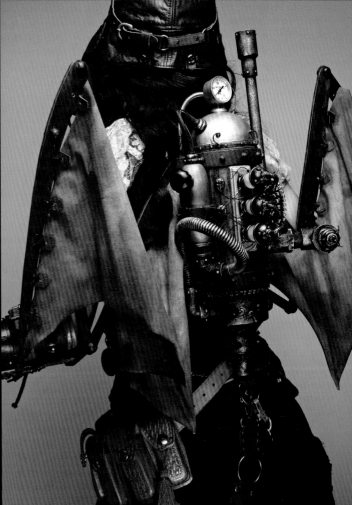

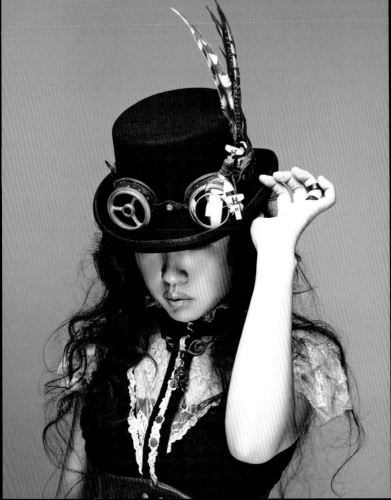

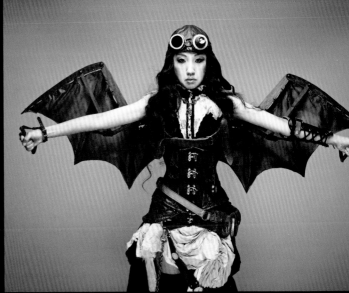

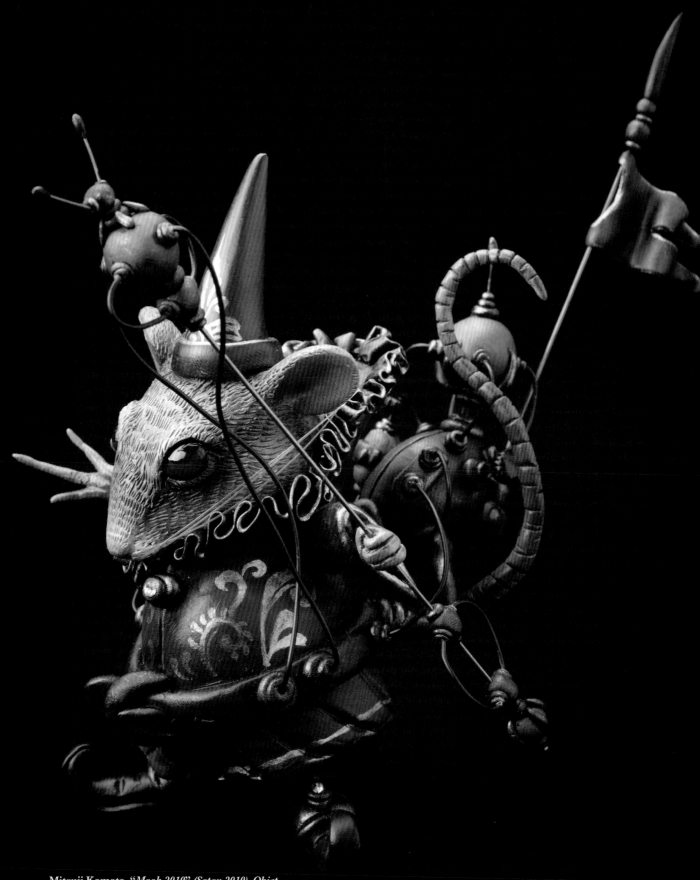

Mitsuji Kamata *"Maoh 2010" (Satan 2010) Objet*
PHOTO: Susumu Miyawaki

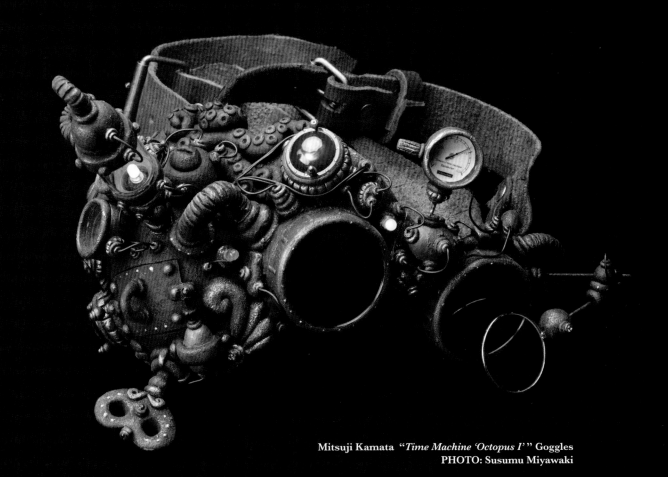

Mitsuji Kamata *"Time Machine 'Octopus I'"* **Goggles**
PHOTO: Susumu Miyawaki

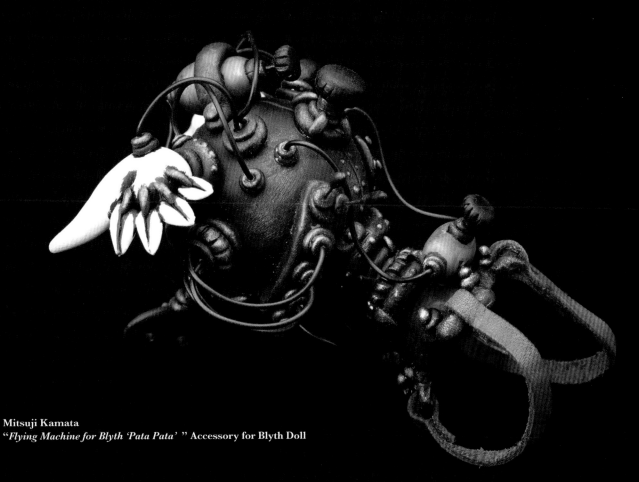

Mitsuji Kamata
"Flying Machine for Blyth 'Pata Pata'" **Accessory for Blyth Doll**

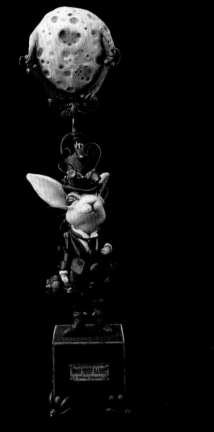
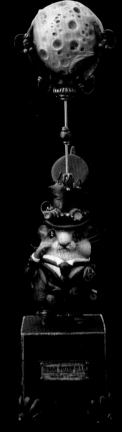

Mitsuji Kamata Left: *"Tsukidorobo (Rabbit)" (The Moon Thief [Rabbit]) Objet* Right: *"Tsukidorobo (Hamster)" (The Moon Thief [Hamster]) Objet*
PHOTO: Susumu Miyawaki

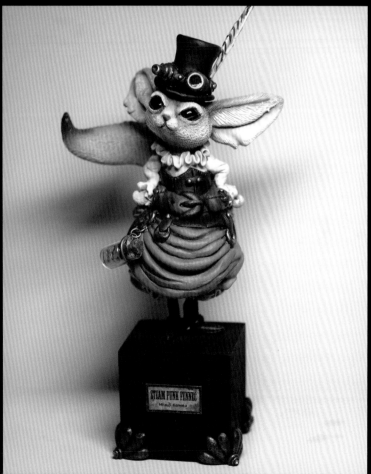
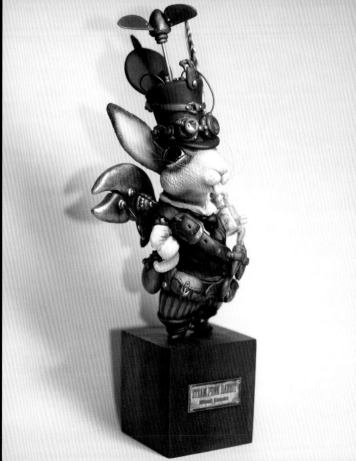

Mitsuji Kamata Left: *"Steampunk Fennec" Objet* Right: *"Steampunk Rabbit" Objet* **PHOTO: Mitsuji Kamata**

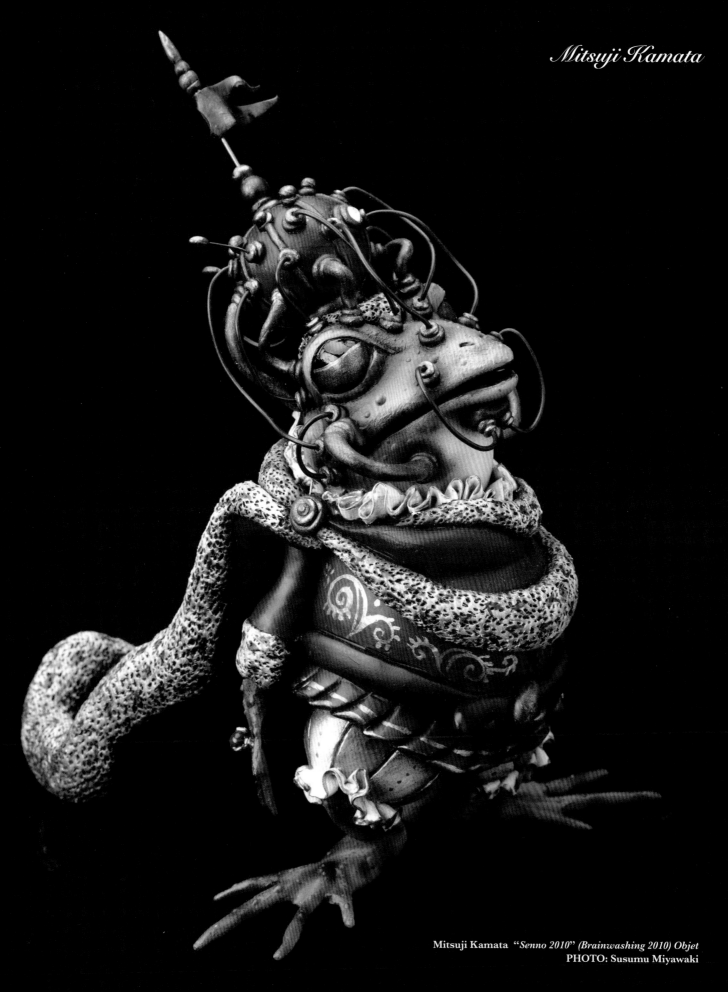

Mitsuji Kamata "Senno 2010" *(Brainwashing 2010) Objet*
PHOTO: Susumu Miyawaki

Mitsuji Kamata

057

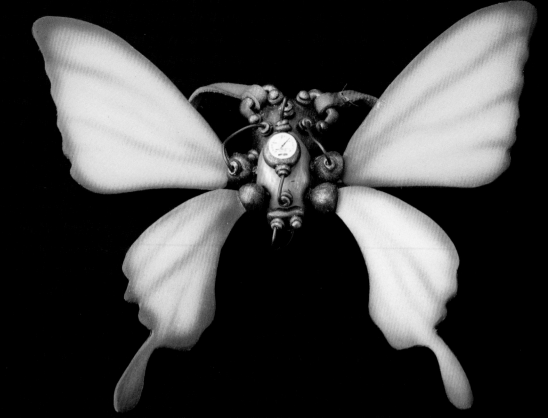

Mitsuji Kamata Top: *"Flying Butterfly for Blyth"* Accessory for Blyth Doll
Bottom left: *"Mekahachi & Beagle" (Mechanical Honey Bee & Beagle) Objet* PHOTO: Mitsuji Kamata
Bottom right: *"Steampunk Wolf" Objet* PHOTO: Mitsuji Kamata

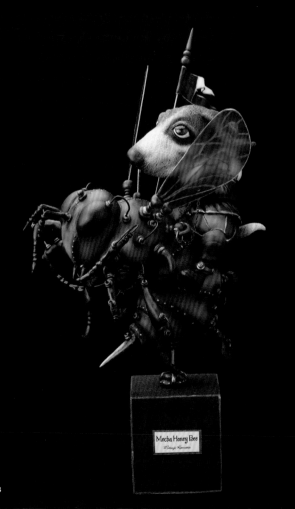

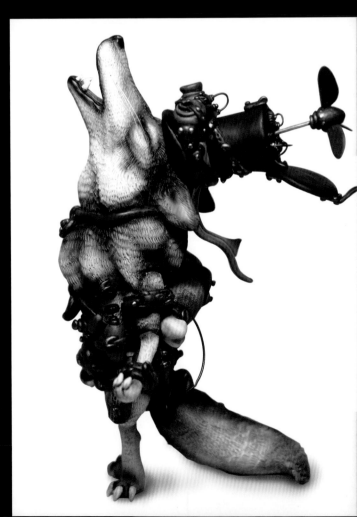

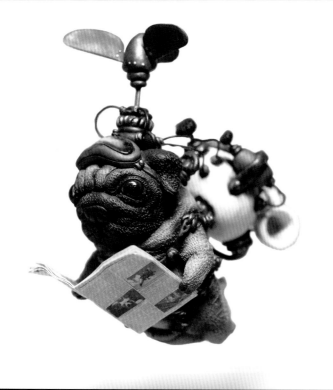
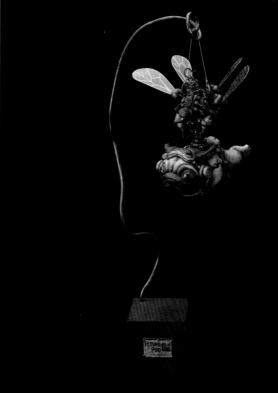
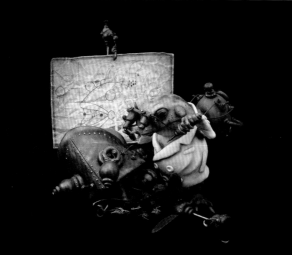
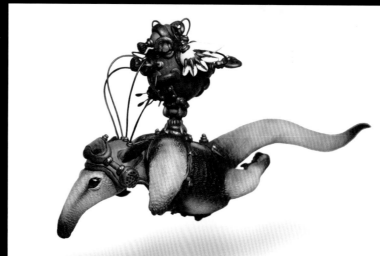
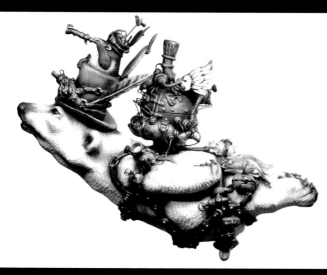

Mitsuji Kamata (Kamaty Moon)
Top left: *"Flying Pug (Newspaper)"* *Objet* PHOTO: Mitsuji Kamata
Top right: *"Flying Pug" (Insect's Wings)* *Objet* PHOTO: Susumu Miyawaki
Middle left: *"Dr Connell Set"* *Objet* PHOTO: Susumu Miyawaki
Middle right: *"Flying Anteater"* *Objet* PHOTO: Susumu Miyawaki
Bottom left: *"Flying Bear and Penguin"* *Objet* PHOTO: Mitsuji Kamata

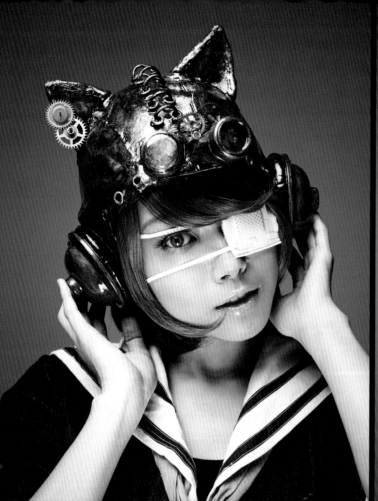
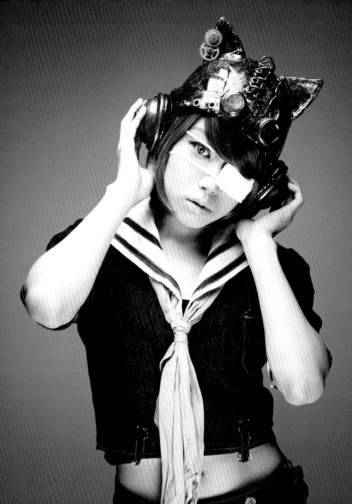
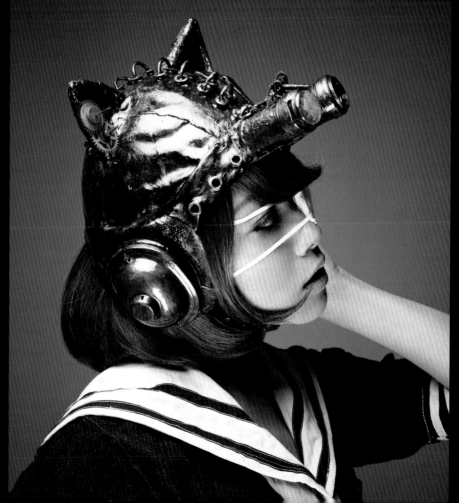

Chasuke
"Neko-san Headgear"
(Cat's Ears Headgear) Headgear
PHOTO: Susumu Miyawaki
MODEL: Nanae

Chasuke

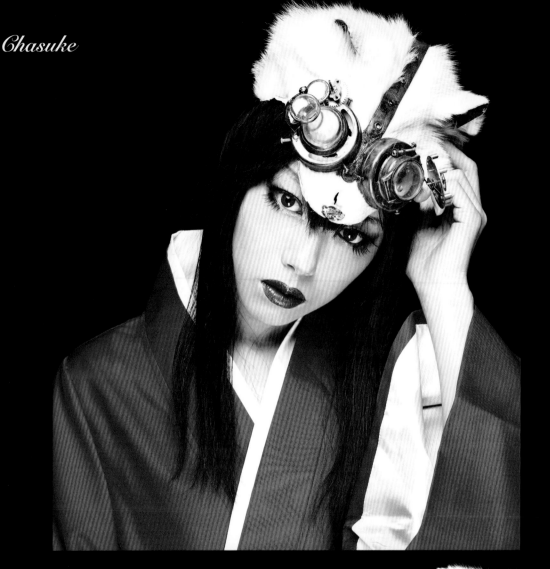

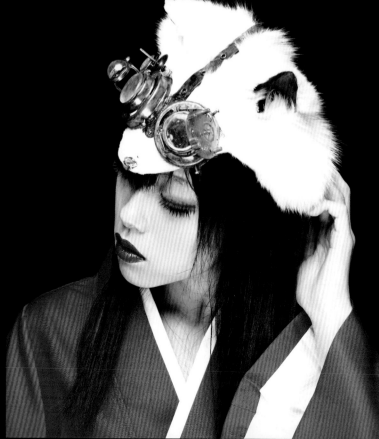

Chasuke
"Kitsune Tsuki Goggles"
(Fox Possessed Goggles) Goggles
PHOTO: Susumu Miyawaki
MODEL: Nanae

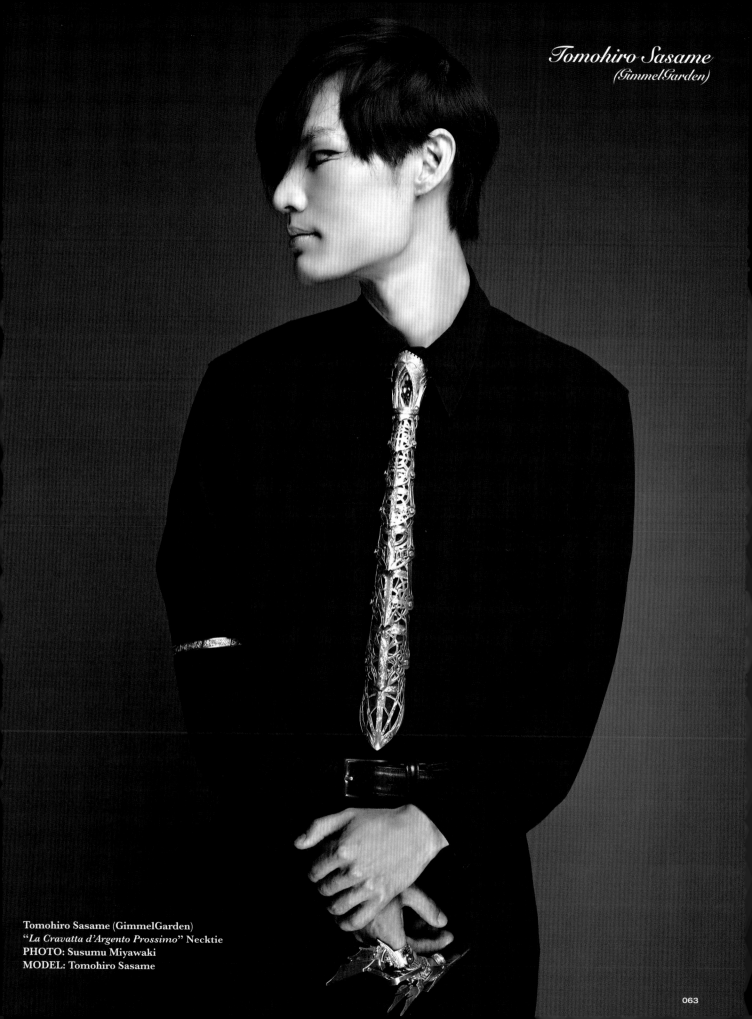

Tomohiro Sasame
(GimmelGarden)

Tomohiro Sasame (GimmelGarden)
"*La Cravatta d'Argento Prossimo*" Necktie
PHOTO: Susumu Miyawaki
MODEL: Tomohiro Sasame

063

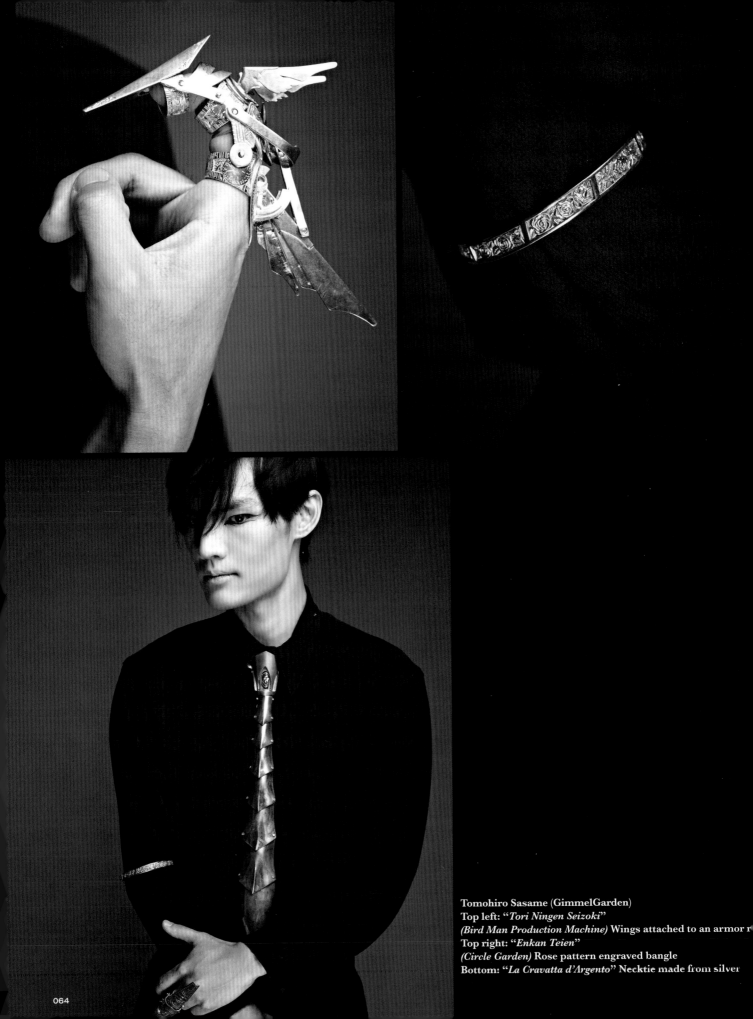

Tomohiro Sasame (GimmelGarden)
Top left: "*Tori Ningen Seizoki*"
(Bird Man Production Machine) Wings attached to an armor r
Top right: "*Enkan Teien*"
(Circle Garden) Rose pattern engraved bangle
Bottom: "*La Cravatta d'Argento*" Necktie made from silver

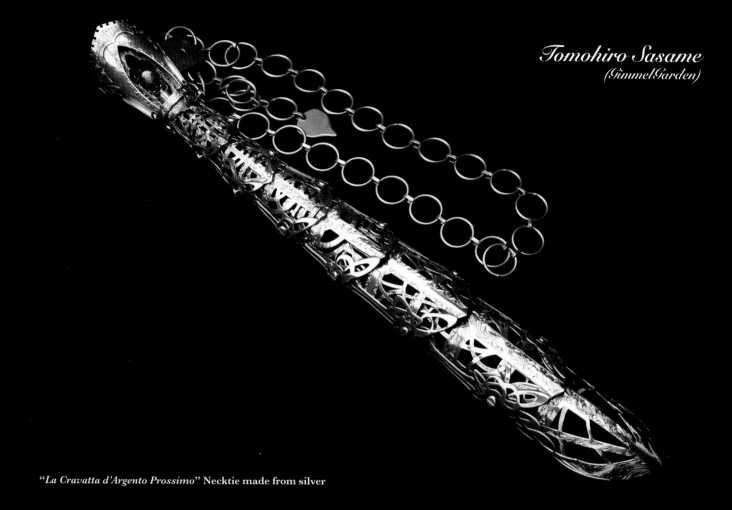

Tomohiro Sasame
(GimmelGarden)

"*La Cravatta d'Argento Prossimo*" Necktie made from silver

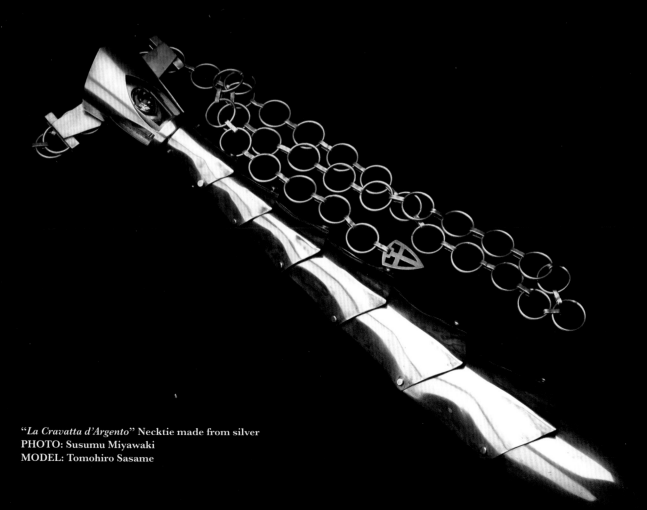

"*La Cravatta d'Argento*" Necktie made from silver
PHOTO: Susumu Miyawaki
MODEL: Tomohiro Sasame

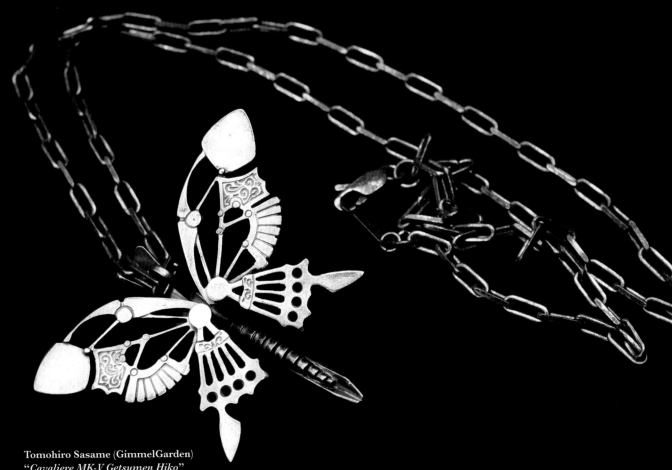

Tomohiro Sasame (GimmelGarden)
"Cavaliere MK-V Getsumen Hiko"
(Cavaliere MK-V Flying Over the Moon's Surface) Pendant

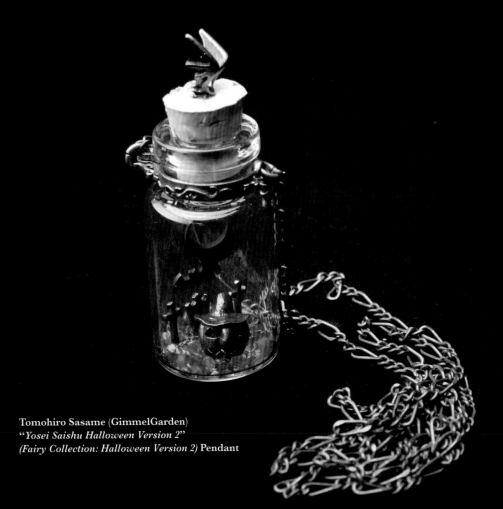

Tomohiro Sasame (GimmelGarden)
"Yosei Saishu Halloween Version 2"
(Fairy Collection: Halloween Version 2) Pendant

Tomohiro Sasame
(GimmelGarden)

Tomohiro Sasame (GimmelGarden)
"Automatico Segretario"
Feather pen and stand

Tomohiro Sasame (GimmelGarden)
"Cosmo Compresso"
Ring

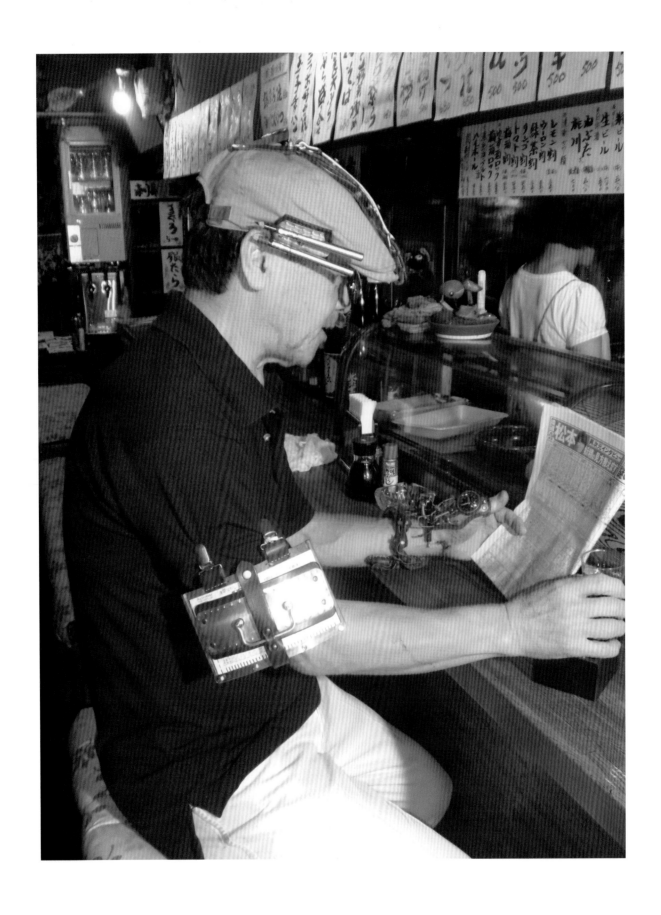

Haruo Suekichi

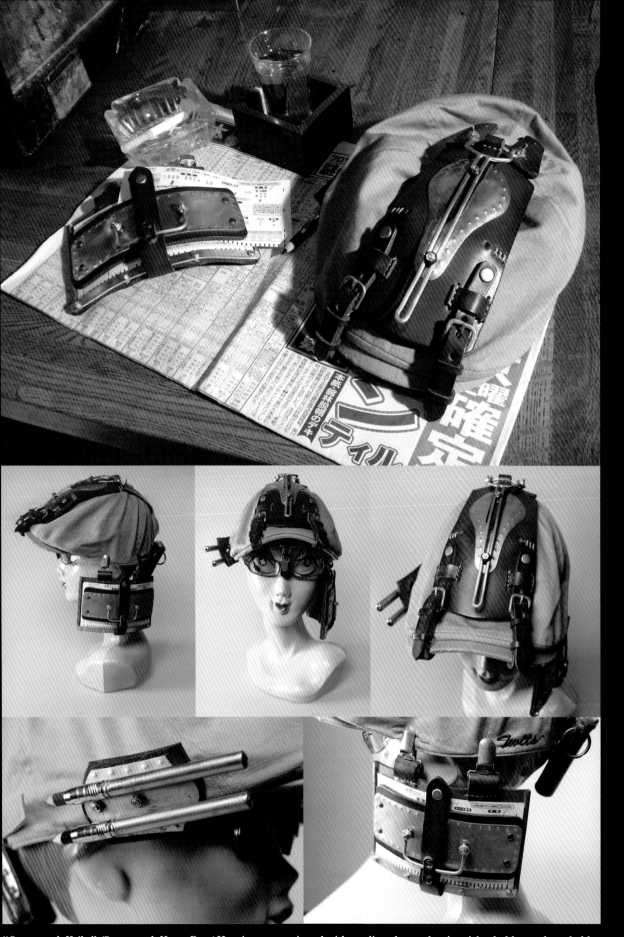

"Steampunk Keiba" (Steampunk Horse Race) **Hunting cap equipped with reading glasses, betting ticket holder, and pen holder**
PHOTO: Haruo Suekichi
MODEL: Sei-chan, a barkeeper at Nebuta

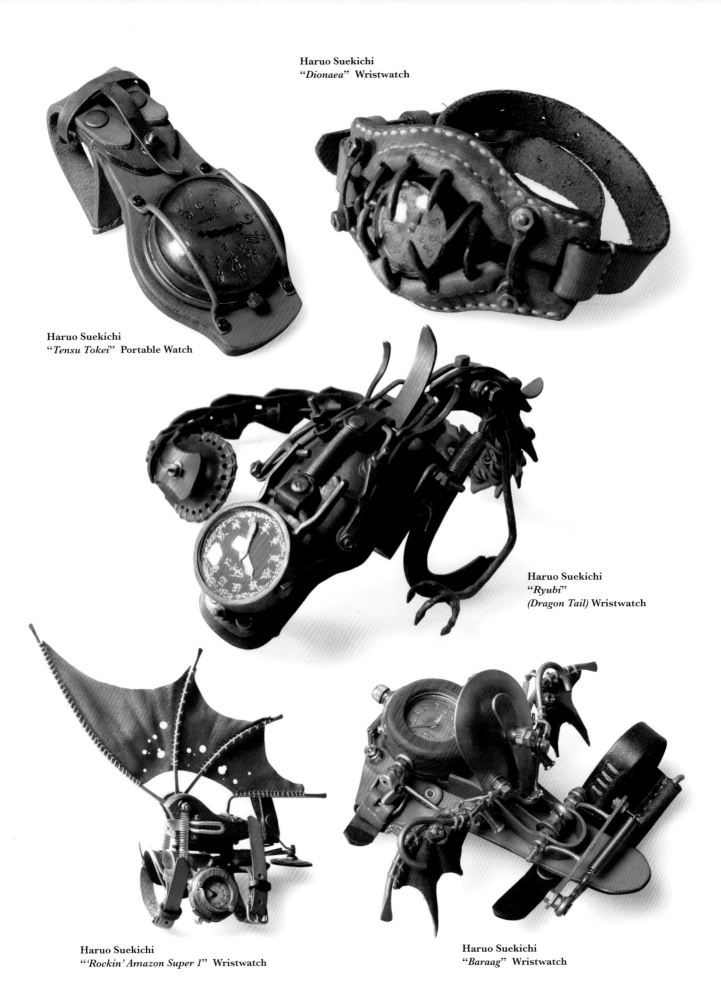

Haruo Suekichi
"Dionaea" Wristwatch

Haruo Suekichi
"Tensu Tokei" Portable Watch

Haruo Suekichi
"Ryubi"
(Dragon Tail) Wristwatch

Haruo Suekichi
"'Rockin' Amazon Super 1" Wristwatch

Haruo Suekichi
"Baraag" Wristwatch

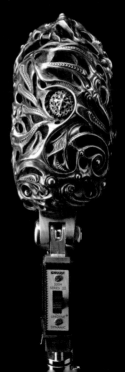

Yuta Sato (Ability Normal)
"untitled" **Microphone Cover**

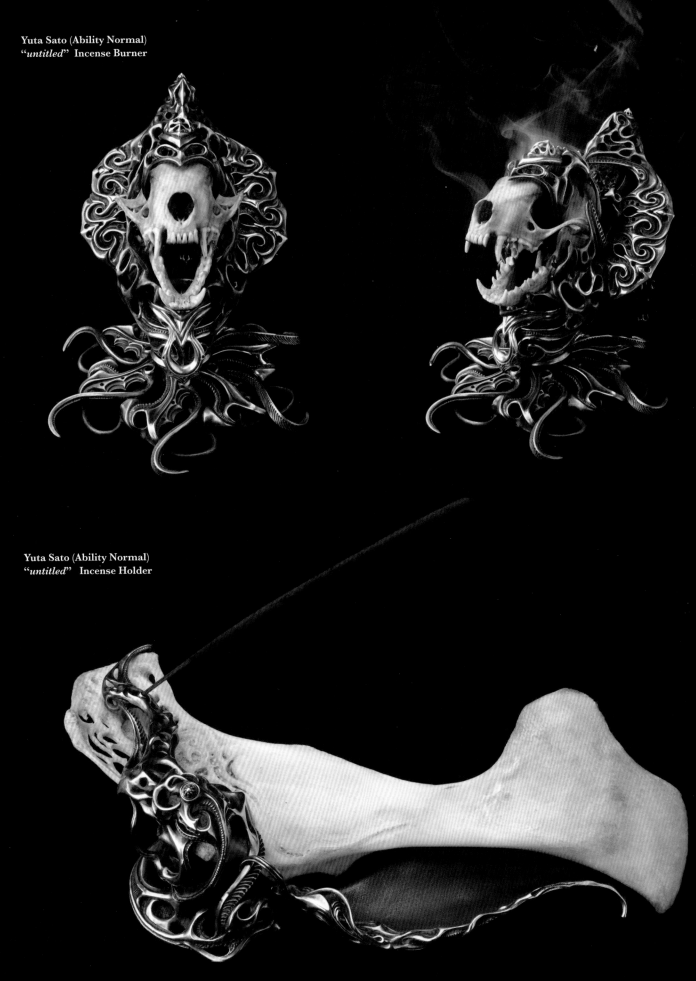

Yuta Sato (Ability Normal)
"untitled" Incense Burner

Yuta Sato (Ability Normal)
"untitled" Incense Holder

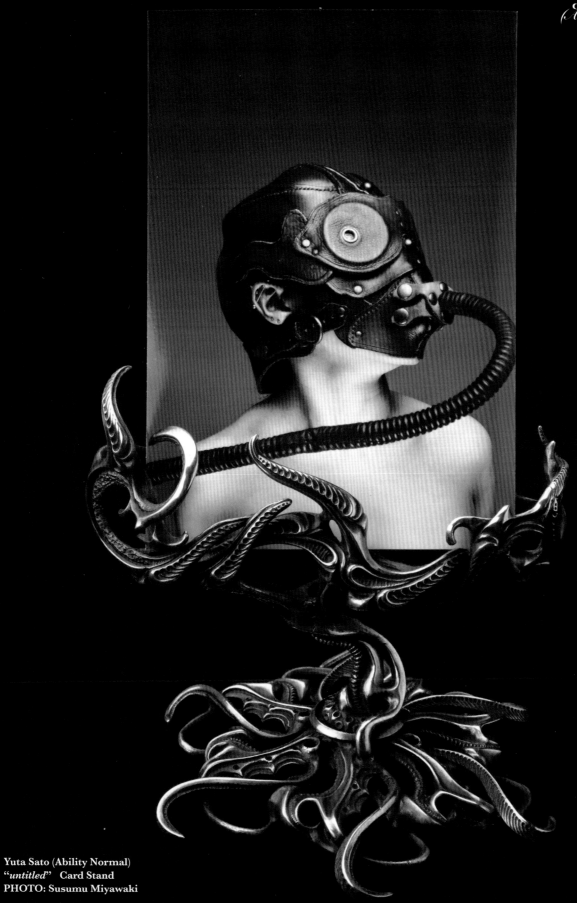

Yuta Sato (Ability Normal)
"untitled" Card Stand
PHOTO: Susumu Miyawaki

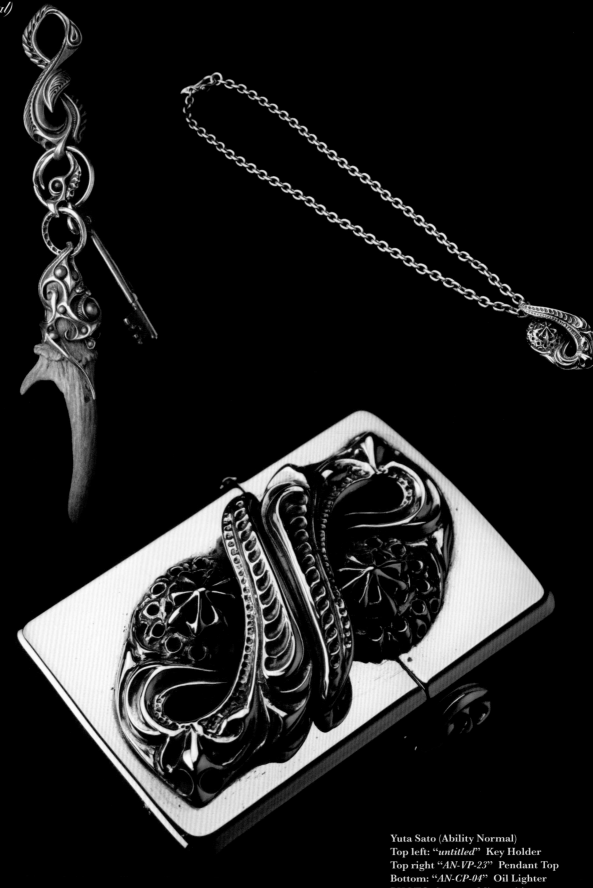

Yuta Sato (Ability Normal)
Top left: "*untitled*" Key Holder
Top right "*AN-VP-23*" Pendant Top
Bottom: "*AN-CP-04*" Oil Lighter
PHOTO: Susumu Miyawaki

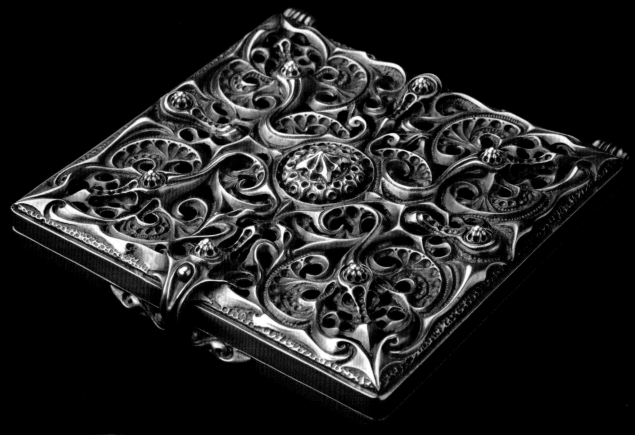

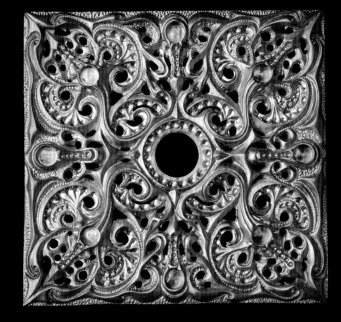

Yuta Sato (Ability Normal)
Top left: *"untitled"* Wallet
Top right *"AN-UM-11"* Bracelet
Bottom: *"untitled"* Object
PHOTO: Susumu Miyawaki

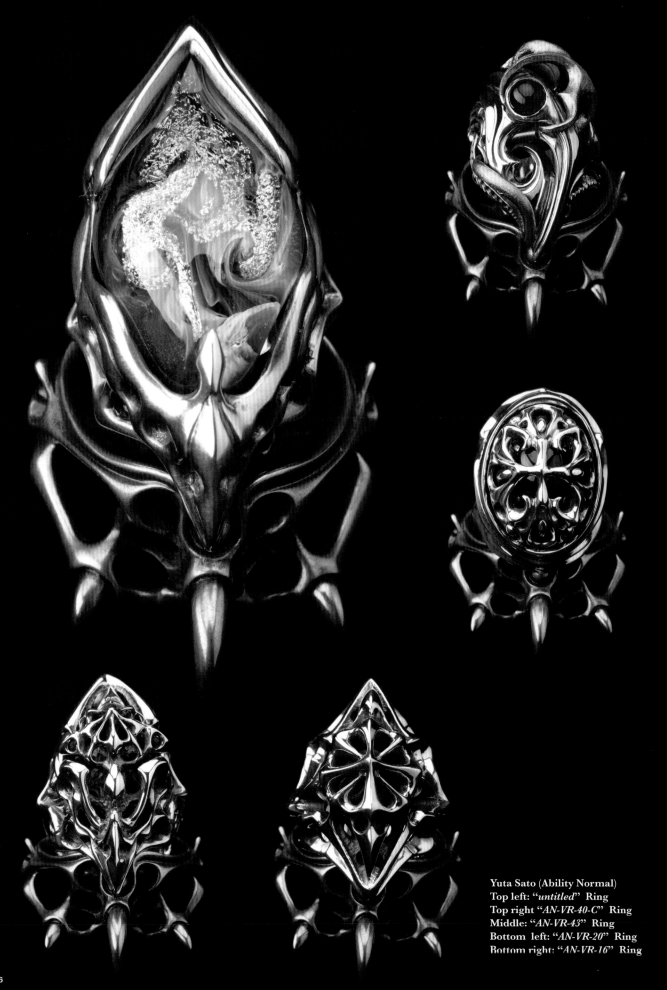

Yuta Sato (Ability Normal)
Top left: "*untitled*" Ring
Top right "*AN-VR-40-C*" Ring
Middle: "*AN-VR-43*" Ring
Bottom left: "*AN-VR-20*" Ring
Bottom right: "*AN-VR-16*" Ring

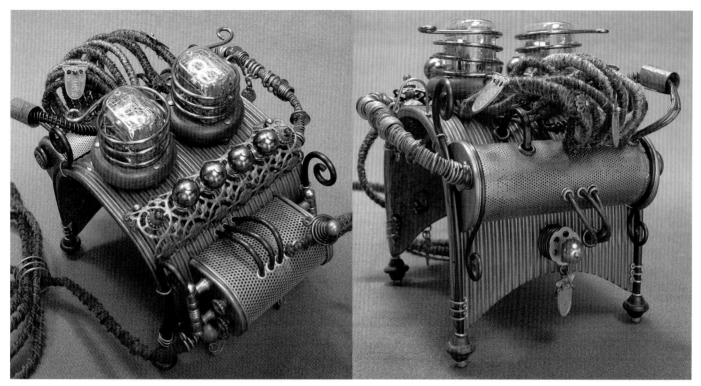

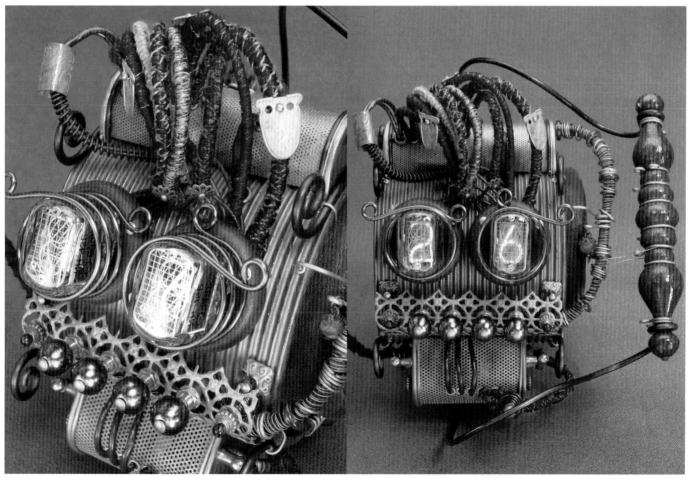

Zettai Shonen

Zettai Shonen
"The Japanese Mixism (nixie wristwatch)" Nixie Tube Wristwatch
PHOTO: Zettai Shonen

Katsutoshi Shirasuna

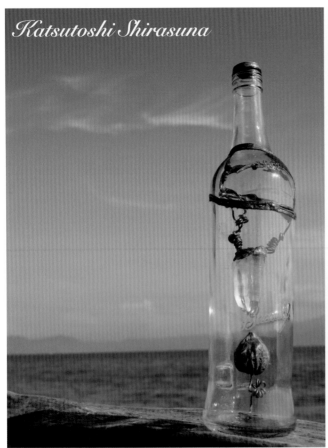
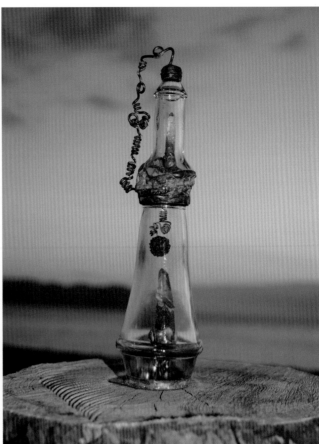

Katsutoshi Shirasuna *"Toki no Namioto (Time Labyrinth Series)"* **Earrings PHOTO: Susumu Miyawaki**

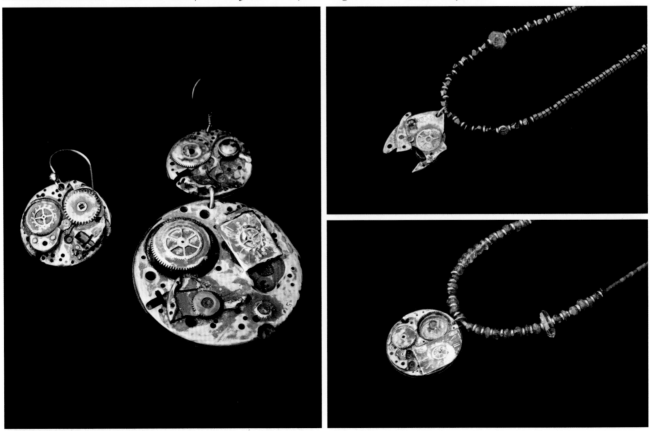

Katsutoshi Shirasuna Top: *"Shu no Kigen ~ Minori (Time Labyrinth Series)"* *(Origin of Species ~ Harvest (Time Labyrinth Series))* Necklace
Bottom: *"Shu no Hanei ~ Shinjitsu no Ai (Time Labyrinth Series)"* *(Glory of Species ~ True Love (Time Labyrinth Series))* Necklace
PHOTO: Susumu Miyawaki

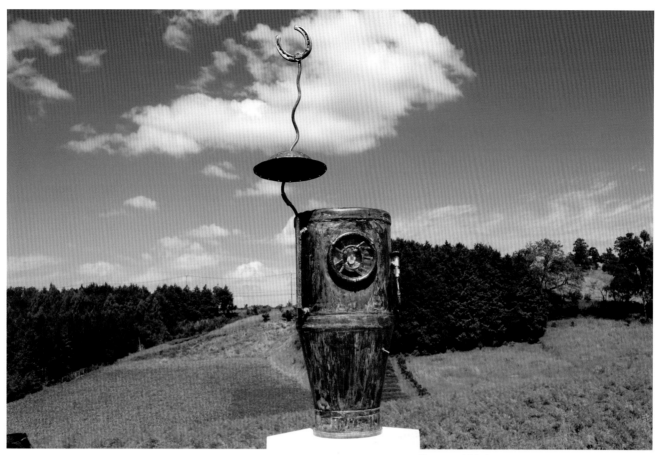

Katsutoshi Shirasuna "*Steamconga*" Hand Drum

Katsutoshi Shirasuna "*Kakokara Kita Mirai no Sochi*"
(*The Future Device That Came from the Past*) Objet

Katsutoshi Shirasuna "*Kyumin no Kaijyo (Hatsuga)*"
(*Lifting the Dormant (Germination)*) Objet

Katsutoshi Shirasuna "*Esper-Cross Lantern*"
Objet

Michihiro Matsuoka
"Scull Ship" Objet
PHOTO: Michihiro Matsuoka

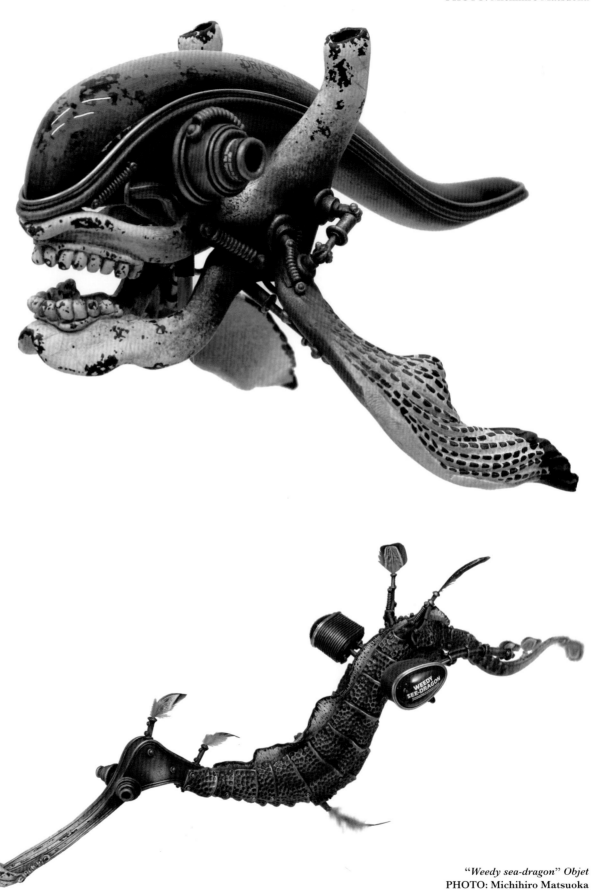

"Weedy sea-dragon" Objet
PHOTO: Michihiro Matsuoka

Top: *"French Bulldog" Objet*
Bottom: *"Custom Rabbit" Objet*
PHOTO: Michihiro Matsuoka

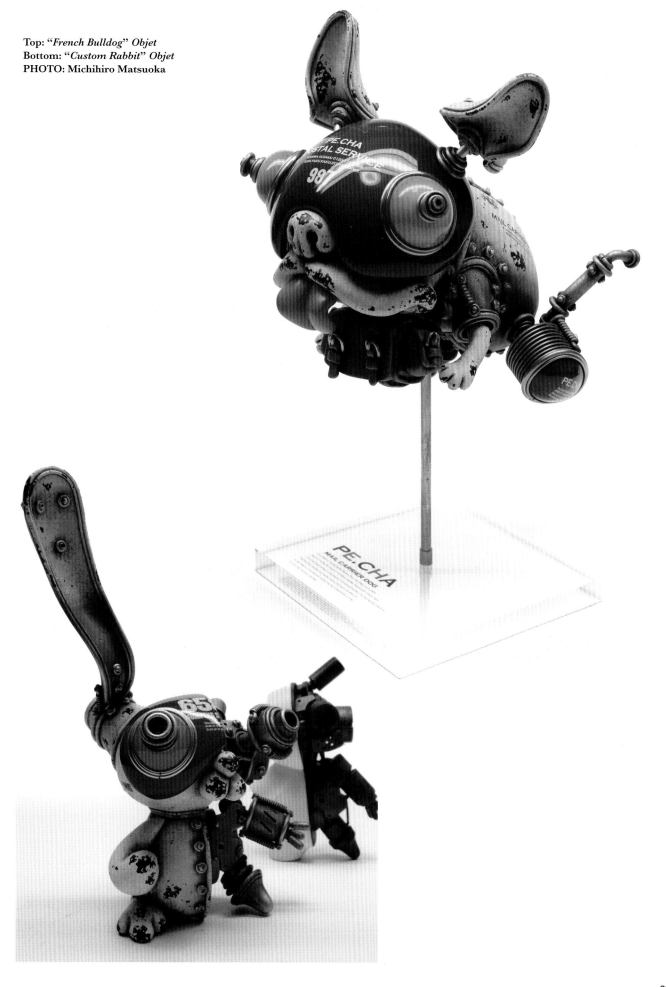

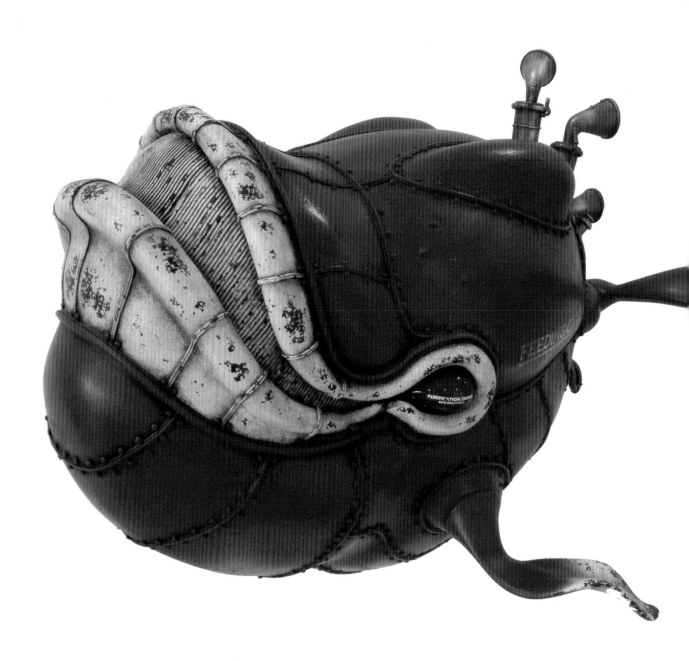

Michihiro Matsuoka
"Kujiragata Taiki Jyokasen" (Whale-shaped Air Purifying Ship) Objet
PHOTO: Michihiro Matsuoka

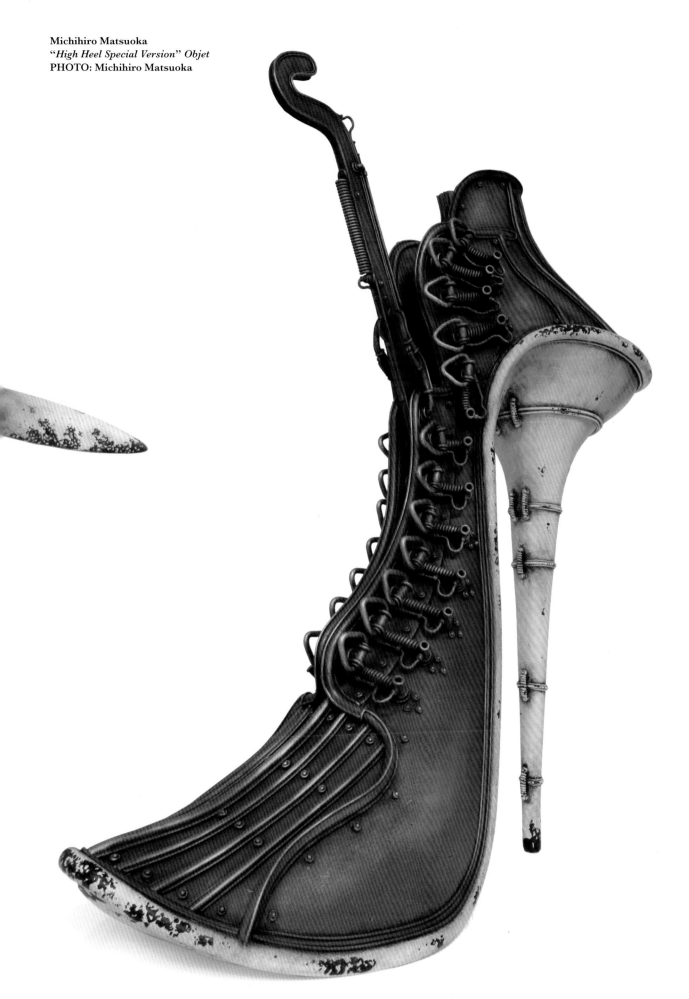

Michihiro Matsuoka
"*High Heel Special Version*" *Objet*
PHOTO: Michihiro Matsuoka

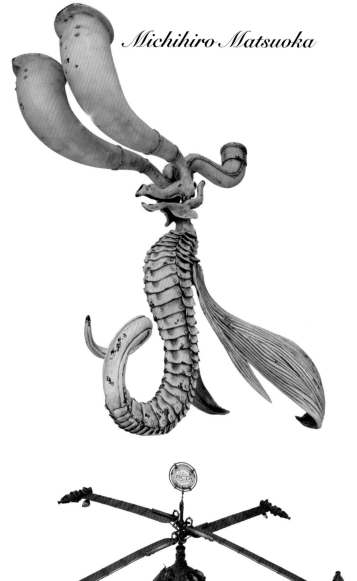

Bottom left: *"Horned Headband Special Edition" Objet*
PHOTO: Keiichiro Natsume

Top left: *"Nyoro Nyoro" Objet*
Middle left: *"TreeHopper" Objet*
Top right: *"PARADIGM SHIFT" Objet*
Middle right, Bottom right: *"Time Machine" Objet*
PHOTO Michihiro Matsuoka

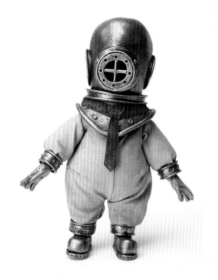

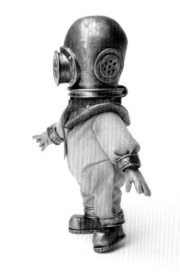

SONIC
Top: "*The Diver*" Doll
Middle left: "*Baron Steam*" Doll
Middle right: "*Mr. Dodo*" Doll
PHOTO: Susumu Miyawaki

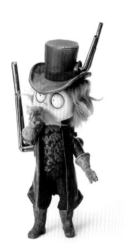

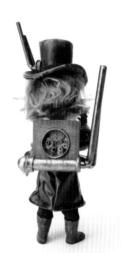

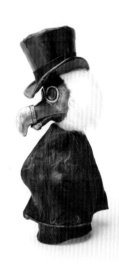

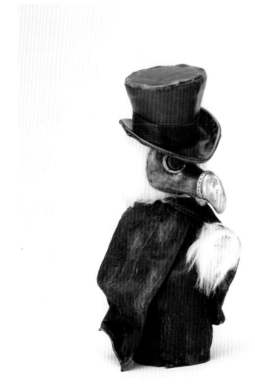

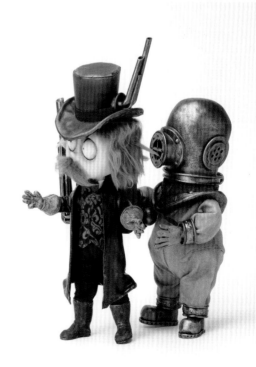

Keizo Hoshino

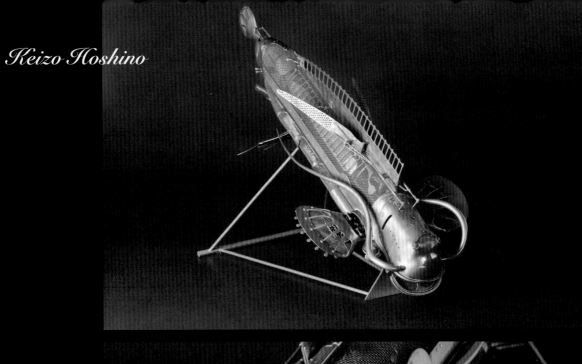

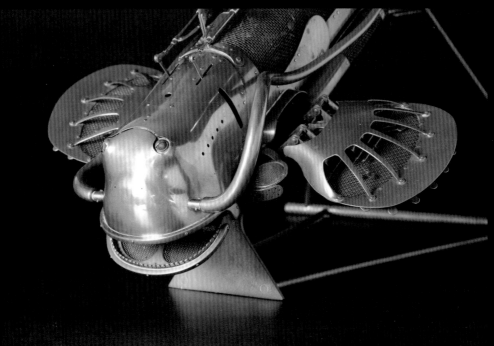

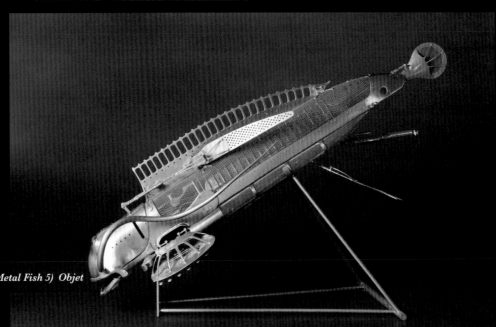

Keizo Hoshino
"Kinzokugyo 5" (Metal Fish 5) Objet
PHOTO: Yun Yua

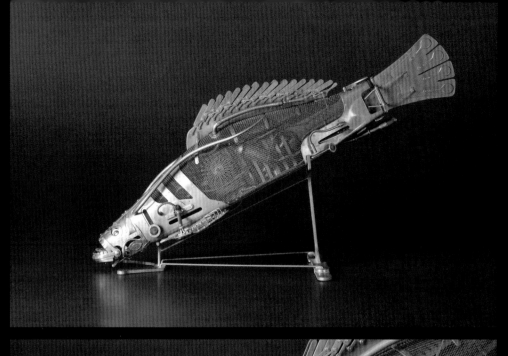

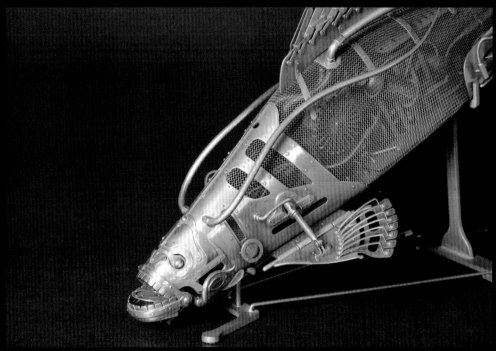

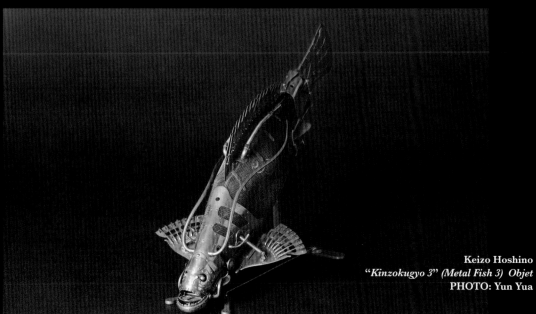

Keizo Hoshino
"Kinzokugyo 3" (Metal Fish 3) Objet
PHOTO: Yun Yua

Mari Igarashi

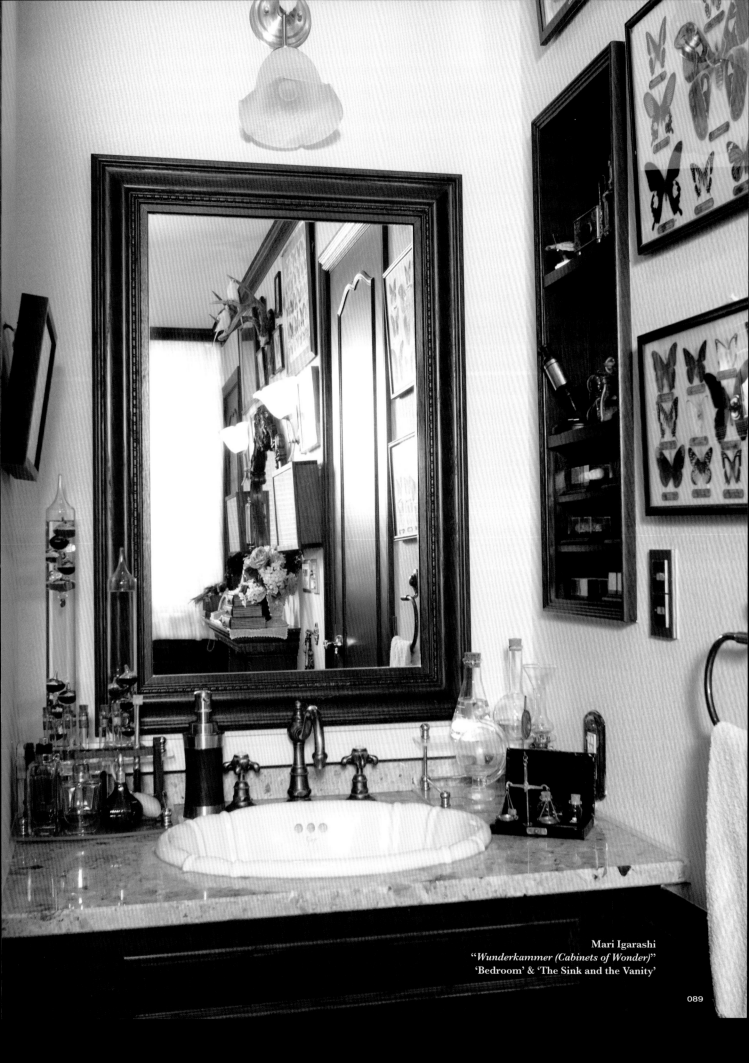

Mari Igarashi
"*Wunderkammer (Cabinets of Wonder)*"
'Bedroom' & 'The Sink and the Vanity'

Antiquarian and Wunderkammer

Introducing a Steampunk world of antiquarianism and *Wunderkammer* (Cabinet of Wonder).

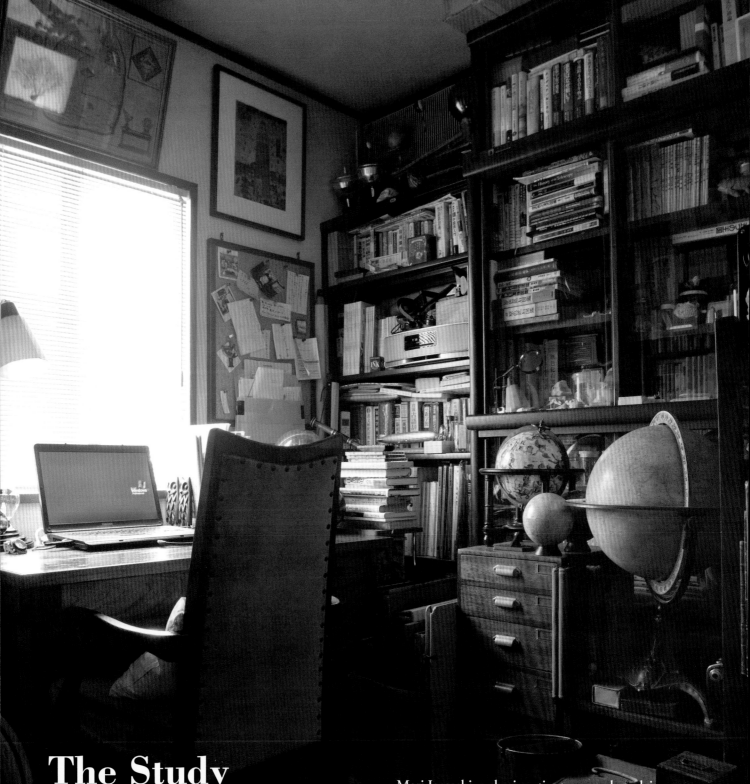

The Study
and Book Shelves
of *Tenmonkogan*

Tenmonkogan: Popular antiquarian blog site administrated by Tsunoda.

Mari Igarashi, a charismatic steampunker, claims Tamaao Tsunoda's study is "the best study anywhere in Japan."

Surrounded by jostling objects from all times and places – such as old star charts, globes, celestial globes, natural history illustrations, rare books, and specimen boxes etc. – Tsunoda spoke, in a small and very crowded study, about the glamor of *Wunderkammer* and about his collections.

In the Study

Objects collected over twenty-five years have been crammed into the study. Even though the master of the study fears that if just a few people enter the room at one time the floor might cave in. More likely than not, the collection will grow continuously.

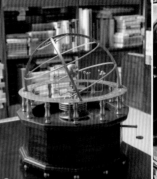
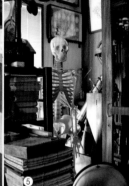

❶ Stuffed bat that used to hang in the science room of an old, all-girls school. ❷ A Globe, Celestial Globe, and Moon Globe. ❸ These bookshelves contain books for astronomy, zoology/botany, mineralogy, folklore, etc. ❹ The Orrery. ❺ This is an old-style human skeleton model made with papier-mâché.

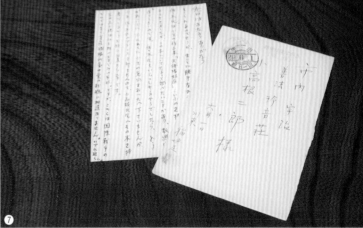

❻ A Gregorian chant book bound in pigskin and secured with brass bosses. ❼ A postcard written by Taruho Inagaki.

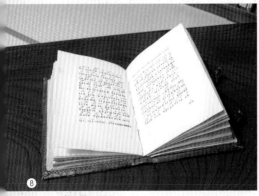
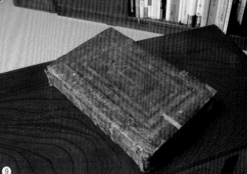

❽ Handwritten Znamenny chant book. ❾ Old Russian Orthodox Church book written in Cyrillic characters, and its interior.

ABOUT WUNDERKAMMER

Wunderkammer is generally translated as 'Cabinet of Wonder' in Japanese. During the Age of Exploration in the 16th century, various rare objects from all over the world were brought to Europe. Royals and nobles used their wealth to collect these objects and display them in their households in order to "take possession of the entire world for oneself." These objects were generally collected in one room and the density the collection in that room would seem to overwhelm the viewer – that is the essence of *Wunderkammer*.

The collections – comprising objects in nature, relics of the past, man-made objects like *Karakuri Zaiku* (mechanism devices), etc. – are very diverse. The genre of the object does not matter; as long as it is rare, anything goes. Introducing *Wunderkammer* in Japan, the herbalist (botanist) Kenkado Kimura (*1), who lived in Osaka during the Edo period (1603–1868), was known to have built an extensive antiquarian collection.

I have always had a thing for scientific libraries and studies. Ever since I was very young, I have always wanted a space that encapsulated this interest. Following the death of Tatsuhiko Shibusawa in 1987, I was able to visit his study, replete with various media including his cabinet filled with seashells and skulls. This inspired me to create a space, inspired in part by Shibusawa's, and soon afterwards I began to create my own study. Over the next 25 years, I steadily collected a wide variety of objects that I liked, and this resulted in the study I have today. What I am aiming for is a 'scietific library-like study,' so to speak. Captain Nemo's room (*3), a Tokyo DisneySea attraction, is an image of the study that comes to mind. Yet, my study is still far from ideal. In reality, I think that is is inevitable as an actual living space always involves "unrefined disunity."

One of the most precious items in my collection is a postcard written by Taruho Inagaki (*4), which I purchased at a secondhand bookstore. I had decided I would like to own an item featuring Taruho's handwriting and this postcard represents the fulfillment of that desire; you can usually find this sort of thing if you search long enough. Taruho Inagaki can be said to be *Wunderkammer* in both his world view and his literature.

Profile
Tamao Tsunoda
Tsunoda is a popular blogger who administrates the antiquarian blog site Tenmonkogan (URL:http://mononoke.asablo.jp/blog/). Mainly covering astronomy, his blog discusses a wide range of science mania topics. His study room and his collection, accumulated over twenty-five years, are highly praised and well respected. Currently, Tsunoda resides in Aichi prefecture.

Books form the biggest part of my collection. I own a lot of astronomy and natural history books, but I recently became interested in rare books related to Christianity. I have also collected, little by little, *The Gregorian Chant Book* (*5), *The Roman Missal* from 1622 (*6), The *Index Librorum Prohibitorum* (List of Prohibited Books) (*7), etc. Among my collection, the book that I think is most precious to me is the Eastern Christian *Znamenny Chant Book* (*8), purchased from a rare bookstore in Estonia. The largest book, size-wise, is *The Gregorian Chant Book*, which is bound in pigskin and secured with brass bosses. This chant book was published in Vienna and bound in Germany.

I think that, among antiquarians, those who are oriented towards naturalism favor 'lights,' while those oriented towards *Wunderkammer* favor 'dark.' I have a preference for both, and I gravitate equally toward science-oriented clean-cut objects as I do to eerie skulls or religious artefacts. So, if possible, I would love to create a cabinet where both of these styles coexist harmoniously. Items that are 'old' are important to me, because I feel a strange curiosity toward objects that were made by the hands of a craftsman but have since lost their utility.

The ideal Wunderkammer will vary from person to person, but what is common among them is their intense obsession with objects. I'd say that this is a type of fetish or animistic behavior. However, given that our modern lives are often dominated by virtual objects, behaviors that are deeply attached to tangible objects, like *Wunderkammer*, may have the ability to evoke peoples' empathy.

*1 Kenkado Kimura (1736–1802): A writer, painter, herbalist, bibliophile, and collector in the mid-Edo period. 'Kenkado' is the name of his study. Kimura was erudite and a man of versatile talents. While he was a merchant in Osaka, Kimura interacted with many writers and artists, and he built networks along with a great cultural salon. Kimura's collection of antiques, maps, microscopes, minerals, animal/plant specimens, porcelain etc., were nationally famous. Thus, his name spread widely to various provinces in that period.

*2 Tatsuhiko Shibusawa (1928–1987): A French literature scholar, novelist, essayist, and translator. In 1956, having published a Japanese translation of all three volumes of *Marquis de Sade: Selections*, Shibusawa was recognized as the first Sade researcher in Japan. Later, Shibusawa greatly impacted young audiences by introducing them to heresy literature, art, black magic, occultism, etc. His major works are: *Kurumi no Naka no Sekai* (World within a Walnut), *Shiko no Monshogaku* (Heraldry of Thinking), *Nemuri Hime* (Sleeping Beauty), *Utsuro Bune* (Hollow Boat), *Takaokashinno Kokaiki* (The Maritime Journal of Prince Takaoka).

*3 Captain Nemo is designer and captain of the Nautilus - a fictitious submarine that appears in Jules Verne's novels *Twenty Thousand Leagues Under the Sea* and *The Mysterious Island*. Inside Japan's Nautilus, which is anchored at Tokyo DisneySea's Mysterious Island, there is a replica of Captain Nemo's study. Though the study is off-limits to visitors, nautical charts, instruments, a model of an albatross, pots that seem to be part of a wider collection, etc. are all on display. It is well worth seeing.

*4 Taruho Inagaki (1900–1977): Novelist. Introduced original anti-realist works. Using motifs such as the desire to fly, artificial models, urban geometry, astronomical objets, love among beautiful adolescent boys, etc., Inagaki's fantastical and extraordinary style garnered great notice and *Shonenai no Bigaku* (The Aesthetics of Boy-love), a collection of his essays published in 1979, created a Taruho craze. Other major works include, *Hoshi o Tsukuru Hito* (Star Maker) and *Issen Ichibyo Monogatari* (One Thousand and One Second Stories).

*5 Gregorian chants are monophonic, unaccompanied, sacred songs in the Roman Catholic Church. The chants cannot be sung using modern five-line staff notation. Instead, they use four-line staff notation, called 'neumes' in order to express precise nuances and fine breathing.

*6 A liturgical book of the Catholic Church in which ritual procedures, etc., are written down in order for Mass to be conducted in an orderly and appropriate fashion. At the beginning, a general provision that summarizes various rules when conducting Mass is listed.

*7 A list of books compiled by the Catholic Church from the 16th century until the mid-20th century. The titles of books, considered to be perilous for Catholic believers, are listed.

*8 *Znamenny* chants are old sacred songs in the Russian Orthodox Church. Fundamentally, they are monophonic and unaccompanied. Since *Znamenny* notation was structured based on the supposition that it would be instructed orally, to this day it is said that many chants are impossible to decipher.

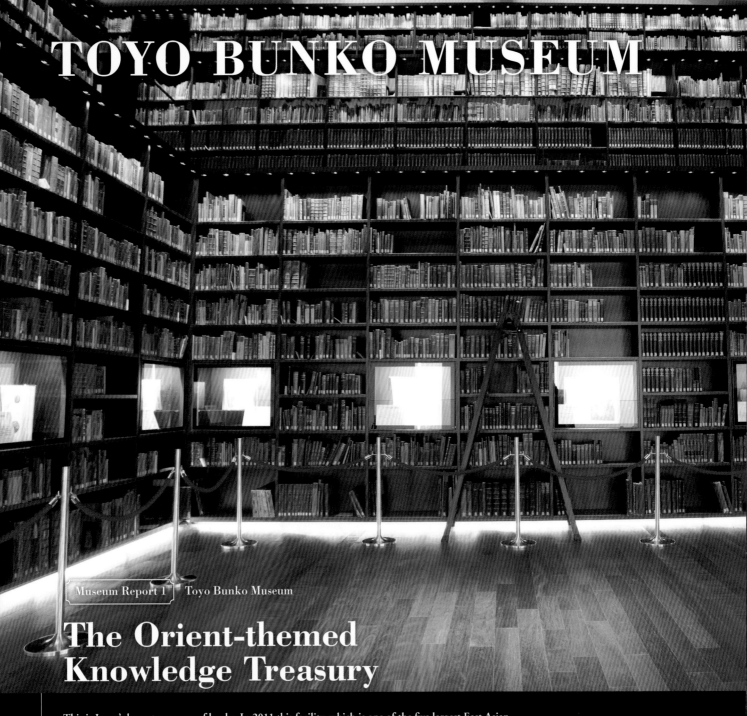

TOYO BUNKO MUSEUM

The Orient-themed Knowledge Treasury

This is Japan's largest museum of books. In 2011 this facility, which is one of the five largest East Asian Studies libraries, along with The British Museum, Harvard University, National Library of France, etc., was established by Toyo Bunko. It allows us to look closely at rare book collections from all time periods and places, including national treasures. Among its exhibits, where vast numbers of books are stored in breathtaking three-tiered stacks, the magnificent 'Morrison's Stacks' stand beautifully. This was a lump-sum purchase (in excess of 60 million dollars in today's currency!) of the massive G.E. Morrison collection, made by the founder of Toyo Bunko, Hisaya Iwasaki - third generation head of the Mitsubishi family. Morrison was The Times' special correspondent to Beijing at the time. This collection, beginning with *The Travels of Marco Polo*, consists of approximately 24,000 items and includes European books, paintings, and booklets that are concerned with East Asian history, geography, flora, fauna, and cartography.

Aside from the Morrison's Stacks, there are plenty of other well-known books and book paraphernalia displayed here, including Japan's oldest printed materials, a first edition of Adam Smith's *The Wealth of Nations*, a copy of the answer booklet for an Imperial Examination, *The Tale of Genji*, *Ukiyo-e*, and more. It will surely inspire your intellectual curiosity.

The Birds of Asia

By J. Gould
1850-1883, London

This is a bird guide created by J. Gould, a well-known ornithologist and taxidermist in England during the 19th century, when natural history studies were at their peak. Illustrations were hand painted using lithograph techniques and, amongst illustrated reference books, this guide has been called the most beautiful and delicate. Since Gould aimed to capture the actual size of various birds, the book is quite large. (Imperial folio format: approx. 56cm x 39cm/22 in. x 151/2in.)

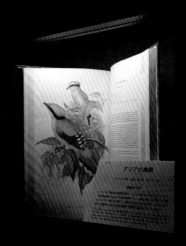

Fauna Japonica

By Siebold
1833-1850, Leiden

After returning to the Netherlands, Seibold, who came to Japan as a physician for the Dutch trading house, published *Fauna Japonica* (five volumes) with the cooperation of The National Museum of Natural History in Leiden. Original paintings for volume four were provided by Nagasaki native painters, such as Keiga Hawahara.

Morrison's Stacks Bookplate

There is a bookplate attached to each book in the Morrison's Stacks. Animals associated with Morrison's home country of Australia, such as kangaroos, a parrot, an emu, etc., are all drawn.

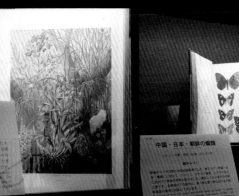

Voyage of Exploration in Indochina (Left)

By F. Garnier, Illustrations by L. Delaborde
1873, Paris

These are records of Indochinese (currently the countries Vietnam, Laos, and Cambodia) exploration conducted by the French Navy from 1866 to 1868. The page on display is an orchid that grows in Laos.

Butterflies from China, Japan, and Korea (Right)

By J.H. Leech
1892 1894, London

Illustrated reference book written by J.H. Leech, an English entomologist. Butterflies from Morocco, the Canary Islands, and the Himalayas are also included.

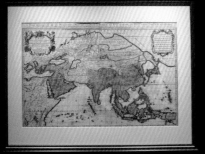

Map of Asia
Sanson, Jaiyo 1692, Paris

Countries in Asia from around the end of 17th century. This map shows that the Mongol Empire spread from Siberia, to Central Asia, and well into the northern part of India.

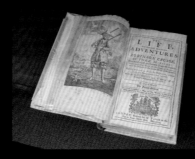

Robinson Crusoe
By Daniel Defoe 1719, London

This rare book was published in London in 1719, the same year that the first edition was published.

The Travels of Marco Polo
By Marco Polo

This is the world's largest collection of the global bestseller, *The Travels of Marco Polo*. This book was much loved by explorers during the Age of Exploration. Seventy-seven different versions of *The Travels of Marco Polo*, with varying publication dates, places, and languages, are held (fifty-four of them were collected by Morrison himself). It is interesting to see how the binding differs depending on the place and period of publication.

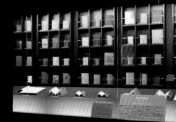

Hyakumanto Dharani (The One Million Pagoda Dharani Sutra)
770

This work, called the *Dharani Sutra*, is considered to be the oldest Japanese printed document in existence. Empress Shotoku commissioned one million of these sacred texts (width 4.5 cm/1.75 in.) and had them placed in small pagodas to be distributed to temples such as Horyu-ji.

The Travels of Marco Polo, published in Belgium in 1485. This is the first Latin translation and, as such, is of great cultural value.

Marie Antoinette's Collection
Collected Letters of the Society of Jesus
Compiled by The Society of Jesus 1780-1783, Paris 26-volume set

A collection of letters from Society of Jesus missionaries who propagated Christianity in Asia from the 17th to 18th centuries. This particular set is thought to have belonged to Marie Antoinette.

Kirin
(Illustrated Sino-Japanese Encyclopedia: volume 38)
Compiled by Ryoan Terajima 1715

This is one of 105 volumes in the *Illustrated Sino-Japanese Encyclopedia*. It covers diverse items, including imaginary things such as the Kirin. The text describes this mythical animal as having "the body of deer with a cow's tail, the hooves of a horse, with a body that is dyed with five-colors."

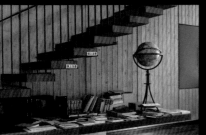

The reading corner on the first floor. There is a gift shop and a café in the museum as well.

Toyo Bunko Museum
A museum near the Rikugien.
Address: 2-28-21 Honkomagome, Bunkyo-ku, Tokyo, 113-0021, JAPAN
Phone: 03-3942-0280
Hours: 10:00a.m.~8:00p.m. (Admission ends at 7:30p.m.)
Admission: Adults 880 yen, Junior high/High school students 580 yen.
Closed: Every Tuesday. (When a national holiday falls on Tuesday, the museum is open on the holiday and is closed on Wednesday.)
URL: www.toyo-bunko.or.jp/museum/

Japan's prominent lockset specialty store, Hori Shoten, deals with everything from manufacturing special locks to the restoration of locks found at historic landmarks. On the second floor of the company's building, inside a small locked chamber, a collection of locks and locksets (which the previous company president, Hideo Hori, had primarily acquired from all around the world) is displayed. A beautifully decorated Iranian padlock, a hidden-keyhole iron box, a European luggage lock, an African wooden lock, etc. are all on display. The exhibition room is a unique space where more than a few hundred kinds of locks and locksets are brought together all at once. The captions describing the origin of acquisition, such as "Acquired at the Balkh Ruins near the Afghanistan and Russian border," etc., are also illuminating.

Rare Antique Keys

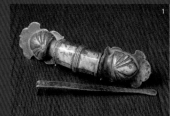 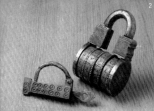

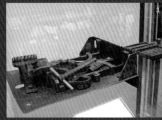 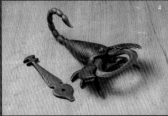 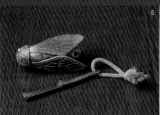 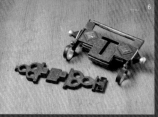

1. Old Japanese padlock thought to have been used from the late Heian period (794 –1185) onwards. Used as Tebako (a jewelry box), Zushi (a miniature shrine), or at temple sutra storehouses, etc. 15 cm/6 in. 2. A Persian combination lock and an Arabian padlock. The combination lock is made from iron and the rotating dials are made from brass.
3. A European latch for a door. 4. A scorpion shaped lock from India. If you loosen a screw located at the head of scorpion, take the leg off, and then insert the key into the keyhole at the base of the leg, you can pull the pincer-shaped shackle open. Brass casting. 11.8 cm/4.5 in. 5. A cicada-shaped lock. Meticulously forged, right down to the veins in the wings. Made in Japan. Insert key in the copper abdomen and the lock will open as the head comes off the body. 6 cm/2.25 in. 6. An Iranian padlock. A thin sheet of brass, copper, aluminum, and German silver is plated on the iron bodies of both the key and lock. Refined decorations are applied to the surface. 10.3 cm/approx. 4 in.

Lock Collection Exhibition Room

Address: 2-5-2 Shinbashi Minato-ku, Tokyo, JAPAN
Phone: 03-3591-6304
Hours: 8:45a.m.~5:30p.m. (Monday through Friday)
*It is necessary to make a reservation in advance (by phone) to visit the exhibition room. Free admission.
URL: http://www.hori-locks.co.jp/

Left: The exhibition room used to be a conference room.
Right: The impressive building was built in 1932. It is designated as a Registered Tangible Cultural Property.

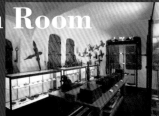

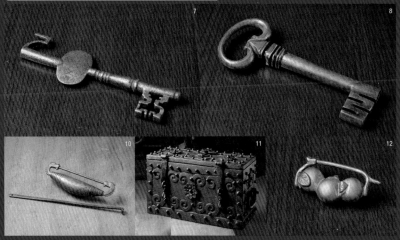

7. This is a "warded" key. In order to increase security, the key has a specific shape to match a unique keyhole. From Europe. 8. This is also a warded key from Europe. 9. A wooden lock from West Africa. This is a lock for a granary that has been carved out. Size approximately 35 cm/13.75 in. 10. A Korean padlock. The dragon head designed lockset is thought to have been used for a ceremony. Yellow copper casting, 23 cm/9 in. 11. An iron box acquired in Spain. The keyhole appears by finding a switch hidden in the decorations.
12. A Japanese small latch "Kaki" (persimmon). A latch does not use a lock. 5 cm/2 in.

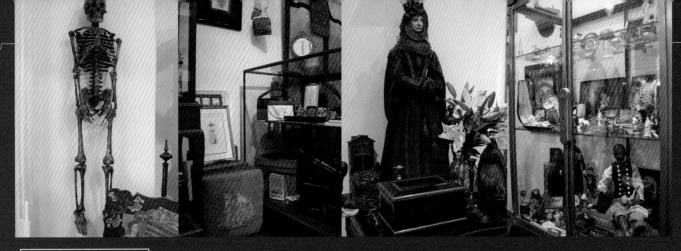

ANTIQUE

Wunderkammer in the Cabinet

Anti-Q is located in a Showa retro modern building where art galleries and antique shops flock together. Anti-Q favors beautiful objects over those that serve a practical use. These items are highly cherished and carefully displayed in vitrines.

Over twenty years after becoming an independent antiques dealer, the virtuoso owner is still in bussiness, even keeping his store running while relocating to Omotesando and Ginza. Having toured rural England and France, he has used his original aesthetic jusgement to purchase antiques without worrying whether anyone was interested in them: If items go unsold, he never hesitates to transfer them into his personal collection. As a result, Anti-Q features rare ad unique items not normally found in other antique shops.

A sample of the eccentric objects available on the Anti-Q website, "*Chinki Chinretsu-shitsu*" *(Cabinet de Curiosités)*, are introduced here.

Anti-Q presents
Cabinet de Curiosités

Photos and Articles by Anti-Q

Anti-Q
Address: 1F Okuno Building, 1-9-8 Ginza Chuo-ku, Tokyo, Japan
Phone: 03-3563-2500
Hours: 12:00p.m. 7:00p.m.
Close: Wednesday
URL: http://www.anti-q.jp/

Anti-Q is located in a modern building that used to be an outstanding luxurious apartment in Ginza.

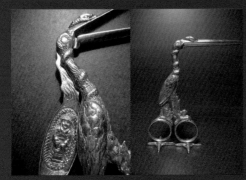

Silver Umbilical Cord Tweezers in Stork Form

Europe (excluding U.K.), Approx. 18th century, Height: 8.6 cm/3.25 in., Beak portion: 4.4 cm/1.75 in., Made from silver (There are some illegible engravings).

Pair of umbilical cord tweezers in the form of a stork - which, of course, was said to deliver babies - with a snake coiling around it. When opened, a baby in swaddling appears in the exposed recess. Since this item is so rare on the antiques market, it remains unknown whether the tweezers were actually used at the time of birth. Based on its refined silver work, and the fact that it was made to stand upright, it is thought that the tweezers were actually an amulet or a gift given to an expectant mother.

Hunting Dog Iron Spiked Studded Leather Collar
Hunting Dog Brass Serrated Edge Collar

(Left) France, Early 19th century, Inside diameter: 11.2 cm/4.5 in., Diameter: 15.5 cm/6 in. (including studs), Width: 6.0 cm/2.5 in., Made of leather with studs attached (Engraving on a nameplate [J.ESSALY A RIALON Cne MESSEIX P-D-D])

(Right) U.K., Late 19th century (the lockset is from the 20th century), Inside diameter: 12.0 cm/4.75 in., Diameter: 13.5 cm/5.5 in., Width: 6.0 cm/2.5 in., Made from brass (Engraving on a nameplate [E.ISMAY. CLOCKBURN.])

These are collars for a hunting dog and a working dog that would prevent direct attacks to their necks from enemies, such as wild monkeys and wild boar. These types of collar are not seen in modern society anymore. There are a large number of antique dog collar collectors in Europe and even a specialized museum found in Leeds Castle in the United Kingdom. Though they were originally practical objects worn by dogs, through time they came to be seen as beautiful objects.

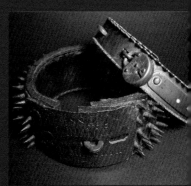

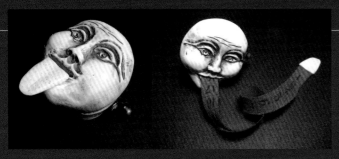

Ivory Mask with Tongue Tape Measure

France, Late 19th century, Length: 4.7cm/2 in., Width: 4.4 cm/1.75 in., Height: 3.8 cm/1.5 in., Ivory, glass, cotton, brass (No engraving.)

This item is made from patina ivory. A 100 cm long (39.25 in.) red tape measure comes out by pulling the tongue. It can be rolled up by winding the brass handle located on the side. Since inexpensive celluloid casted products were becoming popular at this time, this ivory sculpted, very uniquely designed item is a rare tape measure indeed. All of the red tape, which reminds one of a tongue, is still intact (without any tears) and the roll up mechanism is still in good condition. This piece is very valuable.

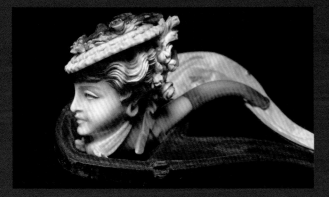

Carved Meershaum Lady's Head Pipe

Austria, Around 1900, Pipe: 15.2 cm/6 in., Case: 16.7 cm/6.5 in., Meershaum, Mouthpiece: Amber

This head of a lady wearing a bonnet (arranged with a garland and a ribbon) is finely sculpted, thus capturing her loose hair falling from braids, her earrings, and the ribbon tied around her neck. It has a double-headed eagle trademark, which is also the family crest of the Habsburg, and comes with a leather case from the high-quality store Franz Hiess.

Carved Animal Horn Skull Walking Stick

Probably Austria, Around 1930, Length: 87.5 cm/34.5 in., Handle: Carved antelope (oryx) horn (no engraving), Brass collar, Shaft: Snakeskin covered wooden stick, Ferrule: Water buffalo horn

The handle of this walking cane is a skull carved out of antelope's black horn. Though matching it with snakeskin is definitely an acquired taste, this item is quite beautifully crafted.

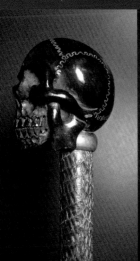
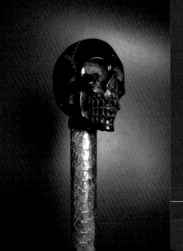

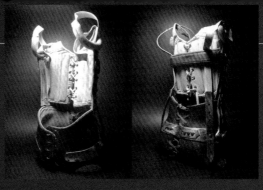

Pediatric Care Corset Made of Leather and Metal

France, Early 20th century, Height: approx. 38 cm/15 in., Leather, metal, cotton (no engraving)

Made in early 20th century, this is a lumbo-sacral orthotic brace that was made as an auxiliary medical treatment tool for children suffering from paralysis, etc. a corset limits the movements of the lumbosacral and sacroiliac joints, from the pelvis to the hips. It was made with thick leather and metal. In order to reduce the weight from excess leather, a cloth made back and shoulder straps were added and it was laced up at the pelvis and the back in three separate places. The leather hip molding, the cloth lining, the metal fittings, etc. are all very carefully made. Thus, it is thought that this corset was made for a child from a noble or very wealthy bourgeois family. Though it was originally a piece of medical equipment, as time passes and we look at it on its own, its small size makes it a beautiful object.

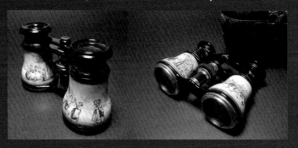

Pair of Tortoiseshell and Enamel Opera Glasses

France, Late 19th Century, Length: 5.7 cm/2.2.5 in. (when stored), Width: 10.0 cm/4 in., Tortoiseshell, Enamel, Brass, Lenses (no engraving)

Galilean binoculars, which combine convex and concave lenses, are used at the theater. The body, made of enamel, depicts villagers enjoying a meal and dancing. The eye cup, focus wheel, and the rim of the objective lens are decorated with tortoiseshell. The contrast between the umber tortoiseshell and the bright enamel is quite beautiful.

The balcony royal box, isolated from the general audiences in the opera house, provided an occasion for socialites, mainly composed of lord nobles and newly risen bourgeois, to mingle. The balcony provided the best seats. While socialites looked down upon the general audience, that same audience gazed up at the balcony, with its perfectly made-up lords and bourgeoisie wearing their elaborate outfits, as if they were looking at another stage. For royal box audiences, opera glasses were necessary not only for viewing but also as a fashion accessory and as a symbol of their wealth and status.

Includes an original case made of silk velvet.

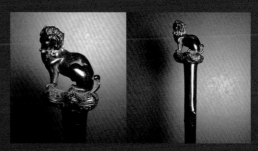

Carved Ebony Pug Walking Stick

England, Around 1890, Length: 76 cm/30 in., Handle: Carved ebony black pug wearing silver collar on a cushion (no engraving), Glass eyes, Shaft: Ebonized, Ferrule: White metal (tin and lead alloy) and steel

After its first appearance in Europe at an English dog show in 1886, the black pug became popular among women in the upper class.

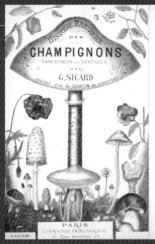

Histoire Naturelle des Champignons comestibles et veneneux

France, Printed 1884, Author: G. SICARD, Leather binding, Hand painted, 308 pages

Book on mushrooms with a very cute frontispiece. Purchased from a bookstore in Leon, France.

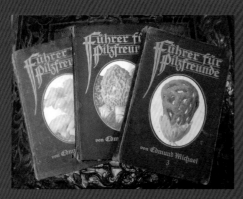

FÜHRER FÜR PILZFREUNDE

German, First edition 1918 – 1919 (depending on the volume, the year varies.), Author: EDMUND MICHAEL, Offset printing,

This German fungi encyclopedia has beautiful binding.

Yukai na Hitobito (Comical People)

Japan, Printed 2009, Illustration: J.J. Grandville, Translation: Rosei Ono

This is not a rare book, but rather one that was published by Kohitsujisha. It is a translation and reproduction of *Comical People*, published in England in 1852, and illustrated by J.J. Grandville. In the mid-19th century, the British Empire was in a state of immense excitement over the Great Exhibition at the Crystal Palace. Refined cities and the quiet countryside provide settings that illustrate the interplay between the different facets of life for gentlemen and ladies, all of whom appear in the form of birds, rabbits, foxes, elephants, etc.

Die Wiegendrucke Der ehemals Reichsstadtischen Bibliothek

German, Printed 1976, Case Bound Book, 91 pages

Prints of precious manuscript collections from the Imperial Lindau City Library of Germany/Franciscan Order of Friars collection. Beautiful manuscripts on alchemy, chemistry, linguistics, etc., are included.

KOHITSUJISHA

Wunder-shop Report 2 Kohitsujisha

From Rare Objects to Rare Books

Kohitsujisha
URL: http://www.mistletoekoubaibu.com/

Individuals who used to work in publishing come together at Kohitsujisha. Making use of twenty-plus year careers as antiques buyers and work experience in antiquarian bookstores, they run a specialty online store called Nikki-iro no Mise (the name originates from the title of a short story collection entitled Skelpy Cynamonowe, by Polish novelist Bruno Schulz). The store deals in overseas rare objects. For example, a Mandrake tin can pill case, glass eyes, a planisphere from the Victorian era, natural history illustrations, rare books, etc., as well as Japanese artists' works. Here we introduce a few rare books from their collection, which were purchased in Germany, France, and other countries across Europe. Genres related to medieval medicine are highly popular among rare book collectors. Books on medicine and astronomy sell out soon after they are in stocked.

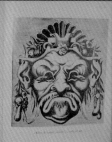
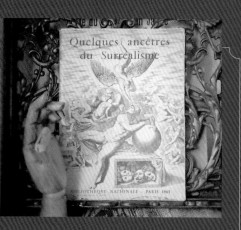

Exposition Quelques ancetres du surrealisme 1965

French, Printed 1965, Saddle-stitching, 14 pages plus a separate print from Etienne Dennery

A booklet from a print exhibition, which influenced surrealism, held at the National Library of France in 1965. 22 prints are collected.

Deutsche Spielkarten Aus funf jahrhunderten

German, Printed 1964, Case Bound Book, 51 pages

The book introduces old playing cards from 5th century Germany. Small picture book like binding.

Aus der Geschichte des Medikaments

German, Printed 1872, Case Bound Book, 175 pages

A book on the history of medicine, from ancient to medieval times. Contains beautiful pictures of pharmaceutical tools.

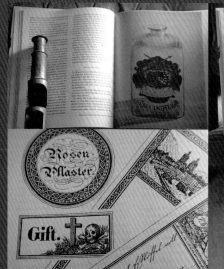

Die alte Apotheke

German, Printed 1985, Case Bound Book, 219 pages

A beautiful photograph collection book on the medieval pharmacy. Chock full of worthwhile images of enamel medicine bottles and old medicinal labels.

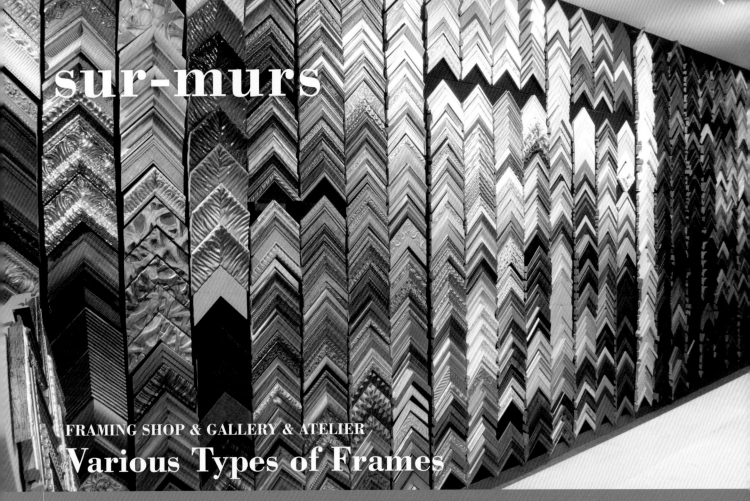

sur-murs

FRAMING SHOP & GALLERY & ATELIER

Various Types of Frames

When you want to display a natural history illustration or a map on a wall, the question is: what kind of frame should you use? You want to find one whose color, size, etc. match with the room's atmosphere. The framing shop Sur-murs is the place to go when you have such difficult questions. Importing mainly from Europe, this company carries several thousand types of moldings and antique-style frames and you can also choose from over one thousand custom frames (available on-line). Framing classes are also held at the store.

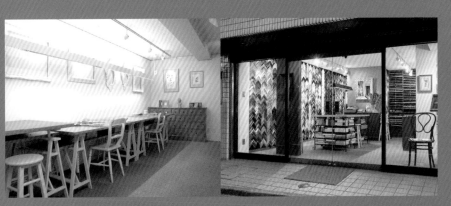

Left: Classes, ranging from workshops to seminars, are always held at the atelier next to the shop.
Right: The shop and the atelier are a leisurely one minute walk from Yoyogihachiman station on the Odakyu-line.

Sur-murs
Address: 1F TMK Building, 4-6 Momoyoyogi Shibuya-ku, Tokyo
Phone: 03-5465-6430
Hours: 10:00 a.m.~8:00 p.m. (Monday through Saturday)
Close: Sunday, Holiday
URL: http://www.sur-murs.com/

Displaying Natural History Illustrations
How to Make Original Frames

Sur-murs offers lectures on how to make frames that properly display natural history illustrations. Secure an etching of a plant on Lavis (mat made using classical techniques), and put it in a water gilding finished frame. This makes for an attractive frame without disturbing the overall feel of the picture.

MATERIALS & TOOLS

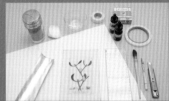

Tools and Materials for Matting
Mat board, Metal leaf, Pigment ink, Acid-free tape (sold at major stationary supply stores), Acid-free double-sided tape, Masking tape, *Terre Pourrie* (aging pigment), Utility knife, Rulers, Ruling pen, Squirrel brushes

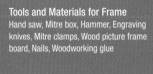

Tools and Materials for Frame
Hand saw, Mitre box, Hammer, Engraving knives, Mitre clamps, Wood picture frame board, Nails, Woodworking glue

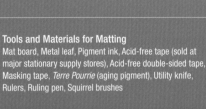

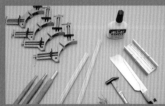

Tools and Materials for Gilding
Hog brush, Squirrel brush, tweezers for gilding, Gilders tip brush, Gilders knife, Gilder's cushion, Agate burnisher, Gold leaf, Plaster of Bologna, Rabbit-skin glue, Gold size (gilding adhesive)

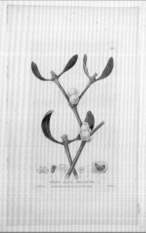

A single page taken form a botanical illustrated reference book, printed around the 19th century in England using hand-colored etching (*Figures and Descriptions of the Genera of British Flowering* by William Baxter). Purchased at an antiques shop.

How to Make the Mat

01 Cut a piece of mat board for the window mat according to the size of the picture and the frame. The picture above shows a window case that is 6 cm/2.25 in. wide.

02 Lightly pencil in the outline of your window using a sharp pencil.

03 Mask the portion that will not be colored.

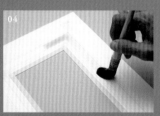

04 Soak a squirrel brush with plenty of water thinned pigment ink and start to paint slowly. Remove excess ink with the brush. Peel masking tape after allowing to completely dry.

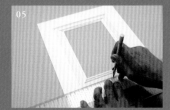

05 Put sepia color pigment ink into a ruling pen, and then draw a line around the outside of the border you just painted.

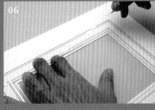

06 Put double-sided tape on the backside of gold leaf backing paper and cut it 2 mm/0.07 in. wide. Then, flip the gold leaf paper over and paste it around the window, cutting the corners to size. The decorative border - using lines, gold leaf, and light paint - is complete.

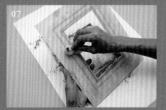

07 In order to give it an aged finish, sprinkle *terre pourrie* pigment ink over the mat board and then spread evenly using a cotton ball in order to create a distressed look.

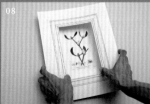

08 Secure the window mat to the etching.

How to Make the Frame

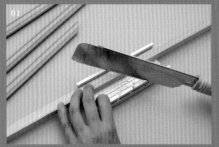

Decide the frame size based on the mat size. Miter saw the wood frame board accordingly, making both ends of the frame board a 45 degree angle.

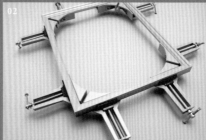

Apply woodworking glue on the cut ends and secure all four corners with miter clamps.

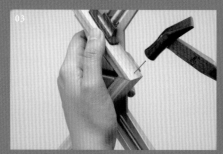

Nail the corners.

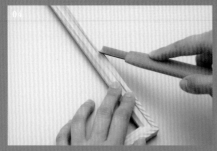

Use an engraving knife to engrave patterns on each corner and along the sides.

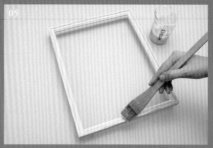

After applying primer (rabbit-skin glue), apply plaster of Bologna, dissolved in rabbit-skin glue water, five to six times.

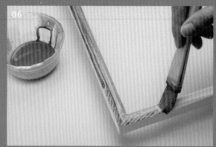

After the plaster dries, apply gilding size, dissolved in rabbit-skin glue, two to three times. Gilding size is a fine clay (silicate) applied under the gilding base.

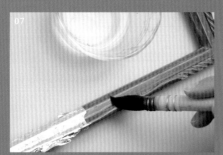

When the gilding size dries completely, use a water-soaked squirrel brush to wet the portion where gold leaf is going to be applied.

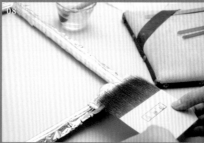

Coat the gilder's tip brush with oil and lift a piece of gold leaf. Apply it on the frame (water gilding method). Apply gold leaf on all four sides of the frame board.

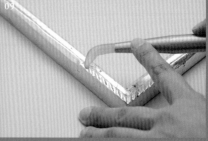

Lightly press the gilding using a piece of pure cotton, etc. After the base coat is well dried, polish the gilding using an agate burnisher.

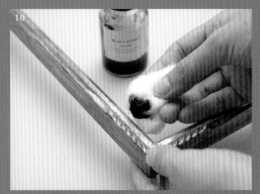

In order to give it an aged finish, apply walnut dye and rabbit-skin glue, which have been dissolved in pigment ink, on the surface.

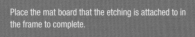

Place the mat board that the etching is attached to in the frame to complete.

Making of Steampunk Creations

This section will instruct you on the processes of making some of the steampunk creations found in the previous gallery.

01 *Steampunk Goggles*

Create proper classical goggles by making a cast from an original mold made from bounce board (Styrofoam) and oil-based clay.

By Makiko Kono

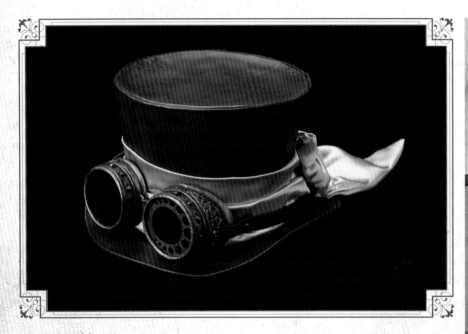

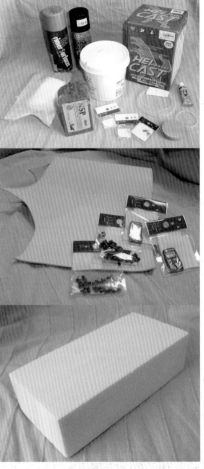

Materials & Tools

- Wooden disk, Oil-based clay, Rivets, Rubber bands, Bounce board, Instant glue, Water colors, Permanent marker, Silicone, Primer-surfacer, Lacquer spray (Glossy black), Decorative paints, Metal fittings, Epoxy-based resin adhesive, Tanned leather, Leather dye, Antique finish, Leather finish, Rivets, Black plastic sheet, Buckle, Silicone (KE-12), Silicone curing agent, HEI-CAST A + B

- Utility knife, Sandpaper, Edge beveller, Brush, Cloth, Wooden mallet, Leather punch, Punch mat, Circle cutter, Scissors, Paper cup, Disposable chopsticks

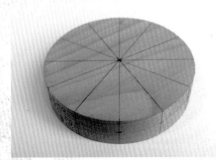

Mark the center of a wooden disk. Find the center by drawing lines to divide the disk into twelve equal parts and then insert a rivet.

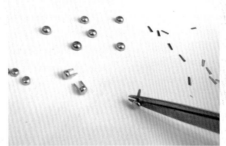

Cut the tails off the rivets using scissors, etc.

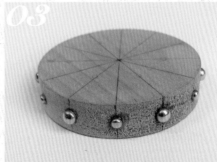

Glue the rivets on around the disk.

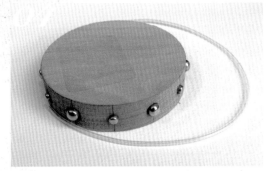

Glue a rubber band around the disk, in a circle, using instant glue.

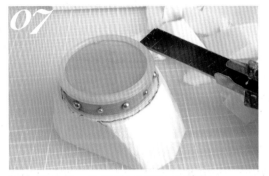

The lens portion is complete.

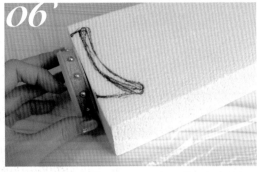

Draw the shape for the lens' base on a piece of bounce board (Styrofoam) using a permanent marker.

Cut the piece of bounce board out using a utility knife.

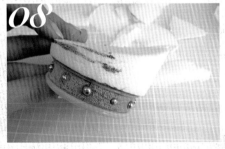

Roughly cut out.

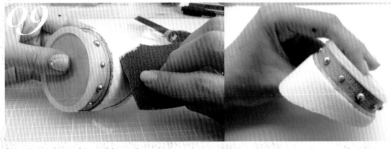

Smooth out the surface using sandpaper.

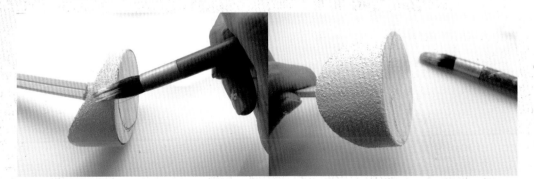

In order to tighten the surface, use a brush to apply watercolors.

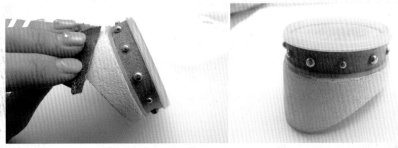

After the watercolors have dried, further smooth the surface using sandpaper.

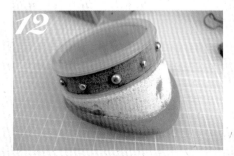

Make the goggles' rim using oil-based clay.

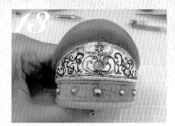

Draw decorative patterns on the ornamental part.

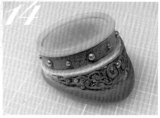

Make engraving-like patterns on the ornamental part. With this, the original mold is complete.

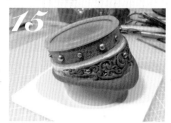

Make a base in order to create a mold using silicone.

Encircle the goggles using a paper cup, etc., and pour in silicone to cast.

Mold Making Using Silicone → Making a Cast

The best method for making molds using silicone. Let's master this often-used method for making steampunk creations.

Materials: Silicone rubber (KE-12) 100g, Curing agent (Catalyst) 1 ~ 3g, Casting resin AB, Lacquer spray (for releasing from mold), Two paper cups, Rubber band

HEI-CAST is a type of resin cast liquid urethane. Mix solution A and B (1:1) together to solidify.

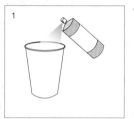
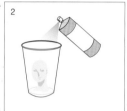
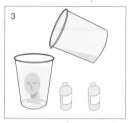
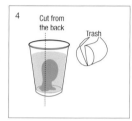

1. Spray lacquer inside a paper cup in order to release the mold. 2. Put the clay model in the bottom of your paper cup and spay lacquer on it as well. 3. Mix the silicone rubber and the curing agent in a 100:1 ratio. Apply detail to areas such as the eyes and nose using a brush. When done, pour the rest over the head of the clay model while trying to restrict any air bubbles from appearing.
4. When the silicone is about as stiff as an eraser, peel the paper cup off and cut the mold vertically near the back of the head.

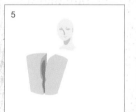
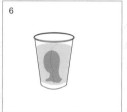
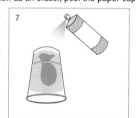
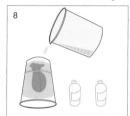

5. Remove the clay model. 6. Cut the bottom off of another paper cup and put the silicone mold in. 7. Turn the paper cup upside down and spray lacquer through the neck-hole onto the cross section of the silicone mold so you can release it later. Wrap a rubber band tightly around the paper cup to close off the incision in the silicone mold.
8. Stir casting resin A and B in a 1:1 ratio and pour it in smoothly to prevent air bubbles. 9. When the resin becomes solid, tear the paper cup and remove the cast using the vertical incision on the silicone mold. And voilà! It's complete.

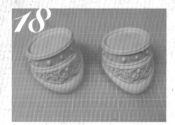

The cast for both lenses is complete.

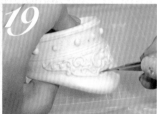

Cut the lens and belt part off.

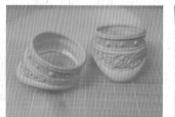

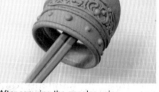

After securing the goggles using disposable chopsticks, spray primer-surfacer (an undercoat which works as both surfacer and primer).

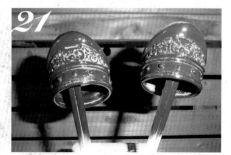

Spray on glossy black lacquer spray.

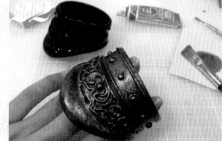

Use a brush to paint on decorative paints such as Mr. HOBBY gold and silver, etc.

After the paint has dried, polish it with a piece of cloth.

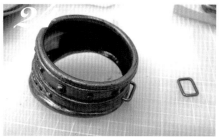

Glue a metal fitting on the belt part using epoxy-based resin adhesive.

Cut the leather to the width of the belt using a utility knife.

Cut the end into a triangle shape.

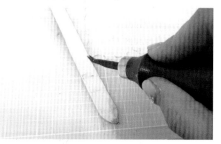

Cut the edge off using an edge beveller.

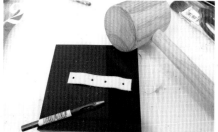

Using a leather punch, pierce holes evenly in the leather for the belt buckle.

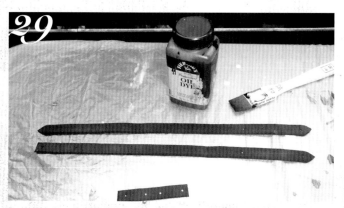

Dye both belts using OIL DYE (leather dye).

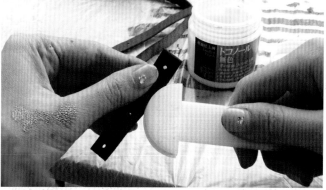

Apply Gum Tragacanth on the back and edges of the belt and then, using an edge slicker, polish the edges to cut off any loose fibers.

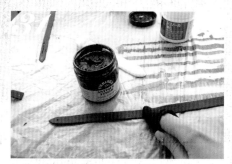

Apply antique finish and rub to create aged affect.

Make a lens by cutting a plastic sheet with a circle cutter.

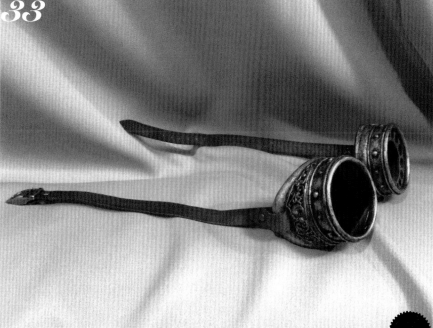

Attach the lens and the belt. It's complete!

Complete.

02 Steampunk Top Hat

Use Styrofoam to make an original model hat - then wrap leather around it to make a classical top hat decorated with a satin ribbon.

By Makiko Kono

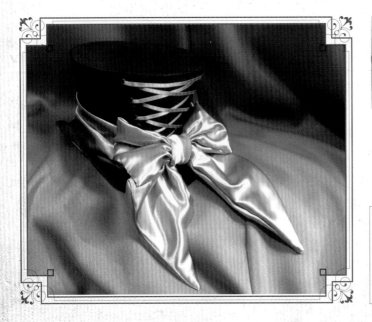

Materials & Tools

- Styrofoam, Tanned leather, Round shaped container, Packing tape, Water, Leather dye, Gum Tragacanth, String, Ribbon
- Utility knife, Hand saw, Sandpaper, Space heater, Spray bottle, Pail, Marking pins, Wooden mallet, Leather punch, Punch mat, Grommet punch

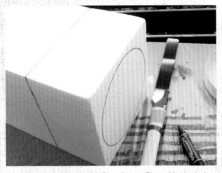

Draw the hat's shape on Styrofoam. Since I intended to make a hat that narrowed at the bottom, I used Styrofoam to shape my hat. But, a cylindrical trash bin or a pail can be used instead.

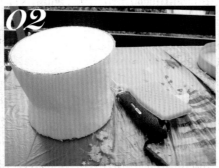

The Styrofoam was roughly cut using a hand saw and utility knife.

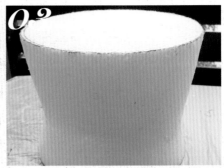

Use sandpaper to form the shape of the hat.

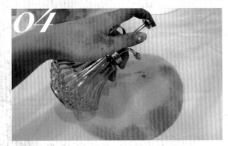

Cut a piece of leather that is slightly larger than the crown of the hat and then wet it using a spray bottle.

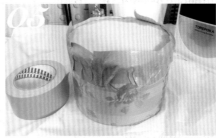

Place a round-shaped container on a table, bottom side up, and then put the wet leather over it. Secure the leather using packing tape, etc., and dry using a space heater.

Cut leather for the side of the hat and soak in water.

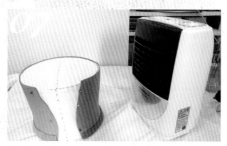

Put the leather around the Styrofoam model and secure it with marking pins. Then, dry using a space heater.

Also cut leather for the brim of the hat.

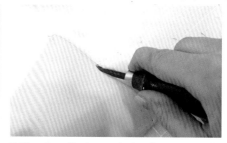

Cut the edges off using an edge beveller.

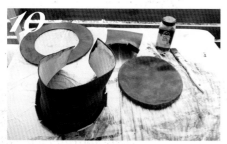

Dye the leather using OIL DYE (leather dye).

Apply Gum Tragacanth on the edges and slick the edges using an edge slicker.

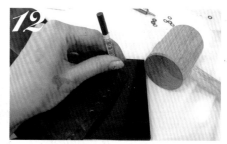

Using a leather punch, pierce holes in the leather for attaching grommets.

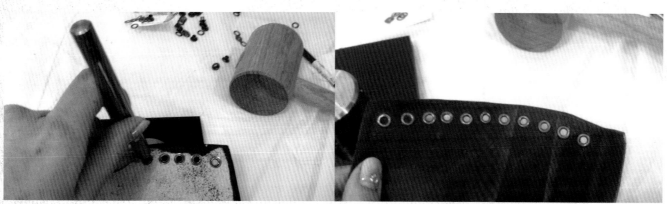

Attach grommets using a grommet punch. Take the time to make the spacing even.

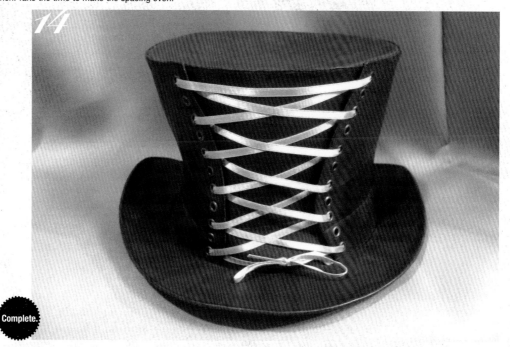

Complete.

Attach a ribbon by cross-threading like a corset. It's complete!

03
Steampunk Detective Headgear

Make microscope headgear that looks completely like it's made from real metal and genuine leather, just by remodeling headphones.

By Naoto Nishiwaki

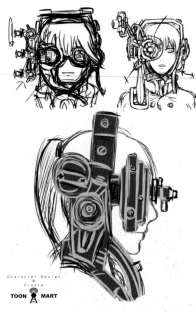

Character Design
&
Create
TOON ✚ MART

Materials & Tools

- Two pairs of headphones (broken), Decorative metal parts, Adhesive, Primer, Bonding agent, Spray paints (black, copper), Long threaded screw, Spring washer, Nut, Sheet material (SUN FOAM, etc.), Quick Drying Bond G10Z, Urethane, Synthetic leather, Acetone, Belt
- Sandpaper, Gloves, Safety goggles, Mask (covering the nose), Electric drill, Scissors, Utility knife, Pliers, Brush, Cloth, Sanding sponge, Electric router

"A gadget for a detective used to investigate evidence found at a crime scene." Other than the concept, nothing was decided in detail, and I just drew a few rough designs in silhouette. I proceeded with this portion of the creative process and also enjoyed improvising on the spot.

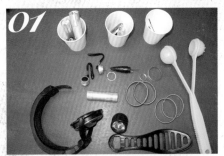

01
Using the two pairs of headphones as the base, the headgear was then made by combining disassembled parts that were purchased at a dollar store. Separating the disassembled parts in a paper cup, according to size, helps carry out the necessary procedures smoothly.

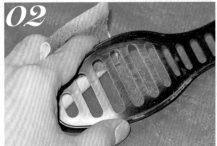

02
Once you decide on the combination of parts to put together, in order to increase adhesiveness (since instant glue is used to attach these hard materials), roughen the surfaces that will be glued using sandpaper.

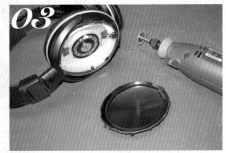

03
Remove all the unnecessary parts, as they may hamper later procedures. Be sure to wear leather gloves, safety goggles, and a mask that covers the nose, as dust is sure to fly all over your hands and face.

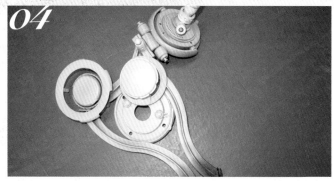

The base shape will be completed when the disassembled parts are glued together. Since the color of each part is different, lightly apply primer and check over all silhouettes. Coloring everything black would make it look somewhat good, but on the other hand, just using the primer color should help you to carefully re-examine the shape of the base.

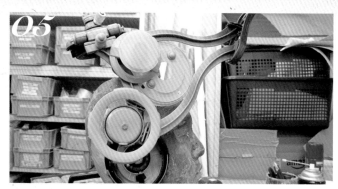

Attach the base to a headphone. For a moveable mechanism, pierce through both parts using an electric drill and secure them using long threaded bolts, spring washers, and nuts. It should be possible to lift the movable part by rotating it upward.

Attach various detailed decorative parts. Metal hobby parts or accumulated stock parts from previous projects can be used.

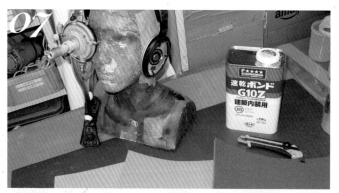

After you have finished decorating the right-hand earphone, move on to the left. We will form shapes by combining a few types of sheet material, SUN FOAM, etc. Since the material used from this step on needs drying time, the procedure for making an accessory mask is carried out simultaneously. For example, apply glue on the headgear and then, using the drying time, form the shape of the mask.

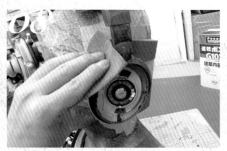

From here, use Quick Drying Bond G10Z to attach parts. To increase adhesiveness on solid material, scratch the material's surface using sandpaper.

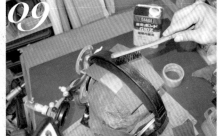

After roughing up the material and removing the dust, apply Bond G10Z. Apply small amounts thinly and then let it completely dry – this step cannot be skipped. As we are attaching plastic in this step, apply Bond once again to increase adhesiveness after the first application dries.

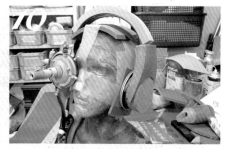

Glue urethane together to make the basic shape and then, using a utility knife, carve the foundation.

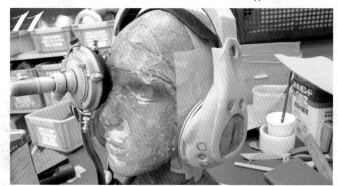

Round out the shape using a utility knife and sandpaper. Then, glue different thickness urethane over top of the shape to make it rounder.

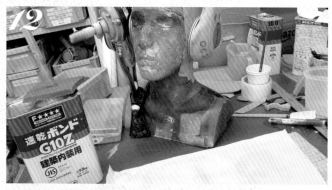

Once the shape is formed, the next surfacing process is to glue on synthetic leather. Evenly apply thin amounts of Bong on the back of the synthetic leather and let it dry completely. As before, the 'double application' step cannot be skipped. Using single applications, or not letting things completely dry, will likely create uneven surfaces.

Though I wanted to purposefully create wrinkles specific to leather crafts, I thoughtlessly glued it too tight. It was a work habit and turned out to be a mistake. I just left it as is and proceeded. The orange color will be utilized (to help obtain the correct color) later in the painting process.

The spray paints used are shown above. This time, an air brush and a spray gun were not used at all. First from the right is primer used to check the base. Second and third from the right are bonding agents to spray all over before painting. Then we have black, the base color (it is weak, but can be sprayed on synthetic leather and plastic at the same time). Finally, on the left, is the copper colored metallic finish (for plastic parts).

Vertical Spray Horizontal Spray

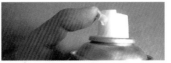

Many spray paints have movable nozzles. Usually the movable nozzle sprays in an oval shape. Moving the nozzle allows you to spray either vertically or horizontally. Prior to application, be sure to check the spray pattern on a piece of paper.

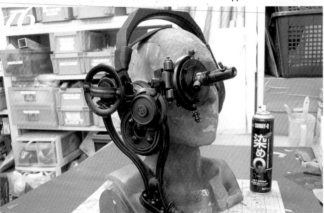

Firstly, dye everything black.

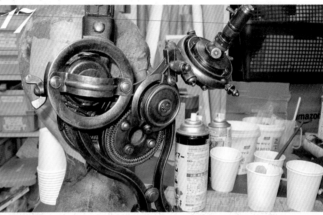

Next, from further away, gradually add copper coloring by spraying lightly. Almost done!

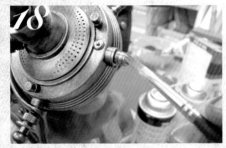

For the metal parts, use a brush to apply acetone and melt off the old paint so you can use the original metal color. To avoid forgetting which part is metal, take pictures of each part with a cell phone or a digital camera before painting. This comes in handy more often than you think.

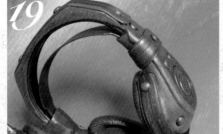

Do the same for the synthetic leather parts. Soak a soft cloth in acetone and lightly rub off the paint. The original orange color of the leather lightly will lightly appear as you rub. This leads to a 'weathering' of the leather. The belt shown here was purchased at a dollar store.

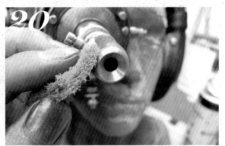

Lastly, polish the metal parts using a fine sanding sponge in order to add extra detail.

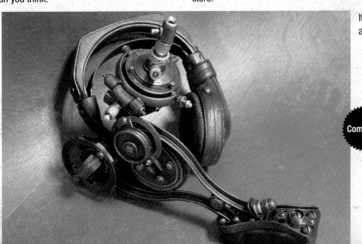

It's complete. The work took approximately one and a half days to complete.

Complete.

04 Phantom Thief Mask

Apply latex on SUN FOAM to make a solid textured rubber mask.

By Naoto Nishiwaki

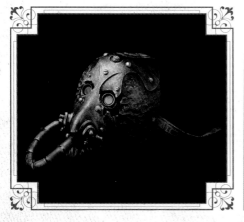

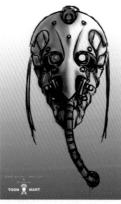

Materials & Tools

- SUN FOAM SHEET (15x rated foam expansion sheet), FOAM ACE (Polyethylene sheet), Latex (Liquid rubber), Quick Drying Bond G10Z, Water-based paint (black), Casting resin, Belt, Zip-tie, Rubber tube, Sequins, Non-slip silicone pads for furniture
- Utility knife, Permanent marker, Hake brush, Tools

Though I only used a rough design draft, I drew a front-facing bilaterally symmetrical design sketch and then painted it about halfway to completion, just to be able to work without second-guessing myself. Without thinking too much, I freely drew the design draft. As someone who grew up watching Japanese superheroes, I really think this design shows off those influences.

01

At first, make a simplified pattern using a polyethylene sheet (FOAM ACE). Only make the left side of the face (from step 7, both sides are put together so it might be fun watching how the steps work interchangeably).

02

Trace the pattern on sheet material (SUN FOAM, 15x rated foam expansion) for this section and cut it out. Use one pattern for both sides.

03

Apply quick drying Bond G10Z thinly on the cross section and pressure join them after the adhesive has completely dried. The foundational form of the mask is complete after gluing the bottom of the chin. Getting to this step took about 45 minutes.

04

Based on your design draft, mold the mask by finely shaving off foam to achieve the intended shape. As far as maintaining uniform thickness goes, after shaving off the excess foam, glue those same foam pieces in different thicknesses over on top to make up any differences. This process goes smoothly when you draw a blueprint in your head in advance by taking your design draft apart in layers according to the thickness of the design detail. This is similar to the digital drawing process.

05

Hollow out and adhere foam to the inside of any parts that have depth, such as the eyes and the mouth. Since this mask is intended to be a prop, and not to wear, there are no eyeholes, breathing holes, ear holes, etc. These three sets of holes are absolutely necessary for masks worn by actors.

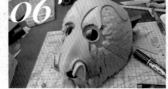

06

Molding complete. Getting to this stage took about two hours.

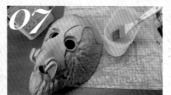

07

In order to apply liquid rubber (Latex), first administer a diluted solution of G10Z. Dilute only with G10Z thinner.

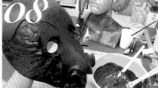

08

Using a hake brush, carefully and evenly apply thick latex, mixed with water-based black paint (NEO COLOR), to the detailed parts. For the part that looks like an iron plate, lightly tap its surface using the hake brush to give the surface an uneven look. Since the first application of latex takes a long time to dry, put it somewhere safe and leave it overnight.

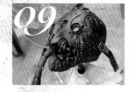

09

The following morning, the latex should be completely dry. Attach casting resin (PLACAST) to each part. For the belt, simply scar up a belt purchased at a dollar store using your tools. The hose is made from rubber (Latex rubber tubing) with zip-ties added. This concludes the decoration and molding stage.

10

Since the eyes were attached after painting, the order of pictures is inverted here. Non-slip silicone pads for furniture (invisible double-sided tape attached) with a reflective material glued on the back (this time a large sequin was used) makes the lens of the eyes. Apply diluted Bond solution before painting. Paint on flexible, water-based paint, using a hake brush and a normal paintbrush to complete. This entire mask took a total of a day and a half.

05 Plague Doctor's Hat

Make a 17th century plague doctor's hat by pasting leather cloth on a piece of chipboard.
Coordinate the hat with the plague doctor's mask.

By Tom Banwell

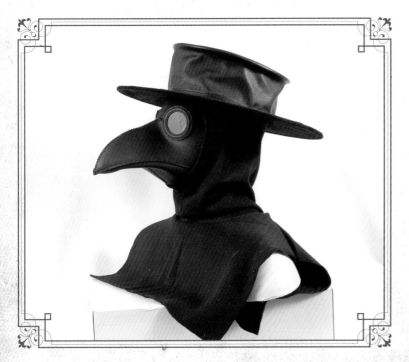

Materials & Tools

- Patterns, Chipboard, Leather cloth (black), Leather adhesive, Cardboard, Wire
- Measuring tape, Marker, Scissors, Hammer, Stapler, Sewing machine, Small knife, Tape, Pail

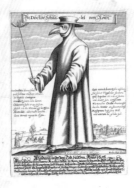

This engraving of a plague doctor from 1656, entitled 'Doctor Schnabel from Rome', served as inspiration.

[pattern]
Firstly, measure the size of your head and then make a pattern. It's okay to hand draw the pattern. Since the hat will be worn over the goggles, make it one size bigger than your head. An oval top looks better than a round one, so I made a 19 cm/7.5 in. wide by 23.5 cm/9.25 in. tall oval.

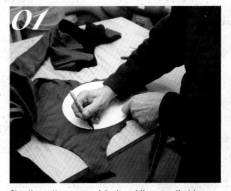

Glue the pattern on cardstock and then use that to mark the black leather cloth.

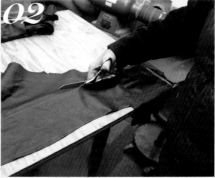

Start to cut the leather cloth by beginning at the crown.

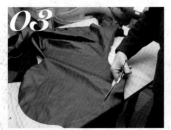

Cut the outer shape of the brim.

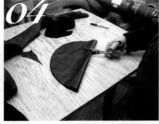

After cutting the outer shape, fold the leather in half and cut the inner oval.

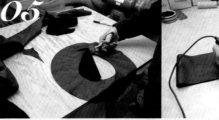

After the three parts are cut, apply leather adhesive on both ends of the crown, about 6 mm/0.25 in wide.

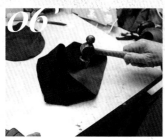

About ten minutes after the adhesive is applied, put both ends together and overlap them. Then tap the seam with a hammer to bond it securely while simultaneously making the seam flat.

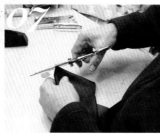

Fold the crown in half and make marks by cutting incisions.

Align the right side of the top and the crown at their marks and then staple them together. Next, staple the left, front, and back. Then, staple in-between where you already stapled in order to firmly secure the two parts together.

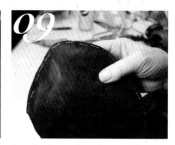

Once the two parts are temporarily secured with staples, sew them together by following the stapled line. I used an industrial sewing machine, but it can be easily sewn using a household sewing machine as long as a diamond shaped needle designed for leather is used.

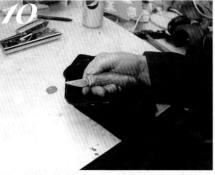

Remove the staples using a small knife after machine sewing the crown and the top together.

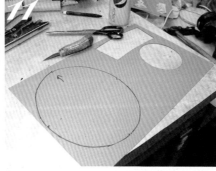

In order to make the top firm, cut out a piece of chipboard.

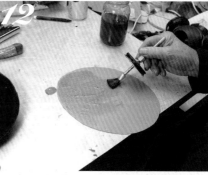

Apply leather adhesive to one side of the chipboard and inside the top.

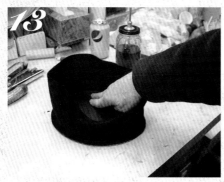

Put the chipboard and the top together carefully, being certain not to make any wrinkles, and press slowly.

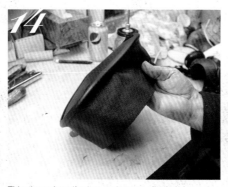

This shows how the two parts were glued.

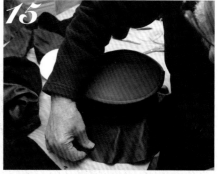

Place the crown over an upside-down small pail about the same size as the crown. Then, apply leather adhesive on the bottom edge of the crown. After leaving it to dry for ten minutes, slide over the brim and carefully attach it to the bottom of the crown. Remove any wrinkles.

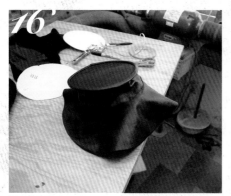

Sew the brim and the crown together from the inside.

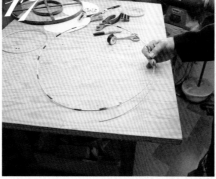

Since the brim is floppy at this point, be sure to insert a wire reinforcement. Wrap the wire twice and tape it together.

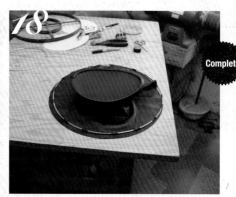

Complete.

The circumference of the wire is slightly smaller than the brim. Wrap the edge of the brim around the wire and then sew the brim from the inside to complete.

06 *Uncle Charlie's Skull Mask*

I had the idea of making a gas mask that was reminiscent of a human skull, so I just went ahead and made it!

By Tom Banwell

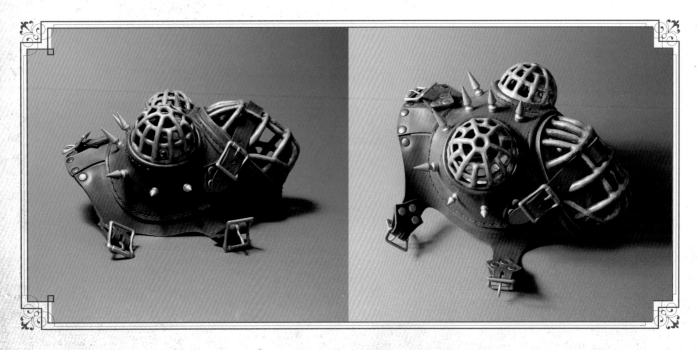

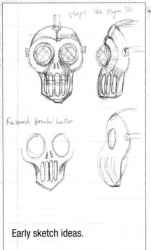

Early sketch ideas.

Materials & Tools

- Clay, Leather, Handle (i.e. a door knob), Weight (i.e. sandbag), Silicone, Casting resin, Spray (silver), Cardstock, Silicone rubber, Acrylic plate, Rigid urethane casting resin, Wax, Dog muzzle, Epoxy-based resin adhesive, Waxed cord (black)
- Utility knife, Scissors, Pliers, Grease pencil, Masking tape, Permanent marker, Needle

01

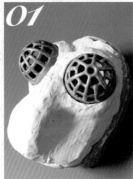

Make an original mold using clay on a face cast. For the eye-cages, previously made eyepieces are used.

[How to Make Eyecages]

1. Cut a circle for the eye shape using a utility knife.

2. Cut spaces out of circular leather like crossbars.

3. Prepare a door knob or a handle with the desired curve. Soak the leather in water about thirty minutes to get it wet and then place it over the handle.

4. Place a bag filled with sand on the leather as a weight. After about one hour, shape the leather as it dries.

5. Once the leather is completely curved, remove it from the handle. Next, mold it in silicone rubber.

6. Pour casting resin into the silicone mold. Polish the surface after the casting resin is solidified and spray on silver color to complete.

02

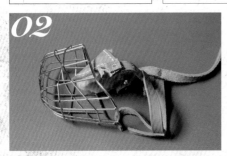

Prepare a dog muzzle.

03

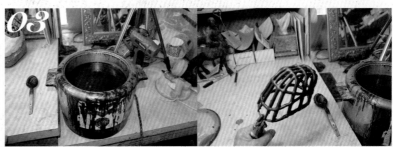

Dip the muzzle in a pot of melted casting resin.

04

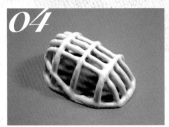

Spray silicone rubber and apply urethane resin on the top.

05

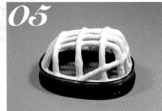

The base was made using a piece of acrylic sheeting and leather. Fill gaps with clay and use epoxy to attach all the pieces together.

06

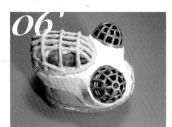

Apply a pink urethane resin and attach it to the original clay model to finish making the shape. Since I had become very fond of this mask, I decided to call it 'Uncle Charlie'.

07

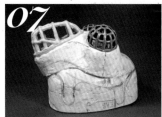

Once the original clay model is finished, coat it with urethane resin. Then, pencil in lines for the leather seams.

08

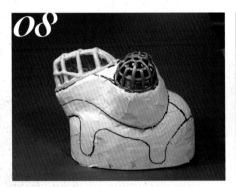

Mark the lines with a grease pencil. The face is sectioned into two pieces around the eyes and one piece for the chin. Then, cover it all with masking tape and trace the lines penciled in using a permanent marker.

09

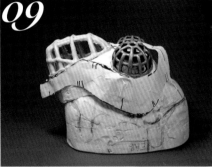

Mark the seam line and gently remove the masking tape from the model.

10

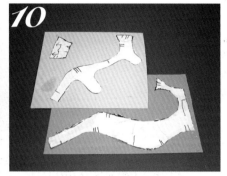

Lay the masking tape pattern on cardstock.

11

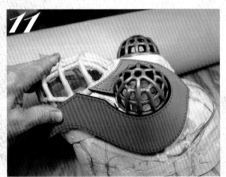

Copy the pattern onto leather. After marking the stitching pattern (handwritten or printed), cut out the leather.

12

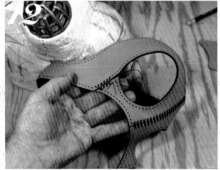

Use black-waxed thread to stitch the leather together.

13

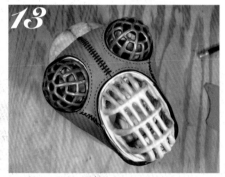

After stitching the parts together. It looks like a grasshopper!

14

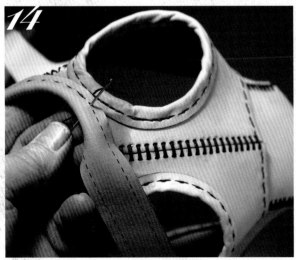

Sew it over the stitching pattern with black thread

15

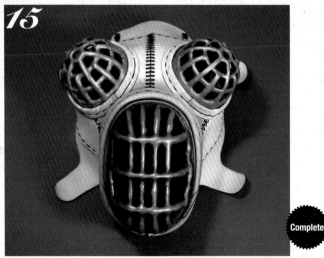

Complete!

Complete.

07 Black Spider Goggles

Make goggles that look as if a black poisonous spider were clinging on to them using FRP, a material often used for prosthetic effects in movies. FRP is a material that even beginners can use.

By Tomonobu Iwakura

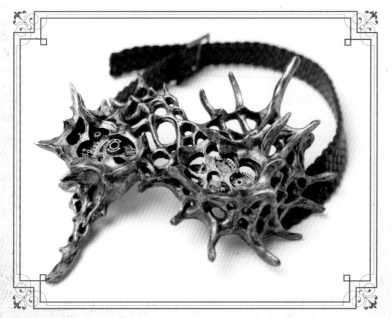

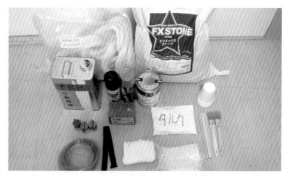

*** All materials used in this section can be purchased at Yoshimura Co., Ltd. (http://www.yoshimura-net.co.jp/), Live House Zokei Big Site (http://homepage2.nifty.com/live-house/), Tokyu Hands, etc.

Materials & Tools

- NSP clay, Primer, Silicone (KE-12), Curing agent (catalyst), Gauze, GELPOLY®, Plaster (FXSTONE), Sisal linen, HOBBY COLOR (Black, Silver, Gold, Rust), Goggles, Instant glue, Dental Acrylic, Fiberglass, Thick fabric, Buckle, Wire, Hardware (i.e. screws)
- Paper cup, Hake brush, Disposable chopsticks, Brush, Scissors or Utility knife, Sandpaper, Gloves, Mask, Dremel tool

[Caution!]
When using FRP, wear gloves and a mask in order to avoid inhaling glass fiber.

Design draft. Write down everything, including the materials.

01

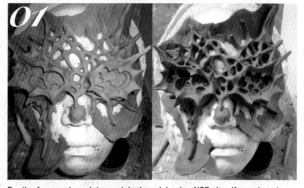

For the face cast, sculpt an original model using NSP clay. If you do not have a face cast, use the head of a mannequin, or a commercially available mask that is three-dimensional.

02

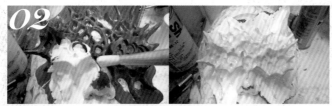

Apply silicone to make a mold. Mix the silicone (KE-12) and the curing agent (catalyst) in a 100:2~5 ratio and apply to detailed parts using a brush for the first layer.

03

For the second layer, plaster on gauze to reinforce.

04

For the third layer, apply only silicone. This is called a veneer layer.

05

Fill the undercuts (cavities and dents that may tear silicone off when releasing a mold) with clay.

Point

[The Reason Why We Fill Undercuts]
When fine thorns, etc., are enclosed between solid materials such as FRP and plaster, releasing the mold is very troublesome. So, add clay around the thorns to make them larger. This makes mold releasing easier by using clay as a cushion.

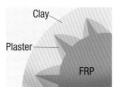

06

Apply Plaster (FX STONE) dissolved in water and plaster sisal linen to reinforce the outer (jacket).

Point

[What is a Jacket?]
Since silicone alone does not make molds that are solid enough to keep their shape, meaning that their form will be distorted, you must reinforce the silicone with hard plaster. This is known as the jacket.

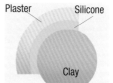

07

After the plaster solidifies, remove the silicone from the original clay model and remove clay from all undercuts. Then, the mold is complete.

08

Use a brush to apply GELPOLY® (a thick liquid made from a mixture of FRP and talc) on the mold.

09

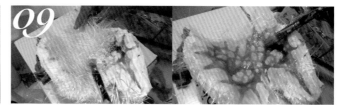

Place fiberglass over the top and reinforce by soaking FRP into the fiberglass.

10

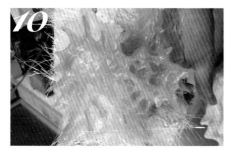

After it has solidified, remove from the mold.

11

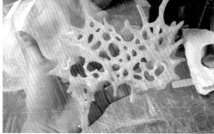

Cut fasting fins (excess or unwanted parts) off using a utility knife and polish with sandpaper.

12

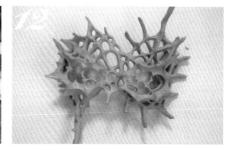

Spray on primer.

13

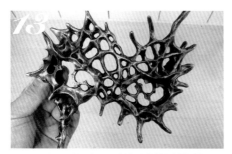

Paint it using gold, silver, and black HOBBY COLOR.

14

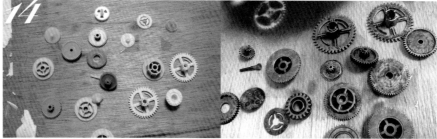

First collect and paint design materials such as screws, etc., using gold, silver, black, and rust HOBBY COLOR.

15

Glue screws on the goggles using instant glue. When done, the goggle part is complete.

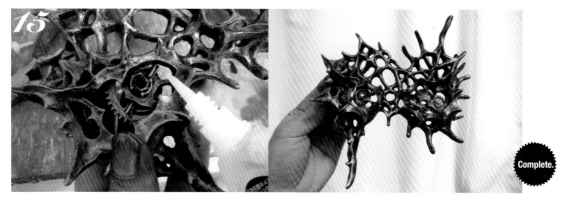

Complete.

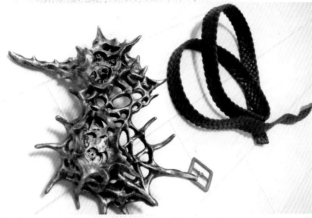

In order to make the goggles wearable, prepare thick fabric and a buckle.

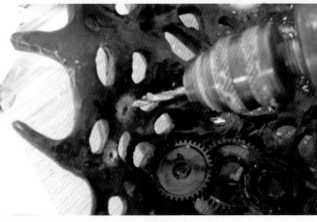

Using a Dremel tool, make two holes about 1mm/0.04 in. in diameter (do not pierce through) on both the left and right side.

Prepare four wires, 1mm/0.04 in. in diameter and 5cm/2 in. long.

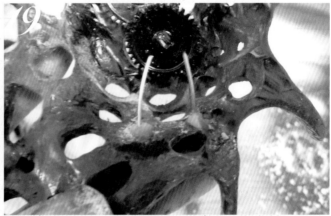

Put a wire on each hole and secure using dental acrylic.

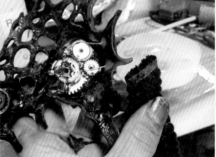

Pierce the wires through the belt.

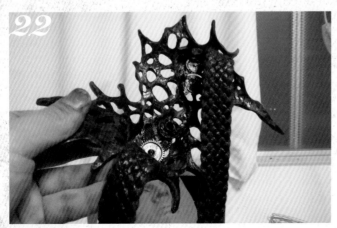

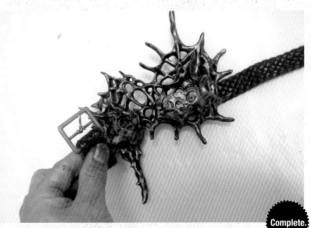

Secure by bending the wire over the belt.

Attach the buckle.

Complete!

Complete.

08 'Search' Gas Mask

Using FRP, make a full-face gas mask with attached glass eye, just like the goggles made in the previous section.

By Tomonobu Iwakura

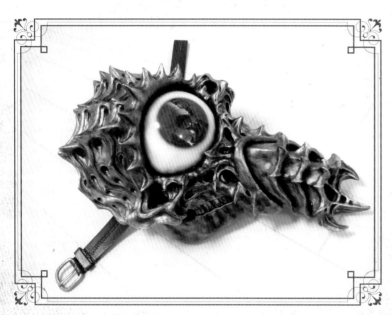

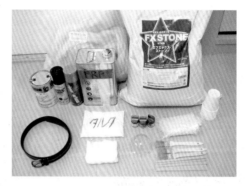

*** All materials used in this section can be purchased at Yoshimura Co., Ltd. (http://www.yoshimura-net.co.jp/), Live House Zokei Big Site (http://homepage2.nifty.com/live-house/), Tokyu Hands, etc.

Materials & Tools

- LEON CLAY, Artificial eye (half dome shape plastic), Silicone (KE-12); Curing agent (catalyst), Gauze, FRP, Primer, Sisal linen, Fiberglass, GELPOLY®, Plaster (FXSTONE), Lacquer spray, Vaseline, Belt, Screws
- Paper cup, Hake brush, Disposable chopsticks, Brush, Scissors or Utility knife, Sandpaper, Gloves, Mask, Hammer, Hollow punch, Driver, Glue gun

An organic, life-like design.

[Caution!] When using FRP, wear gloves and a mask to avoid glass fiber.

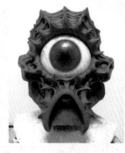

On a face cast (or a commercially available mask, etc.), engrave an original model using LEON CLAY. First, make the face and then make the filter part later. A store bought artificial eye is used here, but if one is not available, you can temporarily use a plastic half dome part (sold at Tokyu Hands, etc.).

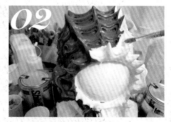

Mix silicone (KE-12) and curing agent together and apply the first layer using a brush.

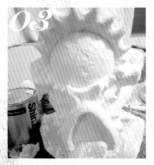

Leave to harden for about 30 minutes to one hour. After the first layer has hardened, plaster on a second silicone layer that has been soaked in sisal linen for reinforcing.

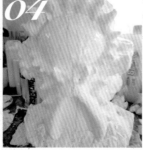

After the second layer has hardened, apply the veneer layer.

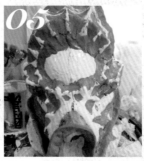

Fill all undercuts with water-based clay.

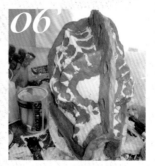

Make a mold by halving the face vertically. Make a wall using water-based clay to halve the head.

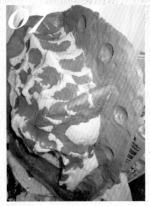

07

In the wall, engrave keys (so that the left and right mold matches precisely).

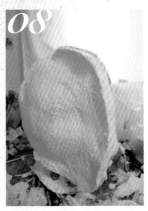

08

At first, apply plaster (FXSTONE) to the right side and make the jacket by plastering sisal linen on to reinforce.

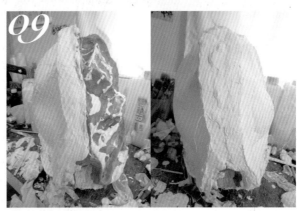

09

After the right side plaster has hardened, remove the water-based clay wall. After applying Vaseline, for releasing mold, do the same procedure to make the left-side jacket.

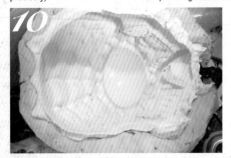

10

After the plaster has hardened, remove both molded sides and the clay in the undercuts. The silicone mold is complete.

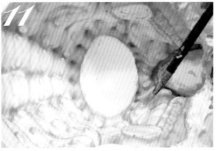

11

Apply GELPOLY® on the silicone molds.

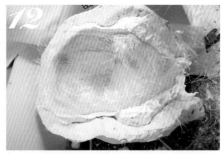

12

After it has solidified, for the second layer, place fiberglass on the mold and apply FRP.

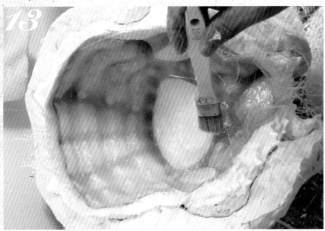

13

Apply a third layer of FRP.

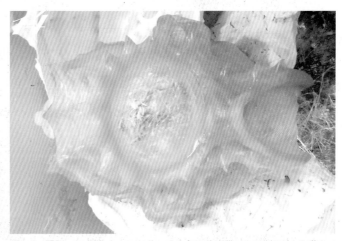

14

After the FRP has solidified, remove the mask from the silicone mold and cut off casting fins using a utility knife.

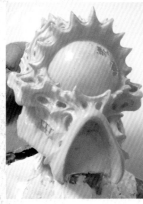

Spray on primer.

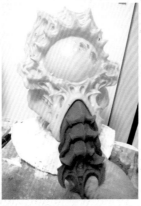

Place the FRP, which you just made, on the face cast. Then, go ahead and engrave LEON CLAY in order to make the filter part.

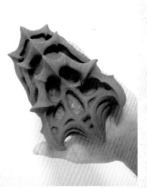

Remove the original clay model of the filter from the FRP.

18

Similar to the base, mix silicone (KE-12) and curing agent together, and then apply the first layer using a brush.

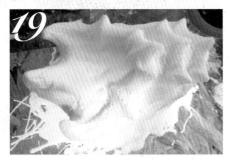

19 After it has hardened, apply a second layer of silicone while plastering on gauze to reinforce.

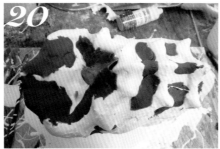

20 Fill undercuts with water-based clay.

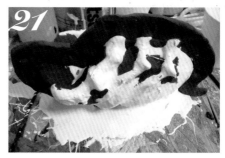

21 Since a separate mold is taken of the left and right, make a wall that equally halves the filter vertically.

22 The plaster + sisal linen jacket is complete.

23 Apply GELPOLY® to the inside of the mold.

24 Once it has solidified, place fiberglass on the mold and apply FRP.

25 Wait for a while until everything has solidified.

26 The FRP made filter is ready now.

27 Put the filter and the base together.

28 Apply GELPOLY® on the joining surface and allow to harden.

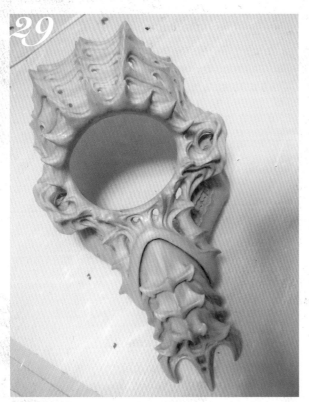

29 After it has hardened, spray primer over the entire mask.

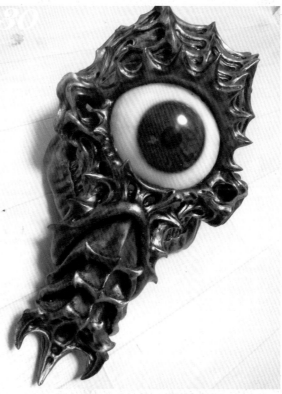

30 Paint using Black lacquer spray. Attach the eyeball (see next page).

<How to Make Artificial Eyes>

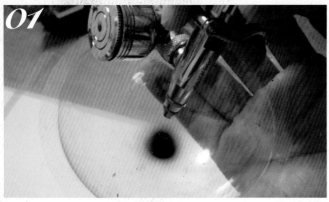

01

On an acrylic half dome cup, paint a pupil in acrylic paint using an airbrush. Paint from the inside.

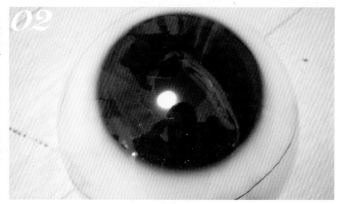

02

Spray the white of the eye on the inside and cut in an oval shape to complete

31

Open a threaded screw hole in the mask to secure a belt. First, apply vaseline to the screw for mold releasing.

32

Touch the end of the screw with a glue gun to heat.

33

Inside the mask, temporarily secure four screws, two on both the left and right, in cavities in the mold (see photo 34 for positioning).

Apply GELPOLY® around the screw.

The arrows point to the cavity where the screws should be attached.

35

After the GELPOLY® has hardened, remove the screws with a screwdriver. If Vaseline had not been applied, the screws would not come out.

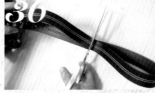

36

Prepare a store bought belt that allows the mask to cover your face closely. Adjust the length while wearing the mask, and then cut to your preferred size.

38

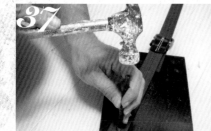

37

Punch a hole in the belt using a hole punch. Using the screws from the previous step, secure the belt.

Complete!

Complete.

Miniature Book and Fish-shaped Case

Make a miniature book, and fish-shaped casing, as an objet that you can read. Anything under 3 in./76 mm cubed is defined as a miniature-sized book. With this standard as a prerequisite, let's make a resin cast.

By Michihiro Matsuoka

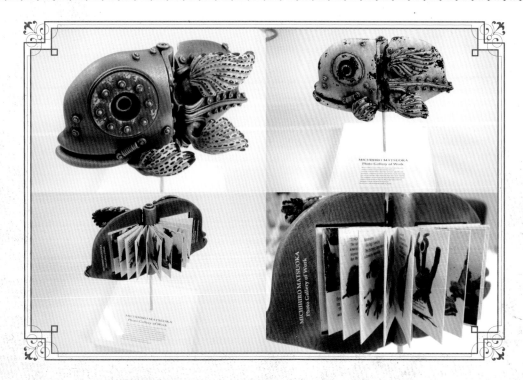

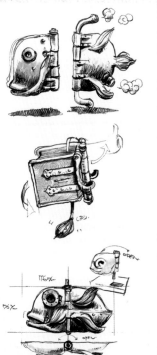

Materials & Tools

- Sculpey® (Polymer clay), Epoxy putty, Primer, Clear Acrylic varnish spray, Matte black spray, Acrylic paint (Liquitex®), Clear decal paper, Transparent acrylic plate (10 mm/0.25 in.), Wire solder, Brass pipe, Silicone (KE-12), Silicone curing agent, Resin cast, Instant glue, Double-sided tape, Decal softening solution

- Oven, Dry printer, Brush, Engraving knife, Spatula, Hake brush, Tweezers, Q-tips, Cloth (i.e. rag)

In order to follow the miniature book standard, I created a design that is under 76 mm/3 in. cubed. This way, the book has a rustic, aesthetic image, when closed and the form of a fish when opened. I took inspiration from the thick iron door of an incinerator for the rustic feel.

Top: Rough sketch 1
Middle: Rough sketch 2
Bottom: Final rough sketch

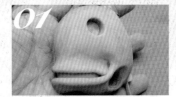

01 At first, using Sculpey® polymer clay, sculpt a base as an original model.

02 In order to harden the sculpted original model, bake it in a 130°/260F oven for about fifteen minutes.

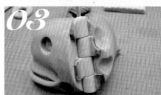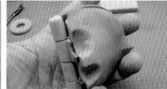

03 Insert a brass pipe in the part that will become the movable axis. Be careful not to let the base and hinges interfere with each other. Ensure that it forms the natural contours of a fish when opened.

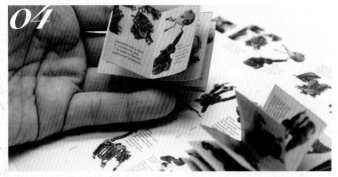

04 Next, make the interiors of the book. While considering fonts and layouts that look attractive at 45 x 30 mm/1.25 x 1.75 in., create contents of the book that are similar to an anthology. Use a PC to create the contents and then print them out on thin craft paper. Fold the paper and cut off any unnecessary parts.

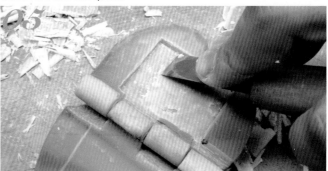

05 Once the book is ready, hollow the base out according to the thickness of the book. Mark an area that is slightly larger than the book. Carve out the marked area using an engraving knife. Sculpey® is relatively breakable, so be careful when working with it.

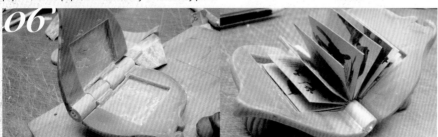

06 After the carving is done, temporarily attach the book to the base to check whether it opens and closes. Once the resin is casted, the opening for the book will shrink a bit. This is why we carved out a section that was a little larger than the book.

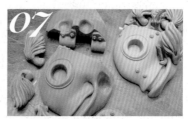

07 Replicate the original model. Mix silicone (KE-12) and curing agent to make a mold and then pour casting resin and allow to harden. After it has hardened, remove from the silicone mold (if you intend this to be a one-of-a-kind item, using a stone clay mold will increase its strength). Make a mold for each part.

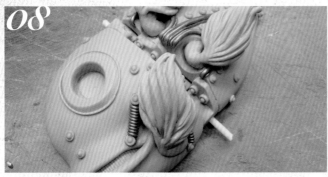

08 Replacing the original model with resin causes slight shrinkage and distortion, so slide a brass pipe in the hinge. Mark the position of the movable parts by repeatedly opening and closing the mold several times.

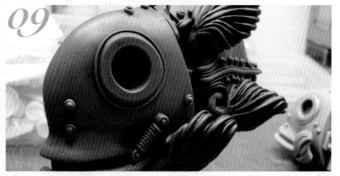

09 After spraying on primer over the resin base, add black paint as an undercoat. After letting it dry, paint in brown acrylic using a firm hake brush.

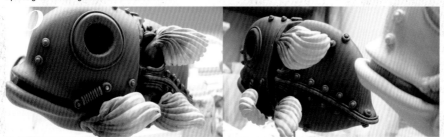

Paint with brown acrylic while adding bright brown gradations little by little. At this point, add gradations to the fins as well.

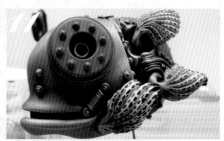

Attach the eye parts and paint in the fin details using acrylic.

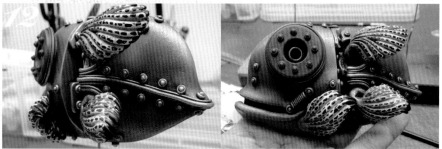

Spray matte clear finish all over after painting all of the brown gradations. Lastly, add in scratched metal 'expressions' using silver paint.

Secure the book inside of the hollowed out portion using wide double-sided tape. Make sure it still closes properly.

Aged Finish

This is one of the color variations in resin reproduction. This one aims to express a painted metal surface that is peeling off.

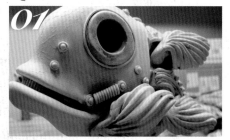

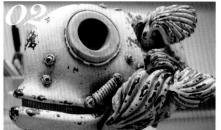

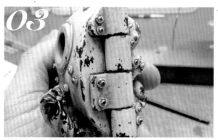

At first, use acrylic paint to apply a thin white base a few times. While applying paint, add a subtle unevenness to the surface so that it doesn't look too dull.

The aged finishing starts from here. Firstly, spray matte clear all over the white base and let dry. After drying, paint thin reddish brown acrylic, diluted with water, on the rivets and in the cavities. Afterwards, add subtle unevenness and gradation by wiping the paint off with a rag.

In order to depict the idea that the painted surface is peeling off of a white metal fish that has been used for a long time, use acrylic to create the peeled off paint. Paint that has peeled off of old office fixtures or industrial heavy machinery can be a good reference.

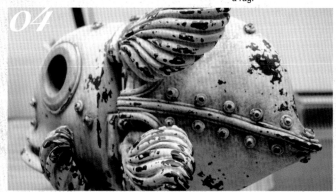

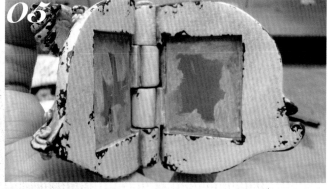

For the spine of the book, paint peeling sections on where the rustic hinges touch, where parts that rub together, etc. Use an extra fine pointed brush to paint thick acrylic for each peel.

When the book is opened, add marks where the paint came off on the inside as well. Make it modest so that it balances with the outside.

Making a Label and Stand

Water transfer, decal paper (a sticker) is used for a label.

❶Using an ink ribbon dry printer, print out on clear decal paper.
❷Trim the paper to leave some margin around the printed text. Peel clear film off from the mount, using water, and paste the film on the acrylic stand base. In order to attach the film properly on the base, use decal softening solution and carefully work with it using Q-tips, etc.
❸After the Decal has dried, spray with acrylic varnish to protect the surface and also to unify the overall luster.

Finally, use the transparent acrylic sheet as a display stand and insert a brass pipe. The miniature book objet is complete.

10

Cat-Ears Goggles

Make cat ears and a hat with attached goggles by remodeling broken headphones.

By Chasuke

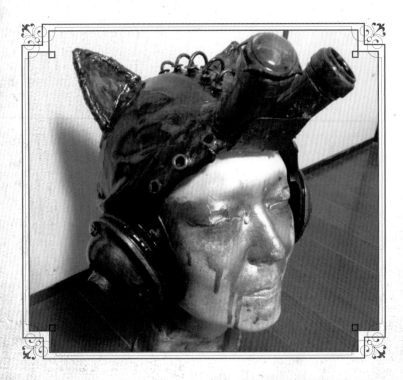

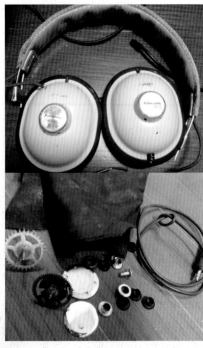

Materials & Tools

- Broken headphones, Black leather, Cords, Clock waste parts, Grommets, G bond, Two-part epoxy, Stainless steel tape, Lacquer spray (Black, Gold, Silver), Solvent-based acrylic paint, Paper clay
- A dollar store cosmetic case, Small can, Utility knife, Brush, Scissors

01 Make a foundation on some sort of pedestal, like a cast of one's own head, a stiff hat that fits tight, or the head of a mannequin, etc. In the picture above, the foundation was made by applying FRP and allowing it to solidify. Packaging materials like thin urethane and SUNPELCA® will also work.

02 Glue the leather together with leather adhesive. Leave wrinkles and overflowing adhesive as is, just to add character.

03 Roughly erase the seam using leather adhesive. Glue grommets on with leather adhesive as a decoration.

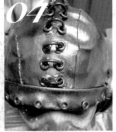

04 Glue cords onto the grommets as if they were threaded and paint the whole thing in gold.

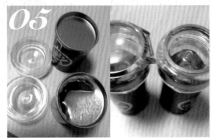

05 Prepare the dollar store cosmetic case and small cans. Glue these together and make the lenses.

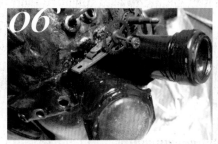

06 Attach clock waste parts, etc., to make them look goggle-like. Use black, gold, and silver lacquer spray all over and add dry brushing to achieve the desired result.

07 Make ears using paper clay and stainless steel tape. Paint them the same as the head part and attach the ears to the head to finish.

Complete.

Fox Spirit Mask

Make a mask that goes well with a kimono using real fox fur.

By Chasuke

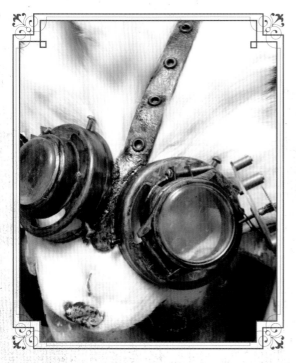

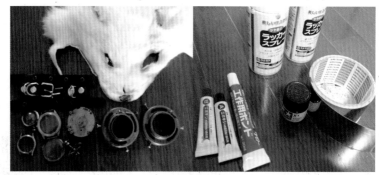

Materials & Tools

- Fox fur, Waste lighting parts, A dollar store dog collar, Clock waste parts, Grommets, G bond, Two-part epoxy, Stainless Steel Tape, Lacquer spray (Black, Gold, Silver), Solvent-based acrylic paint

01

Dry brush gold on the dog collar.

02

Combine clock and lighting waste parts.

To prevent the fur ears from becoming floppy, tape them with stainless steel tape.

04

Paint gold on the stainless steel tape. Afterwards, dry-brush gold over that.

05

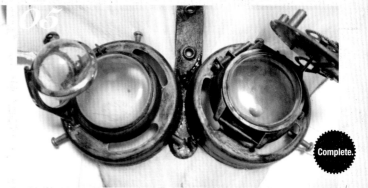

Complete.

Combine various parts and decide on the arrangement. Then, secure with adhesive. Match the color tone to complete.

Original Screws

Make fine, small screws (screw and nut) out of brass and copper.

When commercially available screws do not fit your work, it can be very discouraging. The size and scale of your work can even be influenced by the length and width of commercially available screws. However, if you're able to make original screws, you will be able to greatly broaden the size range of your work.

By Keizo Hoshino

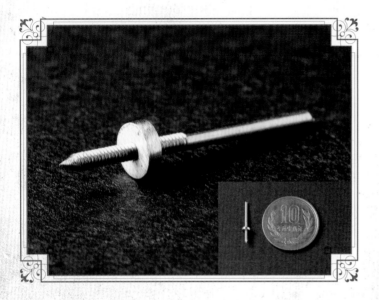

Materials & Tools

- Copper sheet, Brass pole, Silicone oil
- Thread cutting die, Hole punch, Scribe-compass, Tap, Pliers, Nippers, Tweezers, Hammer, Vise, Metal file, Pin vise

<How to Make Bolts>

A garage turned into my Atelier. Neat and organized hardware and tools are lined up, showing off a polished appearance. A large amount of copper and brass, which may take more than a lifetime to use up, is stored at the back.

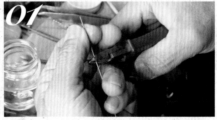

01 Cut a 1 mm/0.04 in. diameter brass pole to a length of 3cm/1.25 in.

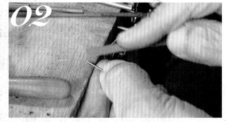

02 Sharpen the tip with a metal file so that it can be inserted into a thread cutting die (a tool for cutting threads) insert the die into the holder and thread it by rotating the holder.

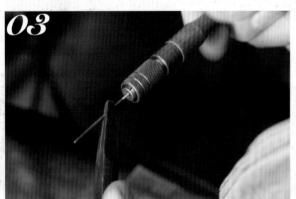

03 Set one end of the brass pole in the thread cutting die.

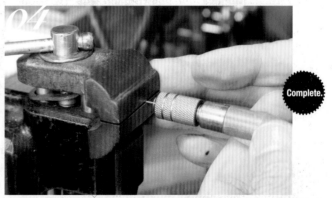

04 Secure the other end in a vise. Cut the threads by rotating the brass pole by hand.

Complete.

<How to Make Nuts>

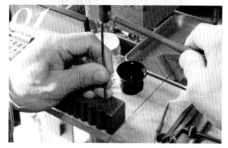

Prepare a copper sheet (or brass pole). Place a hole punch where you want to pierce a hole and mark by tapping the punch with a hammer.

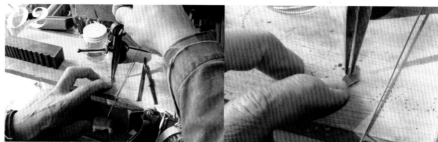

Place a scribe-compass on the mark and draw a circle about 3 mm/0.11 in. in diameter.

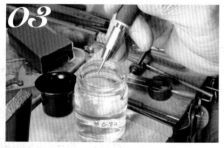

Soak the tip of a 0.8 mm/0.03 in. diameter tap (a tool to cut threads inside of a nut) in silicone oil. Doing so, makes it easier to drill the hole.

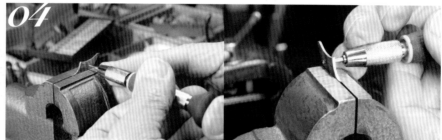

Secure the copper sheet in a vise. Attach a tap to a pin vise and drill a hole by rotating by hand until it pierces through. While paying attention not to chip the tip of the tap, forcefully drill the hole.

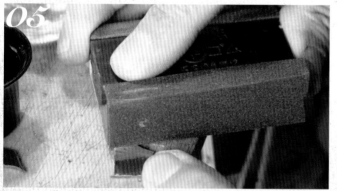

File around the screw hole to make it smooth.

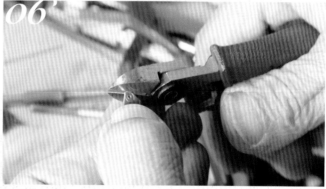

Cut it roughly into the shape of nut using nippers.

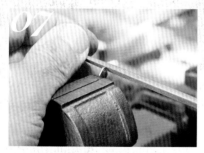

Secure the copper sheet in a vise and file with a metal file. When the nut gets smaller, remove it from the vise. Pinch with a pair of original pliers (made separately) for easier handling. Form the shape of the nut by filing. Follow the circle marked by the scribe-compass.

The nut is complete.

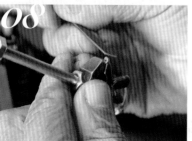

Complete.

<Assemble>

Complete.

Put the nut and the bolt together. The screw is complete. In total, this project took fifteen minutes. Variations can be made by creating a wing nut, making the bolt longer, etc.

DIY Antique Interiors 2

Living in the Steampunk World

by Mari Igarashi

It is not necessarily objects that make something 'steampunk'; it is also the world and culture evolving around it. From desks to rooms, accessories to costumes, and houses to entire towns, the real steampunk is the world that is built entirely around these objects.

The twelve items introduced in this section are all elements that add to the wider world and culture of steampunk.

This is a new telephone model introduced by Steam Co, gilded in gold and brass, and built out of beautifully grained mahogany. When you connect your Apple iPhone to the receiver, you can talk whilst your iPhone is charging.

RECIPE 04
Steampunk iPhone Charger

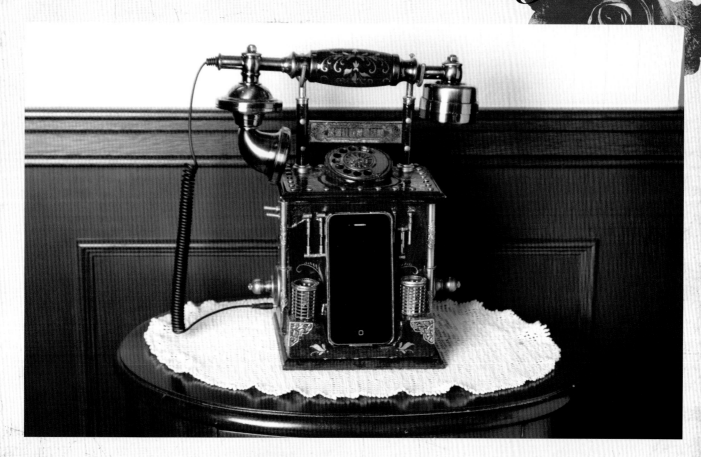

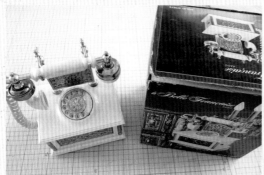

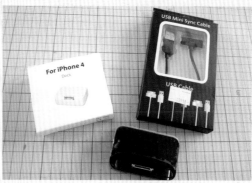

Materials & Tools

Though it looks heavily built, most of this item is made of cardboard, foamcore board (polystyrene sheeting), and paper clay. As far as materials are concerned, they are similar to an art project for a grade school student – in fact, the brass-looking parts are simply painted plastic.

- Various toy parts, Metal fittings (i.e. Grommets), iPhone charger, Primer, Lacquer spray (Metallic Gold, Yellow), Mr. Color Spray (Black, Orange), paper clay, Cardboard, Foamcore board, LED, Transparent sticker sheet, Construction paper (Black), Stamping Leaf, Acrylic paint (Black), Urethane varnish (Mahogany, Transparent), Japanese paper, Woodworking glue, Varnish

- Urethane sponge, Iron, Laser printer, Hake brush, Sandpaper, Driver, Design knife

<Making the Casing>

01

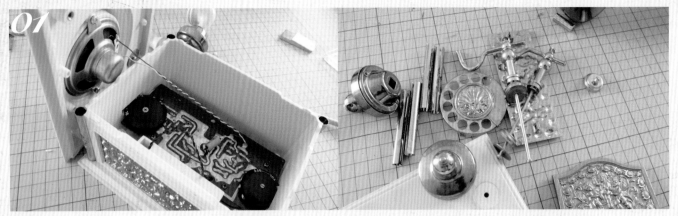

First, find the parts you will use. A toy radio auctioned off on the Internet is shown above. I bought this item thinking that the classical phone shape might be useful for something. Since the radio function was broken, it was only \100 (about $1). Other necessary parts are metal fittings and some plastic. Take everything off the casing and then wash and dry the parts.

02

Purchase other usable parts at a dollar store. A toy crane-truck is shown above.

03

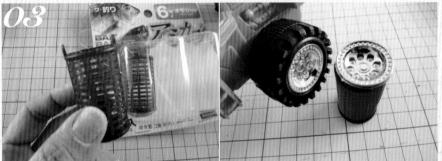

Shown above is a plastic basket used for fishing. It is a good idea to visit dollar stores, junkyards, toy stores, and DIY centers regularly, just to keep up on items you can use for fabrication.

04

Paint the parts you have collected. Spray with metallic gold lacquer after priming the parts. A nice, unified feel is brought out by painting.

05

In order to dull the luster of the gold, age the parts. By applying Mr. Color's black, orange, etc. here and there, the tone of the color becomes refined, as though aged.

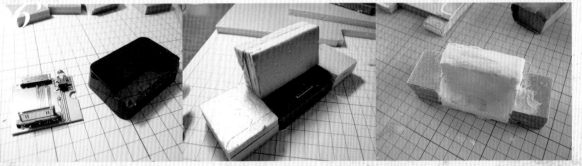

Make a pedestal for the charger. Combine foamcore board and a charger and glue them together. Form the detailed portions using paper clay. Smooth the surface with sandpaper and paste pieces of cardboard on the flat surfaces.

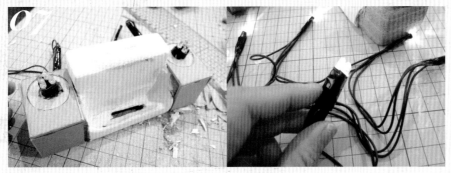

Attach LED lights on both ends of the pedestal and make sure they light up.

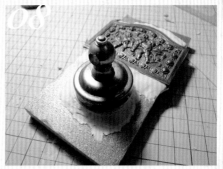

In order to express technology unique to Steampunk, attach various Steampunk-like parts. I decided to attach two of the same shaped pieces, one on each side of the telephone, as decorations. These rounded metal parts are the earpiece and mouthpiece from a toy telephone's receiver that I saved.

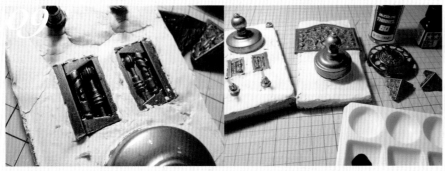

Secure pieces, like the parts cut off from a toy crane-truck, a toggle switch, etc., on formcore board by surrounding with paper clay.

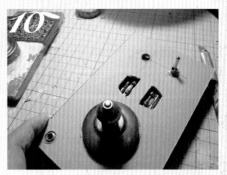

While letting the paper clay dry, paint the wooden board (actually made of cardboard and plastic). First, cut a piece of cardboard according to the size of the parts. Hollow out the spot where the parts poke out using a design knife.

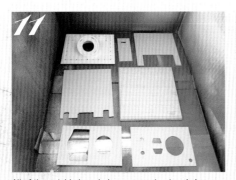

All of the outside board pieces are cut out and shown above. Spray with yellow lacquer all over.

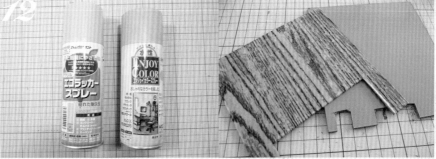

Print wood grain patterns in black and white, processed from a picture, on a transparent sticker sheet. Paste the sheets on the cardboard you painted yellow. This becomes wood grain patterned cardboard, in which the yellow base color shows through, as shown in the picture above.

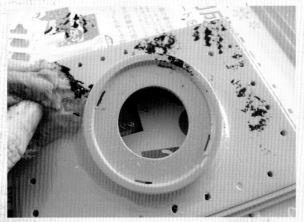

For the other parts, after you paint them yellow, add patterns by stamping with a sponge soaked in black acrylic paint.

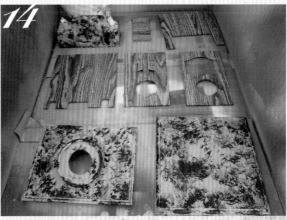

Above: The first layer of wood grain painting is finished.

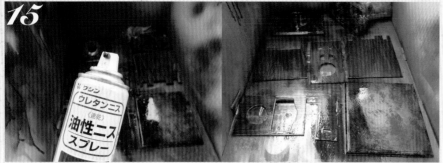

15 Spray with mahogany urethane varnish. This makes the wood grain a glossy amber color. Dry once and then coat in about three more layers.

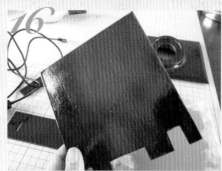

16 The pieces have a beautiful luster as is, but it might be a good idea to spray on some transparent urethane varnish. Now a simple piece of cardboard looks like real wood.

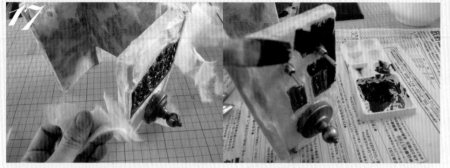

17 Since the strength of the Foamcore board that the parts were attached to is a little questionable, plaster Japanese paper on the surface using woodworking glue thinned with water. Adding Japanese paper increases the strength and also makes it easier to paint and glue. After everything has completely dried, add black acrylic paint around the parts.

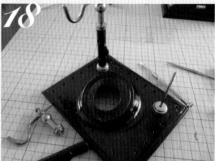

18 Glue the aged gold parts onto the base to assemble.

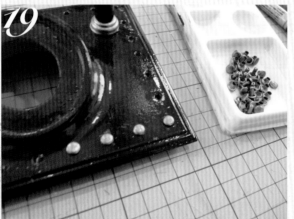

19 Glue on metal fittings, such as grommets, to decorate.

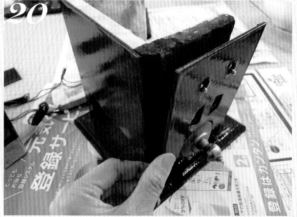

20 Glue a piece of cardboard painted with wood grain paint on the surface. A wooden decoration board is used for the bottom.

\<Embellishing and Final Touches\>

Assemble the parts previously painted in gold and glue them on the casing. Since the casing surface was painted in dark mahogany, these golden parts will really stand out. Attach the parts taken from the toy crane-truck to the front. It looks a little like a steam duct, doesn't it? The plastic fish baskets are used as LED light shades on both sides of the pedestal. Use wheels from the toy crane-truck for lids on the LED light shades.

Point

Sticker edges are softened when varnish is applied over them.

01 Using a laser printer, add patterns for trim decorations on a transparent sticker sheet.

Place a stamping leaf on top of the printed pattern sheet and press an iron over it to create golden patterned stickers.

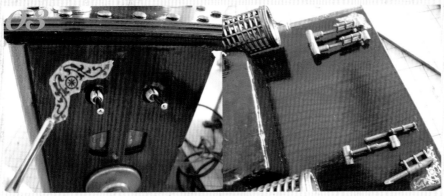

03

Cut the trim decoration patterns out and put them on the casing.

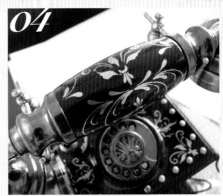

04

Above: After pasting on the decorations.

05

Make a plate and numbers for a dial. Using a laser printer, print "蒸気社謹製電話機" on black construction paper, if you wish. 蒸気社 (Steam Co.) is the name of a fictitious company, which I made up, that makes Steampunk devices. This label also uses a stamping leaf. Transfer the gold leaf onto the printed letters with an iron.

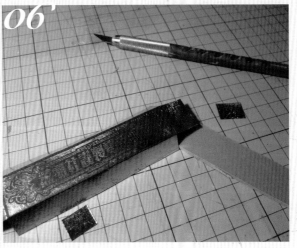

06

Use a piece of thick cardboard as a core and paste the cut out label onto it.

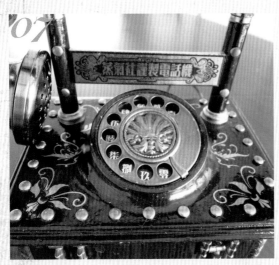

07

Mount the dial on top. Instead of Arabic numerals, Daiji numerals in an old font were used. The numerals are "壹貳參肆伍陸柒 捌玖零." The Kanji character for seven does not have a font so I made it by combining Kanji characters. To complete, attach the plate labeled "蒸気社謹製電話機" on the receiver holder.

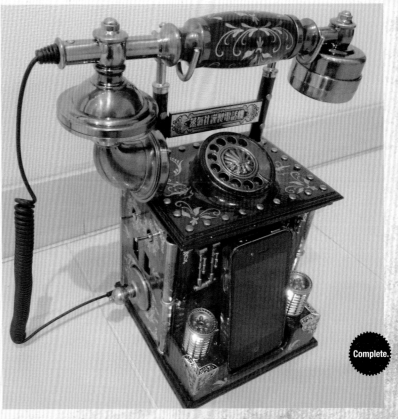

Complete.

RECIPE 02

Steampunk iPhone Cover and Receiver

Mahogany colored iPhone cover with brass cogwheel designs. This is a great combination of a highly technological phone and low-tech cover.

"林檎社謹製携帯電話機" in gold shines on the side.

The painted iPhone cover is simply placed on the phone, so the functionality of the phone will not be disturbed. Likewise, there will be no problems with taking photos and charging the battery.

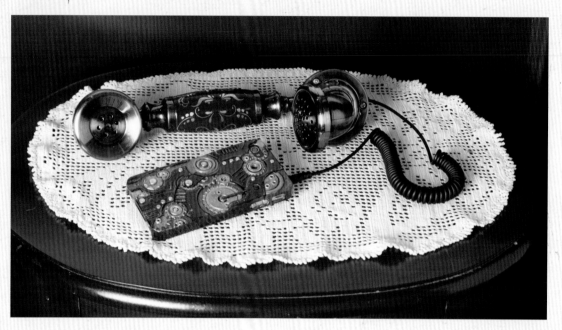

Materials & Tools

This iPhone cover, which is used as a base and a receiver, was purchased at the Chinese on-line store TAOBAO. The receiver looked heavy, but the delivered item was unexpectedly light weight and it only cost 28 CNY($4.50). It uses a 3.5 mm/0.125 in. stereo mini-jack cable and can be used for both iPhones and iPads. No batteries are necessary. It will work simply by plugging it in. At TAOBAO, these unique goods are sold cheaply. For example, if you search using the terms 'antique' and 'phone' a lot of bargain antique phones will pop up.

- iPhone cover, Telephone receiver, Masking tape, Primer, Lacquer spray (Metallic Gold, Yellow), Water varnish (Black, Clear) Enamel paint (Black), Urethane varnish (Mahogany), Acrylic paint, Metal fittings (i.e. Grommets, Rivets), Dry clear glue, Stamping leaf, Transparent sticker sheet
- Disposable chopsticks, Brush, Hake brush, Design knife, Dremel tool, Hammer, Laser printer

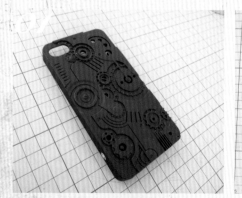
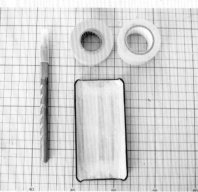
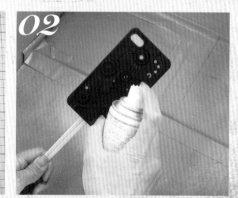

First, completely cover the inside of the iPhone cover with masking tape. Since iPhone cases are made to fit tightly, the iPhone will not fit if the inside of the cover is painted. Make sure to paint only the outside.

It is easier to work with if you attach a handle using disposal chopsticks. After washing your hands with detergent to remove the oil from your fingers, spray with primer.

140

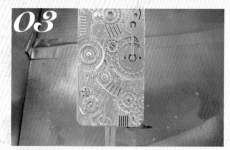

03 Spray with metallic gold lacquer.

04 Use masking tape to cover the spots where the golden cogwheels will be.

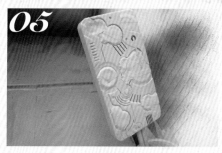

05 Begin to apply wood grain painting. Spray all over with Mr. COLOR yellow lacquer.

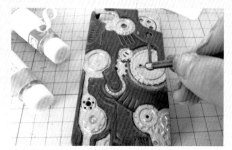

06 Next, paint in wood grain using black enamel paint. For finishing, spray with mahogany urethane varnish three times. Now, the amber colored beautiful wood grain has emerged. Spray once with clear varnish.

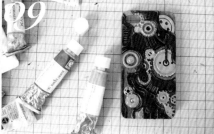
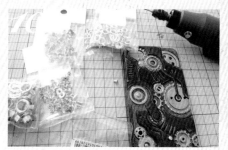

Peel masking tape off using a design knife. Careful! If you try to peel it off forcefully, you may remove paint along with the tape.

Since the surface looks flat as is, and it lacks a realistic look, use weathering and aging effects to bring out a three-dimensional feel.

09 Acrylic paint was used. Paint the shadows of each cogwheel by adding dark colors along the grooves. You can also add white to make areas look as if they are shining.

I decided to add metal fittings like grommets, rivets, etc., for decoration. Pierce holes using a Dremel tool and emb the metal fittings in the holes. Cut or hammer the metal fitting to make them flat, thus preventing them from sticking out inside the cover. Use clear dry glue to fix. Adding metal shine increases the device-like feel of your case.

11 As a manufacturer's logo, I decided to show "林檎社謹製携帯電話機" on the cover. Using a laser printer, print the logo out on a transparent sticker sheet. Then, place the stamping leaf on top and press with an iron to transfer the gold leaf. Lastly, press the gold leaf transferred sheet on the side of the case to transfer the logo.

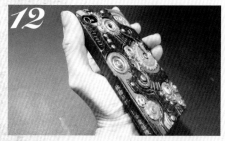

12 It is a good idea to apply water varnish as a last protective layer. The cover should fit on the iPhone nicely, and can be removed with ease. This item took three days total to complete, including drying time.

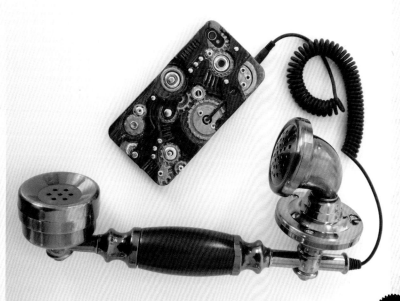

Complete.

RECIPE 03
Steampunk iPad Cover

It allows you to carry around tons of documents in PDF format (i.e. a few hundreds books, pamphlets, etc.). And, by connecting to the internet, it lets you search enormous amounts of information. You also don't get lost, because you have map apps, and it is easy to organize all of your pictures.

Since my iPad is also used in my study, I wanted a classical cover for my iPad to go with the atmosphere in the room.

So, I decided to make a foreign book-style iPad cover by using a store-bought leather cover with gold leaf print.

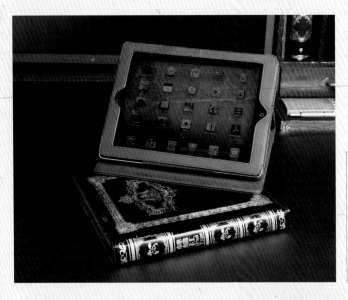

Materials & Tools

For this project, it does not matter whether synthetic or genuine leather is used. However, you must use leather that has a smooth surface. Rough and napped surfaces, such as suede leather, cannot be used.

- Store bought iPad cover, Matte clear spray, Stamping leaf, Adhesive tape, Transparent sticker sheet for laser printers
- Masking tape, Utility knife, Scissors, Iron, Graphic design software

01
Mask off the entire cover, except the outside. You can use paper to cover larger areas if you wish to save masking tape. Do not forget to carefully cover the parts that have holes.

02
Spray matte clear over the iPad cover surface evenly. Any brand of water-based clear matte spray will work. Repeat this process two more times after drying.

03
Using Adobe Illustrator® or Photoshop®, create a design that mimics the cover of a foreign book. Insert "林檎社iPad" on the spine of the cover. "林檎社" means Apple Inc.

04
Print out the cover and spine you have designed. Make sure to print out a monochromatic inverted image of the design. Once the image is printed, cut the design off using a utility knife.

05

Here we get to the stamping leaf. With this you can casually give off a foil-stamping type of feel. Place the stamping leaf on the printed design of your monochromatic inverted image. If the design is larger than a sheet of stamping leaf, connect sheets using masking tape so that they cover the design. When regular adhesive tape is used for this, the tape may shrink due to heat, so be careful.

06

Heat an iron to medium temperature (about 150 /300 F) and press over the stamping leaf. Since a large area is printed in black for this design, firmly press the iron all around the surface. If the temperature is set too high the transferred image might be wrinkled. To be safe, try it out at a lower temperature first.

07

After allowing it to cool, gently peel off the Stamping Leaf. Gold color is left anywhere there was black print, and thus the design is transferred onto the film. What we actually need is this film. The other paper, we can throw out because we do not need it (though a lot of gold color may still remain).

Point

Gold color remains on the film where there was too little heat to transfer the gold film onto the paper. If the gold color did not transfer successfully, try the procedure given below.

1. Cut a very small piece of adhesive tape, paste it on where there is gold color still remaining and then peel it off very gently.
2. By doing this, the gold color is glued to the adhesive tape and it comes off of the film automatically.
3. Repeat this process until all excess gold color is removed. This process takes a lot of time and effort but is very crucial to the final result. Be careful when removing the color.

08

Paste the cleaned film back on where the letters and patterns are supposed to be on the iPad cover. Use masking tape instead of adhesive tape.

09

Press the iron, heated to medium temperature, firmly onto the surface. Press the iron onto the surface three to four times while constantly checking it.

Point

The surface of the film is not sticky once it has completely dried. However, if the film is heated again, adhesiveness that is strong enough to attach the stamping leaf returns. Once the film has cooled, the surface becomes unstuck, so don't worry.

10

Peel the film off after you let it cool. Any stamping leaf left on the film has now been transferred onto the leather surface, as the water-based clear spray applied to the leather surface in the beginning works as a glue.

Above is a picture that shows when all the patterns on the film were transferred.

12

For those who like luminous gold, leave the leather surface as is. However, it should be noted that if it glitters too much, the book will not look antique. You may wish to spray it with matte clear again to settle the shininess.

13

The case is complete. Using this method, you can put your favorite patterns on leather products. If you give someone a present it might be nice to put their name down on the present. However, once stamping leaf is transferred, it cannot be peeled off, so be careful not to make any mistakes. It's a good idea to practice on small leather products first.

RECIPE 04

Steampunk Classical Wooden Ear Defenders

This time, we remodeled ear defenders in a Steampunk-style, labelling them "quiet and peaceful" quality products of Steam Co. Though ear defenders look just like headphones at a glance, their function is the complete opposite. Ear defenders provide protection from loud noises and are mainly used on construction sites, at airports, shooting ranges, etc. Although, for minor noise reduction such as cars, trains, etc. they show their real power. For those who want to study or sleep in a quiet environment, this is the perfect fit. Noise reduction ability is measured by an NRR rating (*). The ear defenders shown below have a 30db NRR rating. For example, the noise inside a bullet train car is about 70db. Wearing these ear defenders, will reduce the noise to 40 db, about the sound of a whisper.
*Abbreviation for Noise Reduction Rating. The higher the rating, the greater the noise reduction.

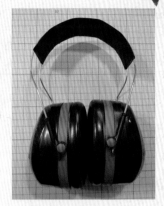

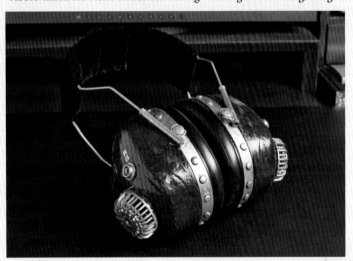

Materials & Tools

- Store bought ear defenders, Dollar store goods (Kitchen drain slime remover, Reflective plate, etc.), Adhesive agent, TAMIYA Polyester Putty, Nuts, Rivets, Grommets, Metal primer, Lacquer spray (Gold, Yellow), Enamel paint (Black), Urethane varnish (Mahogany, Clear), Transparent sticker sheet for laser printer, Stamping Leaf, Acrylic paint, Quilt batting, Hymilon fabric, Thread

- Sandpaper, Tweezers, Hammer, Alcohol, Masking tape, Packing tape, Sponge, Scissors, Needle

In order to make something steampunk-style you should deliberately over-engineer it. In other words, clutter it up a bit with buttons, switches, etc. All the materials you need can be purchased at a dollar store. It can be fun to attach the reflector plate from a car, kitchen goods, etc.

Rough up surfaces with sandpaper so that the paint sticks better. For example, there was a PELTOR logo embossed on our defenders, so I scratched it off.

Attach a bicycle reflector as a light. Glue it on one earmuff and fill around it with TAMIYA Polyester Putty. If a large amount of putty is applied at once the inside will not dry completely. So, apply small amounts and wait for that to dry. Then, apply some more. After it has completely hardened, smooth the surface with sandpaper.

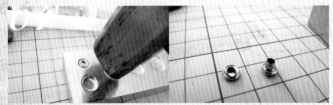

Choose parts that can be used as buttons and screws. This time use nuts instead of buttons and use rivets as screws. Smash a rivet's shaft with a hammer, as it is not needed.

Move onto painting the base and parts. Before you begin painting, wipe oils off your fingers with rubbing alcohol.

Spray with primer. Protect anywhere that paint is not necessary with masking tape. By spraying white primer first, the pieces will end up snow-colored.

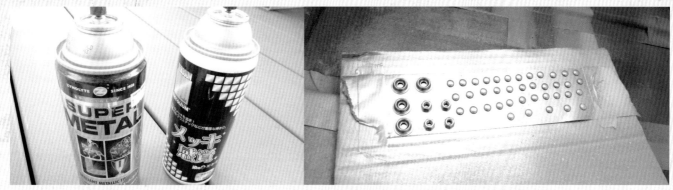

Paint the buttons and screws gold. Painting these small parts can be made easier by pasting them onto packing tape and spraying them all together. After spraying with metal primer, spray with gold paint.

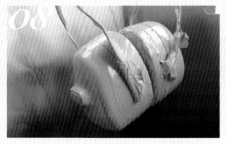

Spray with yellow lacquer and then let it dry well.

Paint on black enamel paint by gently dabbing the surface, in random spots, with a sponge.

Spray mahogany urethane varnish on and let it dry. Since we intend to create a definite mahogany wood grain, repeat the painting process about three times to bring out a beautiful amber color. After drying, spray clear urethane varnish on to add luster.

Cover your wood grain painting and the earmuff pads with masking tape. Paint the remaining exposed area in gold. After it dries, glue on parts, such as buttons, etc. The picture above shows how rivets were glued on at equal intervals as if they were screwed on.

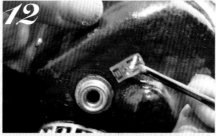

Put on some gold letters. First, print letters onto a transparent laser printer sticker sheet and then make the letters gold by using stamping leaf. Paste on the gold lettered stickers you cut out. Make it appear as though the sound can be turned off (by pushing buttons labeled "防音" and "外音") that you place over top of the switch.

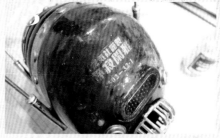

Spray clear varnish over the sticker. This makes the edge of the sticker less prominent and makes the letters appear as if they are printed directly in gold. Over the product name 静寂閑雅 (Quiet and Peaceful), there are letters 蒸気社謹製 (A Quality Steam Co. Product). 蒸気社 (Steam Co.) is the name of the fictitious company that sells these kinds of gadgets.

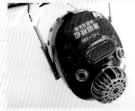
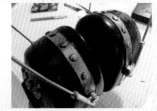

Give a weathered (aged/degraded) finish. Add weathering to the grooves and seams of the buttons and screws by using enamel or acrylic paint. In doing so, an aged and heavy image is created, thus making it more realistic.

Since the original head pad was plain vinyl, I decided to make a classical velvet head pad. Use quilt batting (cotton) as a core and wrap it with Hymilon fabric. Then, simply sew together.

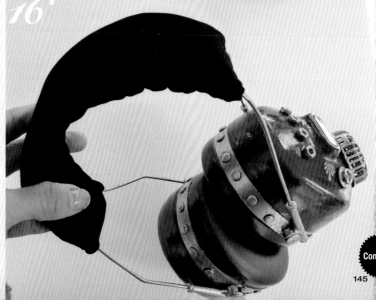

Complete.

145

RECIPE 05

Steampunk iPod Nano Arm Holder

While doing housework, I always listen to something on my iPod Nano. However, since cleaning involves lots of standing up, squatting down, and moving my arms up and down, it's difficult to find a place where the iPod is accessible but not in the way. To get around this, the iPod Nano Arm Holder comes in handy. This holder is made for fifth generation iPods, but it can be used for sixth and seventh generation iPods by changing the size of the display window and not covering the window with a protective sheet.

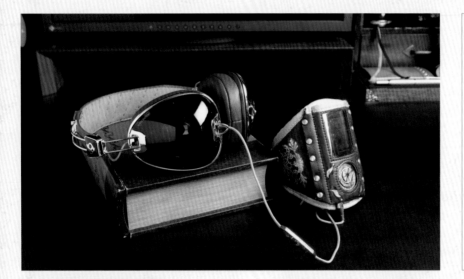

Materials & Tools

According to your budget, use either genuine or synthetic leather.

- Leather, Cushioned purse, Ribbon (Bias tape), Thread, Yellow vinyl (i.e. vinyl bags, etc.), Velcro®, Mouth-shaped plastic parts, Rivets, Stamping leaf, Transparent sticker sheets for laser printers

- Scissors, Measuring tape, Sewing machine, Needle, PC, Graphic design software, Iron, Laser printer

01 First thing: measure your arm and cut leather according to its size. There are two parts to cut out, one for wrapping the arm and the other for a pocket to put the iPod in.

For cushioning, sew thick batting inside. A dollar store cushioned purse is shown above. Since it has enough thickness and tone, and is easy to sew on, it is often used as batting for cosplay costumes.

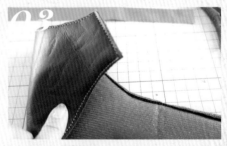

03 Sew the cut out cushioned purse on the inside of the leather using a sewing machine. Sew finely around edges.

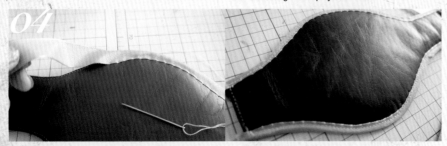

04 Cover edges over with bias tape. If you can't find bias tape in the color you like, use ribbons, etc. Here, shiny gold ribbon is sewn on.

05 Next, for the window part that holds the iPod Nano, cut out a piece of thick filter material. Using a yellow color sample from a Cosmo Color Filter (often used for stage lighting) brings out a retro feel. Since Cosmo Color Filter is hard to acquire, you can always substitute it for a dollar store vinyl bag.

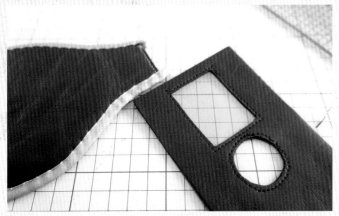

Sew the yellow filter on the leather from the back.

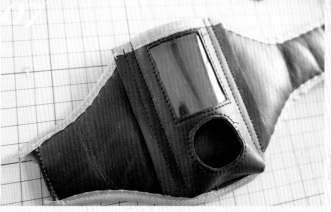

Sew the pocket for holding your iPod Nano onto the armband. Since an iPod Nano has some thickness to it, it is better to sew these two parts so that the leather sags slightly.

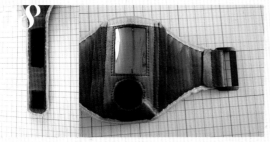

Sew Velcro® on one side and on the other sew on a mouth-shaped part.

Apply some rivets for decoration. When golden metal parts like these are applied, it instantaneously brings out the steampunk atmosphere.

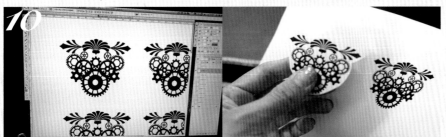

Put foil-stamping decorations on the leather. Create classical cogwheel designs using Adobe Illustrator® and Photoshop®.

Decorating with stamping leaf has appeared a few times up to now, so just go back and follow those directions.

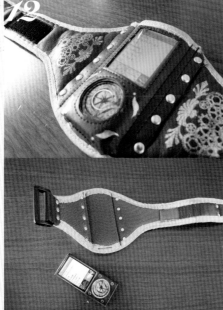

It's complete. You can enjoy doing housework, going for a walk or jog, or even going out with your iPod wrapped around your arm. I hope it's helpful for keeping music in your life!

Complete.

RECIPE 06
Aviator Style Dog Wear

My dog, Sugar, is a breed of Whippet categorized as a sighthound (a dog that hunts by sight and sound). The whippet is a beautiful medium-sized-dog and is one of the best sprinting species in the world. Sugar is my best friend, so I made her some steampunk-like aviator-style dog wear. An aviator cap complete with goggles is really indispensable for anything that is aviator-style. I found goggles that were just right for dogs online.

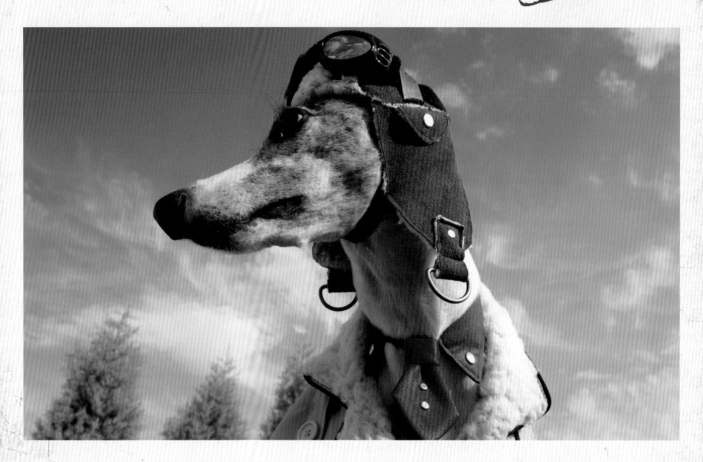

Materials & Tools

- Brown cotton fabric, Copying paper for patterns, Rivets, Old necktie, Snap fastener, Adhesive tape, Brown fabric that is lined with boa-fleece, Basting thread
- Measuring tape, Scissors, Iron, Sewing machine, Rivet punch, Sewing needle

<Making the Casing>

01 Let's make the collar first. Measure the dog's neck circumference and make a collar pattern accordingly. The margin is about 1 cm/3/8 in.

02 Cut out the fabric. Brown cotton fabric is used. In the picture above, the top two pieces become the collar and the bottom is a piece of fusible interlining.

03 Use the fusible interlining to add firmness to the fabric. There is already adhesive on the fusible interlining, so just place the adhesive side down on the fabric and press an iron over it. Make sure to firmly press down on the iron so the adhesive melts.

04 Lay the two pieces of fabric inside out and sew them together. Later, these will be turned inside out so make sure to leave one side open. Leave about 1 cm/3/8 in. space unsewn where the collar button would be located on a shirt.

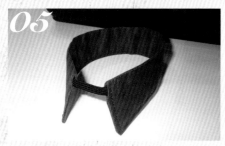

05 Turn inside out, from the unsewn left side, and machine-sew a margin of about 2mm/1/16 in. At this time, insert a flat elastic band in the space left unsewn in the previous step and then sew. This will make the shape of the collar.

To really bring out the steampunk style, decorate the collar with rivets. Punch a hole where desired and embed the rivet. The collar is complete.

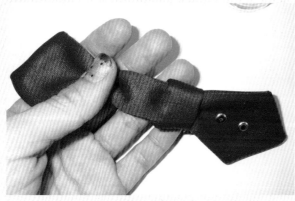

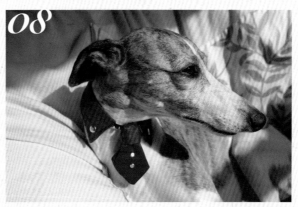

As for the necktie, it is acceptable to reuse an old necktie. Fold it in half and hang it from the elastic band. Instead of sewing it on, use snap fasteners to secure it so you can enjoy different neckties.

08 It's complete. Since the elastic band stretches out, it allows the dog's head to pass through. Be very careful to ensure that it does not constrict the neck.

\<Aviator Cap\>

01 Let's make an aviator cap. The size and shape of the head will vary depending on the dog breed. As such, pattern making is the key. Cut out some paper and try to assemble it by pasting with adhesive tape. Once you decide on the shape, take it apart and make the cap's pattern.

02 Use a piece of fabric where one side is brown leather and the other is boa-fleece. Boa-fleece is fluffy and warm – and is the perfect fabric to warm the head of a canine aviator flying through the air. The cut edge of this fabric doesn't fray so edge treatment is easy.

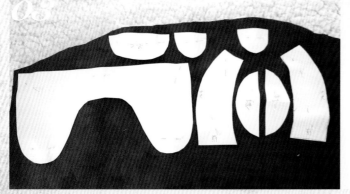

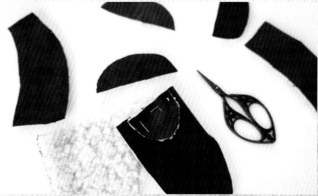

03 Cut the fabric out by pinning the pattern using marking pins. Carefully cut the boa-fleece so the edge of the fabric doesn't bristle.

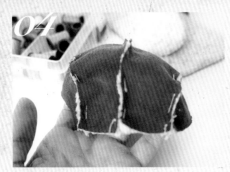

04

Stitch up the parts you cut from the fabric using basting thread.

05

Machine sew along the stitch.

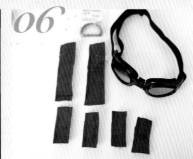

06

Washing the cap becomes difficult if goggles are sewn onto the cap. Instead, use a snap fastener and belt to secure the goggles. Sew one side of the belt on the cap and then emb the female hale or male hale of the fastener into the cap across from the goggle strap (see photo 7).

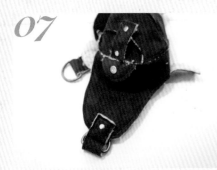

07

By embedding golden rivets in various places, you can really bring the steampunk aesthetic alive. Lastly, sew a flat elastic band on the neck part so the cap will be secure when worn.

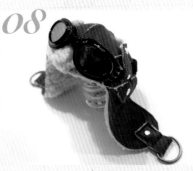

08

The picture above shows the finished product with the goggles snapped on. That's it!

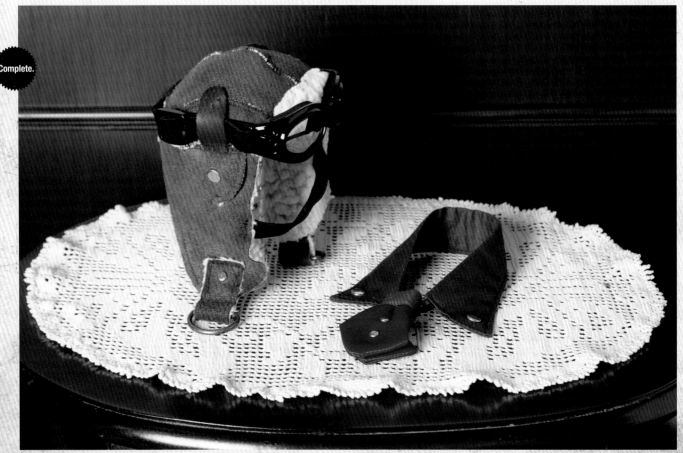

Complete.

Done! When I put the cap on Sugar, she initially seemed concerned with the elastic band around her neck, so I was very careful to make sure the elastic wasn't too tight. On another note, shooting dog photographs is a lot of work, isn't it?

Antique Labels

Somber glass bottles look more 'steampunk' than plastic bottles. This section introduces easy-to-do antique label making, including printing and aging them.

Seashell Specimen Labels

For specimen box labels, create a retro-design label using Adobe Illustrator® or Photoshop® and then print it out on a sheet of adhesive labels. Spill coffee over the label and bake it at 120 /250 F for 3 to 5 minutes. When done, iron the surface.

Materials & Tools

- Glass bottles, Adhesive labels, Acrylic paint, Water-base varnish
- Graphic design software, PC, Utility knife, Brush

Wash glass bottles well and let them dry.

For those who think making their own labels is bothersome – ready-printed labels can be bought online. An 'antique' label, purchased online from a store called Merci Present, is shown above. Choose one that fits with the shape of your bottle and cut it out. Merci Present's website: http://www.rakuten.co.jp/merci-p/

Soak the cut out label in water and paste it on a bottle. Adhesive is already applied on the label so it can be pasted on just by soaking it in water. Give aged effects on the label by painting with acrylic paint. When done, wipe off with a piece of tissue paper.

For finishing, apply varnish. Here, water-based varnish is used, but don't worry: once it dries, it will become water resistant.

Ta-da! Your antique looking bottle is finished!

Complete.

Steampunk Chronicles

by Keita Makuta

The essence of steampunk is often depicted using high-spirited girls. Trotting through a story filled with mist and soot, in both fiction and non-fiction, we must ask: who are these girls?

Steampunk Girls

Most critics would agree that what is now considered modern day steampunk, originated from the 1987 novel Infernal Devices, written by K.W. Jeter. Initially, steampunk was thought of as a subgenre of science fiction's 'cyberpunk', which had created buzz around the world when first introduced. In recent years, it feels like the positions in popularity have reversed as the steampunk genre has gradually grown and established itself across a myriad of texts.

Cyberpunk's central theme focuses on potential computer technologies of the near future, which represent an extension of our current status quo. But, given that the speed of technological advancement in the real world is far more rapid than in cyberpunk, these novels don't really function as futuristic novels anymore - one reason for cyberpunk's decline. In spite of depicting a high-tech setting of the near future, there aren't many novels that predicted the ubiquity of the internet or the widespread use of cellphones and tablet devices.

In that respect, steampunk, which implants fictitious technology into the period of the Industrial

Soulless
By Gail Carriger, Hayakawa-shobo
Paranormal fantasy in a new age by a female novelist.

Revolution, deviates from the category of science fiction- normally defined as futuristic novels - and is similar, rather, to the fantasy genre.

Among such steampunk novels, female characters are portrayed vividly, in a truly animated style. In reality however, the Victorian and Edwardian eras were defined by male-dominated societies. Within steampunk though, female characters incessantly take an active part in the story. It's hard to tell whether this is a reflection of the rise in female-dominated spaces in modern society or if the upper class gentlemen and noblemen of the 19th century, who are models for the steampunk era, simply are not thought tough enough to be protagonists in wild adventure stories.

I don't believe that it is only me who feels that female characters are an essential element for making vivid stories that are bright and thrilling in the dark era steampunk depicts. In this section, let me introduce some of these high spirited, so-called 'Girls' Steampunk' novels…

Adventure, and Adventure Again.

One example is the recent popular series, Parasol Protectorate by female novelist and a steampunker, Gail Carriger. The main character, British noblewoman Alexia Tarabotti, is a supernatural being called Soulless who can void any other supernatural being's power. In a world where human beings coexist with vampires and werewolves, Alexia gets involved in many mysterious incidents. This popular series is an excellent work of comical horror-fantasy, with Soulless as its debut entry.

Published in 1995, The Golden Compass (known in the UK as Northern Lights)-the first book of the His Dark Materials trilogy-is a young adult, fantasy novel, written by Philip Pullman. The main character, Lyra, lost her parents in a car accident and lives at Oxford University's Jordan College. She is mischievous and tells lies constantly. Lyra departs to the North Pole to rescue her kidnapped friend and her explorer uncle, both of whom have been imprisoned. Simply from the main character's

サハラ砂漠の秘密

ジュール・ヴェルヌ＝石川 湧 訳

The Barsac Mission
By Jules Verne
The last great adventure novel published after Vern's death.

atypical, "bad girl" characteristics, it is easy to tell how high-spirited this work will be. Given that this work offers an indirect (but complex) critique of modern Christianity, its anti-religious overtones have attracted adult audiences too. A film adaptation of The Golden Compass opened in 2007 and was filled with a variety of splendid, steampunk-inspired folk. However, the movie was severely criticized by the Catholic League, which subsequently led to poor box office sales, thus forcing the producers to give up on developing the sequels.

If we briefly look back at the history of steampunk, the real is question is: Who was actually the pioneer of 'Girls' Steampunk'? The definitive answer: The Barsac Mission by Jules Verne – which I would say with confidence is the grandfather text of all steampunk literature. In Verne's story, after one Lieutenant Buxton is branded a traitor and shot dead in Africa, his sister, Jane, comes to doubt her brother's cause of death and thus departs for the inner-depths of the Dark Continent. What she finds there is a secret city where ultra-science is being studied, along with the mysterious antagonist of this adventure, Harry Killer!

The strong-spirited Jane unravels a great adventure and there are countless mysterious ultra-

devices that pepper the plot. With this in mind, it is amazing that the novel was written around a century ago. That the progenitor of heroines in the modern adventure genre appeared so long ago is surprising, indeed. In addition, this novel was made into a Japanese animated television series, Secret of Cerulean Sand, in 2002. According to recent research on Verne, it is now known that his son, Michel Verne, finished writing this novel after collating a few manuscripts left by his father.

Steampunk-Style Women in Reality

Another reason why I think that women are well suited to steampunk is when we think of females in the Victorian and Edwardian era in general, along with the Industrial Revolution, gentlewomen come to mind. Their image is far from someone who would feature in adventure or action films but extraordinary women really did exist in that era and did in fact lend their names to history. Isn't it possible to think that those women were unconsciously reflected in the 'Girls' Steampunk' genre?

For instance, in Mary Anning no Boken (The Adventures of Mary Anning), Mary was a fossil collector and dealer who greatly contributed to the newly minted sciences of geology and paleontology in Victorian Britain. This book tells the exciting story of a girl, who had neither education nor money, and how, while competing with nobles and scientists, she finds the fossil of a marine reptile that will later come to be called an ichthyosaur. Almost no records of Mary's life exist and she had nearly been completely forgotten. However, fate

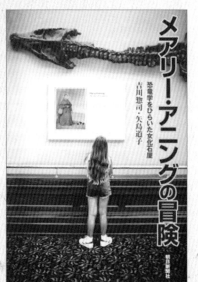

Mary Anning no Boken (The Adventures of Mary Anning)
By Soji Yoshikawa, Asahishimbun-sha
A critical biography of a female fossil dealer whose life was veiled in mystery.

London no Kyofu (Terror in London)
By Katsuo Jinka, Hayakawa-shobo
Gives clear commentary on the unsolved 'Jack the Ripper' case, which still attracts people to this day.

took a very interesting turn when a paleontologist, Michiko Yajima, and a scriptwriter, Soji Yoshikawa, both stumbled into writing a critical biography of Mary Anning. Surely this wasn't just an accident.

Another story involving women in the late Victorian era is the tale of London's Jack the Ripper, who in 1888 cruelly murdered five prostitutes one after another. While a tragic incident, it forms a story that cannot be missed. At that time, there were many prostitutes who were impoverished in London and the serial killer, known only as 'Jack the Ripper', brutally murdered five of them by slashing their throats and their genitalia. He even went as far as dissecting and taking parts of their internal organs with him. To this day, these horrific events have come to symbolically represent the darkness of the Victorian era and continue to trouble many 'Ripperologists', remaining the most famous unsolved case in history. Though various researchers and novelists wrote books about this case, it was the graphic novel From Hell, by Alan Moore and Eddie Campbell that was made into a hit film starring Johnny Depp in 2001. London no Kyofu (Terror in London) and Shin London no Kyofu (New Terror in London), by Katsuo Jinka, a 'mystery' genre novel commentator and Ripperologist, are the best introductory books to read in Japanese on this subject.

Many of you might already know of the two young cousins from The Case of the Cottingley Fairies, Elsie Wright and Frances Griffiths, who have been the subject of a few Japanese television programs. They are the girls who found 'fairies' and photographed them in their garden in Cottingley, England, near Bradford. Although this case actually

occurred from 1916 to 1920 - which is to say that it is not exactly set in the steampunk period – it makes sense to recognize these girls as dwellers of the steampunk domain. In the end, after the two girls grew old, they confessed to the world that their fairies were a hoax. It would be safe to suggest that this incident was a fantasy of its time. It was innocent and yet reminiscent of the mystery of the Victorian era, which was already receding into the mists of time. The fact that Sir Arthur Conan Doyle, spiritualist and author of the Sherlock Holmes series, was completely deceived by the girls is somewhat humorous. The Case of the Cottingley Fairies by Joe Cooper is an excellent non-fiction work that covers the incident's circumstances. As for a fiction novel, Photographing Fairies by Steve Szilagyi was made into a film under the same title in 1997.

Although the 19th century was a male-dominated society, 'Girls' Steampunk' seeks to readdress this gender imbalance and 're-style' history. If we deviate from the framework of ideas that forecast the future of technology, as found in cyberpunk, we find that high-spirited girls are in fact, well-suited and much needed in the unfolding of lively and carefully written stories taking place in a smoggy Europe.

The Case of the Cottingley Fairies
By Joe Cooper, Asahishimbun-sha (Japanese version)
How does the supernatural incident that surprised the whole world play out?

Keita Makuta
Born in 1966. Pop culture researcher and special novel critic. Co-authored the book *Jules Verne ga Kaita Yokohama: Around the World in Eighty Days no Sekai* (Compiled by Susumu Niijima, Keio University Press.) Member of the Société Japonaise des Etudes Verniennes.

Works Index

The works listed in the Gallery pages are introduced with the creator's comments.
If you are interested in purchasing anything, please contact the creator directly.

Toshiyuki Kimura

Born in 1969. When he was attending Nihon University College of Art he became fascinated with matte painting. From then, he began to study matte painting processes while at film production companies, etc. He was responsible for VFX art direction and matte art at *Kaibutsu-Kun*, doing both film and TV shows. He has a long list of credits for VFX and matte paint in films like, *CASSHERN, GOEMON*, Harakiri: Death of a Samurai, *Eight Ranger*, and TV series like *Humanoid Monster Bem, Garo 2*, and music videos such as, 'Chase' by L'Arc-en-Ciel, 'My Dearest', 'Kokuhaku' by Super Cell, 'SALING' by AAA, 'No Man's Land,' 'POP DIVA' by Kumi Koda, EXILE, etc. Being an active modern art creator himself, he also supports young creators using VFX studio LOOPHOLE as a base.
Contact: VFSstudio LOOPHOLE, http://loophole.jp/

"ZONE ~ Kokka Osen Shitei Keiyaku Kuiki ~" (ZONE ~ National Contamination Designated Contract Zone ~)
004-005p •W257 x W380 (mm) (H10 x W15 in.) 350dpi / Photoshop CS 6, Cinema 4D (Software used) / 2012 •Comments: ZONE, a city in the future troubled by nuclear fallout, was an area that was 'evaporated' - meaning it was moved to a different dimension by a Government conspiracy.
•For Sale.

"Indora-shonen to Soratobu Zo" (Boy Indra and the Flying Elephant)
007p •H257 x W190 (mm) (H10 x W7.5 in.) 350dpi / Photoshop CS 6, Cinema 4D (Software used) / 2012 •Comments: A scene with an Indian boy riding on a flying mechanical elephant to challenge the Indo-strial Temple enemy to one last fight. •For Sale

Naoto Nishiwaki (Toon Mart)

Born in Aichi prefecture. He creates character designs, known as Kigurumi, and special objects such as costumes and props. Nishiwaki has worked on several films, including Zebraman, Zebraman 2: Attack on Zebra City, Gyakuten Saiban, Nankyoku Ryorinin, and so on. He is actively involved in television series, commercials, theater and other events.
Contact: toonmart@gmail.com

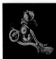 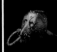

"Genba Kensho" (On-scene Investigation)
008-011p •Headgear: W30 x D30 x H35 (mm) (W1.25 x D1.25 x H1.5 in.) / Headphones, Metal fittings, Googles, etc., / 2012 / Mask: W23 x D16 x H30 (mm) (W7/8 x D5/8 x H1.25 in.) / SUN FOAM SHEET, FOAM ACE, Latex, Zip-tie, Belt, etc., 2012 •Comments: A gadget used by detectives to investigate evidence (the phantom thief mask) found at a scene. •Not For Sale
Model: Keaki

Hatohiro Mikami

Born in Saga prefecture. Now living in Chiba prefecture. Makes leather craft masks. After completing his debut piece *Derashine (Déraciné)* in 2008, he started to produce other works. Since 2012, he has created masks, shoes, etc., for people as well as animals and dolls. He is actively involved with events and group exhibitions that showcase his works. Currently, Hatohiro is holding a permanent exhibition at abilletage in Shinjuku, Japan.
Contact: Hatohiro Mikami http://hatohiromikami.main.jp

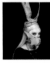

"Shiro Shokkaku Gear" (White Antennae Gear)
012-015p •Headgear: W260 x D130 x H760 (mm) (W10.25 x D5.25 x H30 in.) / Cow leather, Sewing needle, Linen thread, etc. •Comments: This piece was made of leftover leather from the twin antennae gear, eureka. Obviously, this piece is conscious of its rabbit's ears. •Not For Sale
★ What the model is wearing:
White gold full wig [Heat resistant, straight, long] (zephyr)
Dress (alice auaa)
Silver and onyx rosary necklace (Exhibitionist / C.R.E.A.M. Tokyo)
Bustier (NUDE N'RUE)
Fishnet stockings (Baby Doll Tokyo)

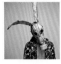

"eureka"
016-017p •W200 x D210 x H760 (mm) (W7.75 x D8.25 x H30 in.) / Cow leather, Russian made gas mask parts, Linen thread, etc. •Comments: The brother of Derashine (Déraciné). •Personal Collection
★ The model is wearing:
Goblins coat (Small Change Koenje)

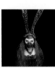

"Shokkaku" (Antennae Gear)
018-019p •W260 x D130 x H760 (mm) (W10.25 x D5.25 x H30 in.) / Cow leather, Wires, Linen thread, etc. •Comments: Created while thinking it would be nice if insect wings grew on top of the head like an antennae.
•Not For Sale
★ The model is wearing:
Orange brown full wig [Heat resistant, curly, long](zephyr)
Black dress / Sample product (Baby Doll Tokyo)

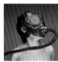

"Miffy"
020-021p •W200 x D210 x H240 (mm) (W7.75 x D8.25 x H9.50 in.) / Cow leather, Sheet glass, Linen thread, etc. •Comments: It was an experiment which without using regular parts, how I can bring a real gas mask like appearance. •Not For Sale

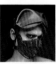

"Belt Leatherface"
022-023p •W150 x D200 x H250 (mm) (W6.00 x D7.75 x H9.75 in.) / Cow leather, Linen thread, etc. •Comments: At the time, I wanted to make a humorous mask with a constricted feel. •Not For Sale

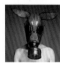

"Derashine (Déraciné)"
024-025p •W180 x D220 x H550 (mm) (W7.00 x D8.75 x H21.50 in.) / Cow leather, Russian made gas mask parts, Linen thread, etc. •Comments: A gas mask that has an animalistic element in both the materials and the look was the theme for this creation. I wanted to be a non-human creature by wearing the inorganically and organically blended head. •Not For Sale

TOMO

Born in Iwate prefecture. He studied production arts at Nikkatsu Eiga Geijutu Gakuin and after graduating moved on to study special effects make-up at Yoyogi Animation Gakuin. In 1995, he went independent. After working as a freelancer he founded Hyakutake Studio in 2004. His credited films are *CASSHERN, GOEMON, The Graet Yokai War, Dororo, Big Man Japan, TOKYO, Parmanent Nobara, 20th Century Boys, Confessions, Smuggler, Thermae Romae, Resident Evil: Damnation* (character design), *Kyo Koi o Hajimemasu, Himitsu no Akko-chan, No otoko*, and others.
Contact: Haykutake Studio Co., Ltd. http://www.hyakutake-st.jp/index.html
Blog: http://zhomoblog.blog72.fc2.com/

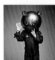

"Star Boy "
026-027p •W300 x D300 x H300 (mm) (W11.75 x D11.75 x H11.75 in.) / Acrylic sphere, Copper paint, Screws, Junk parts, etc. / 2012 •Comments: An animal-shaped helmet.
•Not For Sale

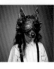

"Wolf Boy"
028-029p •Urethane, Copper paint / 2012 •Comments: I wondered, wouldn't an animal with attached goggles be kind of rare? •Not For Sale

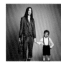

"Young Brother "
030p
★ The model is wearing:
Embroidered jacket (DIET BUTCHER SLIM SKIN / Venom)
Embroidered waistcoat (DIET BUTCHER SLIM SKIN / Venom)
Embroidered cropped pants (DIET BUTCHER SLIM SKIN / Venom)

Manabu Namikawa

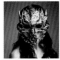

Born in Kyoto prefecture. Studied special effects make-up at Yoyogi Animation Gakuin in the Special Make-up Artist course. His list of film credits include *CASSHERN*, *GOEMON*, *The Graet Yokai War*, *Dororo*, *Big Man Japan*, *TOKYO*, *Parmanent Nobara*, *20th Century Boys*, *Confessions*, *Smuggler*, *Thermae Romae*, *Kyo Koi o Hajimemasu*, *Himitsu no Akko-chan*, *No otoko*, and more, often working with TOMO. He is chief of staff at Hyakutake Studio Co., Ltd.
Contact: Hyakutake Studio Co., Ltd.
http://www.hyakutake-st.jp/index.html

"Thistle "
031p •W210 x D150 x H230 (mm) (W8.25 x D6.00 x H9.00 in.) / Epoxy putty, Paper clay, Plastic, Metal, Glass, Acrylic, Rubber, Leather string, Resin cast, Seashell, Carapace, etc. / 2012 •Comments: A fusion of machinery and exoskeleton. This mask was made with the idea that thistles are the language of the flower. •Not For Sale
★ The model is wearing:
Black full wig [Heat resistant, curly, long] (zephyr)
Black paisley long corset (KIKIRARA-shoten)

Makiko Kono

Born in Fukuoka prefecture. In 2004, she went to study in England. Whilst at the University of Hertfordshire as a Modeling & Special Effects major, she took part in many TV programs, films, commercials, special art productions for theater, and costume production projects like props, armor suits, etc. After graduating she freelanced and worked as a model maker in London. Her credits include the TV series *Game of Thrones*, commercials for Sony Bravia, Play-Doh, Cadbury Dairy Milk Chocolate Charmer, and Volvo The Glove, as well as theater pieces such as *Little shop of Horrors*, and films like *Prince of Persia: The Sands of Time*, *Kick-Ass*, *Babylon A.D.*, *Alice in Wonderland*, and various personal exhibitions.

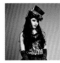

"Mary's top hat with goggles "
032-033p •W200 x D240 x H180 (mm) (W7.75 x D9.50 x H7.00 in.) / Leather, Brass, Resin, Plastic / 2012 •Comments: A corset image top hat and goggles for women. •For Sale
★ The model is wearing:
Black full wig [Heat resistant, curly, long] (zephyr)
Black paisley long corset (KIKIRARA-shoten)
Dulce skirt (Baby Doll Tokyo)
Satin gloves taxes incl. (Baby Doll Tokyo)
Embroidered jacket (DIET BUTCHER SLIM SKIN / Venom)

Tom Banwell

Lives in Penn Valley, California, United States. Self-taught artist who, after working on Batik ('pattern dying' in Indonesian), wood carving, and doll making, encountered steampunk. He presented various ideas for masks in the steampunk genre while incorporating techniques he had already mastered. His original mask works, which take elephants, birds, cows, etc., as their motifs are popular worldwide.
The Art of Tom Banwell http://www.tombanwell.com/

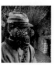 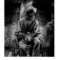

034-035p *"Crixus Bust Portrait"*

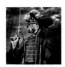

034-035p *"Aero Field Sargent"*

040p *"Dr. Beulenpest"*

036p *"Aero Fighting"*

041p *"The Displeased Patron Ichabod"*

037p *"Olifant Outlaw"*

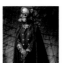

042p *"Dark Air Lord"*

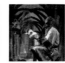

038p *"Krankheit Medieval"*

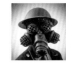

043p *"Ragnarok Soldier"*

039p *"Black Krankheit"*

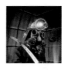

043p *"Sentinel"*

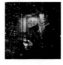

039p *"Stone Cold"*

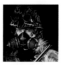

043p *"Transmutator"*

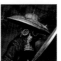

043p *"Invasion"*

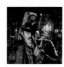

045p *"TrophyHunter"*

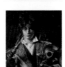

044p *"Olifant"*

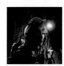

045p *"Dark Explorer"*

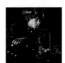

045p *"Firemaster"*

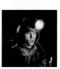

045p *"Underground Explorer"*

Kozo Saito

Graduated from Graduate School of Tohoku University of Art and Design. Currently, he is a thriving metalwork artist. Participated in: TETSUSON 2010 Zenkoku Godo Sotsugyo Seisaku Tenjikai at BankART studios NYK in Yokohama, the metal & ceramic craft communication exhibition at Tourindou-garo in Aoyama in 2010, seven Brooches at Crossroad in Sendai in 2011, Tohoku University of Art and Design Graduation/ Research and Production Completion Exhibition at Tohoku University of Art and Design in Yamagata, Tokyo Geijutsu Gakusha in Gaien, Tokyo, etc. He is a Kamen Rider enthusiast.
Contact: crafts milch http://craftsmilch.jimdo.com

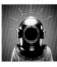

"Senshin " (Mind that Dives)
046-047p •W600 x D550 x H600 (mm) (W23.50 x D21.50 x H23.50 in.) / Copper, Brass, etc. / 2012 •Comments: A meditation machine for self absorbtion. •For Sale

Tomonobu Iwakura

Born in Kagawa prefecture. After graduating from Tokyo Visual Arts, with a Special Effects Make-up major, he was involved in various productions as a freelancer. At a very young age, he was fond of woodworking, crafting, and manufacturing objects. His influence is XJAPAN. He has consecutive Kawasaki Halloween Award titles: second place in 2003, first place in 2004, second place in 2005, best group award in 2006, judge's special award in 2007. Also, he won second place in the 2004 Velfarre Roppongi Halloween Costume Contest, as well as the Ageha Halloween contest in 2010. His credited films are *The Graet Yokai War*, *GeGeGe no Kitaro*, *The Movie Kaibutsu-kun*, and others.
Contact: iwakura_sv@yahoo.co.jp

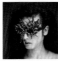

"BLACK SPIDER"
048-049p •W200 x D70 x H180 (mm) (W7.75 x D2.75 x H7.00 in.) / FRP / 2012 •Comments: Created while imagining a spider's web. •For Sale

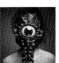

"SEARCH"
050-051p •W200 x D240 x H450 (mm) (W7.75 x D9.50 x H17.75 in.) / FRP / 2012 •Comments: I originally designed and created this work by using a CD jacket, from the solo album 'Hide Your Face' by XJAPAN's HIDE, to stimulate my imagination. •For Sale

Mitsuji Kamata (Kamaty Moon)

Born in Tokyo. Creator of items that mainly involve clay figures. Kamata entered the world of creation by thinking he would make 3D works using about a dozen cats he had in his house. His works' major characteristics are deformed animals such as frogs, dogs, pigs, cats, etc., and a fantastic and original worldview. Beginning with various sized flying machines, his animal themed 3D work, combined with steampunk taste, is also very popular. He is a member of Flying Megalopolis.
Contact: Kamaty Moon http://www16.ocn.ne.jp/~k-moon/contents.html

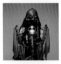

"Steam Flying Machine"
052-053p •W150 x D150 x H400 (mm) (W6.00 x D6.00 x H15.75 in.) • Cylinder only / Sculpey®, Stone powder clay, wood, brass pole, vinyl cloth, bamboo stick, Vinyl chloride pipe, LED, Pressure gauge/ 2012 •Comments: From the wearable steampunk series. •For Sale

"Maoh" (Satan)
054p •W80 x D100 x H140 (mm) (W3.00 x D4.00 x H5.50 in.) / Sculpey®, brass pipe, Acrylic paint / 2010 •Comments: This is a work for the cover of a Software Design magazine. The villain's boss in a story. •For Sale

"Time Machine Octopus I"
055p •W250 x D100 x H130 (mm) (W9.75 x D4.00 x H5.25 in.) / Sculpey®, Stone powder clay, Welding goggles, brass pipe, Lens, LED, Leather / 2011 •Comments: A goggle-shaped time machine. The octopus motif is hidden. •For Sale

"Flying Machine for Blyth Pata Pata"
055p •W50 x D50 x H100 (mm) (W2.00 x D2.00 x H4.00 in.) / Sculpey®, Brass pipe, Leather / 2012 •Comments: The Blyth doll accessory series. Stroll in the sky leisurely and slowly. •For Sale

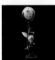

"Tsukidorobo (Rabbit)" (The Moon Thief (Rabbit))
056p •W100 x D100 x H300 (mm) (W4.00 x D4.00 x H11.75 in.) / Sculpey®, Stone powder clay, lumber (pedestal), Brass pipe / 2012 •Comments: A work for a moon themed exhibition. A member of the moon thief trio. •For Sale

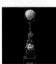

"Tsukidorobo (Hamster)" (The Moon Thief (Hamster))
056p •W100 x D100 x H300 (mm) (W4.00 x D4.00 x H11.75 in.) / Sculpey®, Stone powder clay, lumber (pedestal), Brass pipe / 2012 •Comments: A work for a moon themed exhibition. A member of a moon thief trio. •For Sale

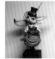

"Steampunk Fennec"
056p •W100 x D100 x H180 (mm) (W4.00 x D4.00 x H7.00 in.) •Including the pedestal / Sculpey®, lumber (pedestal), Brass pipe, Bottle / 2012 •Comments: From the Steampunk-themed animal series. •Sold Out

"Steampunk Rabbit"
056p •W100 x D100 x H200 (mm) (W4.00 x D4.00 x H7.75 in.) / Sculpey®, lumber (pedestal), Brass pipe, Bottle / 2012 •Comments: From the Steampunk-themed animal series. •Sold Out

"Senno" (Brainwashing 2010)
057p •W120 x D170 x H200 (mm) (W4.75 x D6.75 x H7.75 in.) / Sculpey®, Brass pipe, Acrylic paint / 2010 •Comments: A work for the cover of a Software Design magazine. A frog king is brainwashed by Satan in this story. •For Sale

"Flying Butterfly for Blyth"
058p •W130 x D40 x H120 (mm) (W5.25 x D1.50 x H4.75 in.) / Sculpey®, Plastic plate, Brass pipe, Leather / 2012 •Comments: The Blyth doll accessory series. Stroll in the sky, leisurely and slowly, with the butterfly wings. •For Sale

"Mekahachi & Beagle" (Mechanical Honey Bee & Beagle)
058p •W120 x D170 x H200 (mm) (W4.75 x D6.75 x H7.75 in.) / Sculpey®, Brass pipe, Acrylic paint / 2010 •Comments: A work for the cover of a Software Design magazine. This is one member of a group that goes to rescue a princess in a story. •For Sale

"Steampunk Wolf"
058p •W150 x D150 x H250 (mm) (W6.00 x D6.00 x H9.75 in.) / Sculpey®, Brass pipe, Bottle / 2012 •Comments: From the Steampunk-themed animal series. •Sold Out

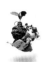

"Flying Pug" (Newspaper)
058p •W70 x D120 x H100 (mm) (W2.75 x D4.75 x H4.00 in.) / Sculpey®, Lumber, Brass pipe, Aluminum pipe / 2010 •Comments: A pug strolling in the air leisurely, while reading a newspaper by wearing a flying machine on the head. •Sold Out

"Flying Pug" (Insect's Wings)
059p •W100 x D120 x H90 (mm) (W4.00 x D4.75 x H3.50 in.) / Sculpey®, Lumber, Brass pipe, Aluminum pipe / 2010 •Comments: A flying pug wearing a bee's wing-type flying machine on the back. •For Sale

"Dr. Connell Set"
059p •W100 x D120 x H150 (mm) (W4.00 x D4.75 x H6.00 in.) / Sculpey®, Brass pipe, Acrylic paint / 2010 •Comments: Dr. Connell wrestles with the research and development of various flying machines. •For Sale

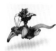

"Flying Anteater"
059p •W170 x D60 x H80 (mm) (W6.75 x D2.25 x H3.00 in.) •Body / Sculpey®, Lumber, Brass pipe, Aluminum pipe / 2010 •Comments: An anteater pilot flies in the air wearing a flying machine developed by Dr. Connell on his back. •Sold Out

"Flying Bear and Penguin"
059p •W500 x D100 x H300 (mm) (W19.75 x D4.00 x H11.75 in.) / Sculpey®, Lumber(pedestal), Brass pipe, Bottle / 2012 •Comments: A polar bear and a penguin depart on a treasure hunting journey with steam flying machines on their backs. Received Yuzawaya Category Grand Award. •For Sale

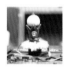

"Queen Crown for Blyth"
059p •W30 x D30 x H50 (mm) (W1.25 x D1.25 x H2.00 in.) / Sculpey®, Ribbon / 2012 •Comments: From the Blyth doll accessory series. •Sold Out

Chasuke

Born in Fukushima prefecture. Graduated from Nikkatsu Geijutsu Gakuin in Special Effects Make-up. She has a double role – as creator she is Chasuke and, as a model, she is Nanae.

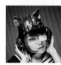

"Neko-san Headgear" (Cat Ear Headgear)
060-061p •L250 (mm) (L9.75 in.) / Goat leather, Grommets, Headphone waste parts, Clock waste parts, paper clay / 2012 •Comments: Headgear that is fashionable, but against the rules, for high school girls in the near future. For battling purposes. •Not For Sale

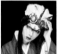

"Kitsune Tsuki Goggles" (Possessed Fox Goggles)
062p •W150 x L200 (mm) (W6.00 x L7.75 in.) / Fox fur, Waste lighting parts, Clock waste parts, Dog collar / 2012 •Comments: Combined Japanese motifs and steampunk, with added fur finishing, for a bizarre feel. •Not For Sale

Tomohiro Sasame (GimmelGarden)

After graduating from the Mathematics Department in the Faculty of Science and Engineering at Chuo University, Sasame started his self-study of metal work in 2002. He studied Japanese-style carving at the Japan Jewelry Craft School. And then he went abroad to a jewelry school in Florence, Italy and studied processing, designing, western style carving, and setting. After coming back to Japan, he founded a jewelry band company called GimmelGarden. He has been primarily making jewelry that is delicate and unisex with wing, cross, butterfly, and arabesque motifs. In 2008, he taught western-style carving at the Japan Jewelry Craft School as a lecturer.
Contact: GimmelGarden http://gimmelgarden.jp/

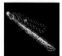

"La Cravatta d'Argento Prossimo"
063p, 065p •W70 x D40 x L350 (mm) (W2.25 x D1.50 x L13.75 in.) +chain / Silver925 / 2009 •Comments: The previous necktie that I made was too heavy and the shoulders got stiff, so I made it lighter. •Not For Sale

"Tori Ningen Seizoki" (Bird Man Production Machine)
064p •W30 x D50 x L180 (mm) (W1.25 x D2.00 x L7.00 in.) / Silver925 / 2009 •Comments: Created for the Flying Wheelchair Exhibition. If it is difficult to walk, wouldn't it be better if you were able to fly? •Not For Sale

"Enkan Teien" (Circle Garden)
064p •W72 x D72 x L10 (mm) (W2.75 x D2.75 x L0.5 in.) / Silver925
•Comments: The rose garden spreads in all directions. •Not For Sale

"La Cravatta d'Argento"
064p-065p •W70 x D40 x L350 (mm) (W2.75 x D1.50 x L13.75 in.) +chain / Silver925 / 2009 •Comments: There are many gorgeous necklaces for women, but it is rare to find one for men so I made one. •Not For Sale

"Cavaliere MK-V Getsumen Hiko" (Cavaliere MK-V Flying Over Moon Surface)
066p •W43 x D38 x L9 (mm) (W1.75 x D1.50 x L0.5 in.) / Silver925
•Comments: Though the wings of this butterfly are mechanized, don't you think it could fly if it existed where there was less gravity? •For Sale

"Yosei Saishu Halloween Version 2" (Fairly Collection: Halloween Version 2)
066p •W18 x D22 x L47 (mm) (W0.5 x D0.75 x L2.00 in.) / Brass, Glass, Cork / 2012 •Comments: A bottled Halloween world. •For Sale

"Automatico Segretario"
067p •W60 x D8 x L10 (mm) (W2.25 x D0.25 x L0.5 in.) / Silver 925 (In the photo, copper) Brass (pedestal, in the photo, brass and copper) / 2012
•Comments: The shaft of a quill pen. It is replaceable when the pen or feather becomes worn-out. •For Sale

"Cosmo Compresso
067p •W24 x D24 x H2 (mm) (W1.00 x D1.00 x H0.75 in.) / Silver 925 / 2012 •Comments: A ring is transformed into a Celestial Globe. The twelve signs of the zodiac are engraved in Hebrew on the inside. •For Sale

Haruo Suekichi

Born in Aomori prefecture. After moving to Tokyo when he was eighteen years old, Suekichi began to learn watchmaking while working at a print shop and a wholesale store, straying from one job to another. He started to sell his watches at a flea market and gradually cultivated his clientele and now he is much sought after. He even has fans overseas. His watches are sold at three stores in Shimokitazawa Tokyo, Chikyu Saibai Shimokitazawa-store, Tabatha, Little Tabatha, and at SHINYA in Kyoto.
Contact: Studio Toms Co., Ltd. info@tom-s.co.jp
Suekichi Haruo Tokei Kobo http://www.eagerbeavers.net/suekichi/tokei.htm

[Characteristics of Suekichi Tokei]
★ Use SEIKO, Citizen's quartz movement.
★ Materials used are brass, cow leather, stainless steel, acrylic, etc.
★ Essentially, the crown of the watch is located at the 12 o'clock position so that both left and right-handed people can use them.
★ Most of watches are not water resistant. Those that are water resistant do not display pressure.
★ Battery changes can be performed at a regular watch shop and at Suekichi Tokei dealer shops.

"Steampunk Keiba" (Steampunk Horse Race)
068-069p •A pen holder with a magnet, a pocket to hide winning tickets, a cover to hold money to buy return train tickets, reading glass attachment for seeing small print, a hook for a portable radio to gather information in real time, a holder for marking sheets that allows one to mark directly, etc. This is a special hunting cap in which the necessary items for betting on horse races are assembled. •Sold Out

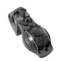

"Tensu Tokei"
070p • This is a belt-type watch for hooking on one's belt. Hooking it around your Tensu - an acupuncture point for stimulating bowel movements - should help. •Sold Out

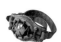

"Dionaea"
070p •Inside the form of a carnivorous plant, this undigested clock is ticking the time away until it dies. Though you cannot take the watch out when wearing it on your wrist, once you take it off it easily comes out so it can be enjoyed as a pendant clock. Open the forbidden honey pot and turn it upside down! •Sold Out

"Ryubi" (Dragon Tail)
070p •Like a coiled dragon's tail, this annoying watch wraps around your arm. By pulling a lever on a side of the body, it wraps around as if it were alive. It prickles and feels like it's tightening. This squeezing feeling invites you into a land of pleasure you have never before known. •Sold Out

"Rock'in Amazon Super 1"
070p •Wear it like Kamen Rider Super One! The fan opens at the push of a button, like Amazon Rider. With your own power, you can fan it like a round fan – a delightful watch in summer time. Despite efforts at fanning, the breeze is very weak. A troublesome watch that will make you think about the energy issues in Japan. •Sold Out

"Baraag"
070p •When wearing this watch you cannot tell the time, given that the face is hidden by a cover. When you pull the function belt, the cover will open. Though this is impressive enough the wings also open like the frills on a frill-necked lizard (for no particular reason). It is chock full of useless but wonderful functions. •Sold Out

Yuta Sato (Ability Normal)

Designer for the silver accessory brand Ability Normal. Though Sato's works have strong personality they contain no specific motif. He designs and develops unrestricted items that change according to any image.
Contact: Ability Normal http://www.abilitynormal.com/

"untitled"
071p •W70 x D140 x H300 (mm) (W2.75 x D5.50 x H11.75 in.) / Brass, Silver925 / 2010 •Comments: A microphone cover •Not For Sale

"untitled"
072p •W110 x D130 x H120 (mm) (W4.25 x D5.25 x H4.75 in.) / Brass, Silver925, Bone / 2009 •Comments: An incense burner •Not For Sale

"untitled"
072p •W270 x D150 x H80 (mm) (W10.50 x D6.00 x H3.00 in.) / Brass, Silver925, Bone / 2011 •Comments: An incense stand •Not For Sale

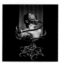

"untitled"
073p •W120 x D110 x H100 (mm) (W4.75 x D4.25 x H4.00 in.) / Brass, Silver925, Bone / 2011 •Comments: A card stand •Not For Sale

"untitled"
074p •W30 x D30 x H230 (mm) (W1.25 x D1.25 x H9.00 in.) / Brass, Silver925, Horn / 2010 •Comments: A Key chain •Not For Sale

"AN-VP-23"
074p •W24 x H41 (mm) (W1.00 x H1.50 in.) / Silver925 / 2006
•Comments: A pendant top •For Sale (JPY25,200, excluding chain)

"AN-CP-04"
074p •W38 x H57 (mm) (W1.50 x H2.25 in.) / Brass, Silver925 / 2006
•Comments: A oil lighter •For Sale (JPY71,400)

"untitled"
075p •W95 x D90 x H15 (mm) (W3.75 x D3.50 x H0.50 in.) / Brass, Silver925 / 2011 •Comments: A wallet •For Sale (Price negotiable)

"AN-UM-11"
075p •W80 x H30 (mm) (W3.00 x H1.25 in.) •Silver part / Silver925, Leather cord / 2012 •Comments: A bracelet •For Sale (JPY45,150)

"untitled"
075p •W95 x D90 (mm) (W3.75 x D3.50 in.) /Brass / 2011 •Comments: A plate objet •Not For Sale

"untitled"
076p •W25 x H47 (mm) (W1.00 x H2.00 in.) / Silver925, Glass / 2007
•Comments: A ring •Not For Sale

"AN-VR-40-C"
076p •W20 x H35 (mm) (W0.75 x H1.50 in.) / Silver925, Brass, Cherry
Amber / 2009 •Comments: A ring •For Sale (JPY37,800)

"AN-VR-43"
076p •W22 x H30 (mm) (W0.75 x H1.25 in.) / Silver925, Onyx / 2009
•Comments: A ring •For Sale (JPY39,900)

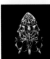

"AN-VR-20"
076p •W26 x H40 (mm) (W1.00 x H1.50 in.) / Silver925 / 2009
•Comments: A ring •For Sale (JPY45,150)

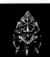

"AN-VR-16"
076p •W27 x H38 (mm) (W1.00 x H1.50 in.) / Silver925 / 2006
•Comments: A ring •For Sale (JPY39,900)

Zettai Shonen (Masato Sato)

Born in Tokyo. After graduating from the JGSDF Youth Technical School, Sato mastered FRP forming techniques at the Japan Art Craft Co., Ltd. and at Cosmo Productions. He was accepted to the 23rd Modern Japanese Art Exhibition. In 1990, he became a studio artist and started to work under the name of the studio Zettai Shonen. He displayed his works at the Wonder Festival hosted by KAIYODO. He is a leader of the three dimensional art creators group Flying Megalopolice. His work has been introduced in many different publications like Nikkei BP, CATV leaflet, Mitoshi Sogo Johoshi, YOUNG JUMP, Mono Magazine, Hobby Japan, Media Works, Toys Works, and many others. He specializes in objet lamps with original designs.
Contact: zettai-shonen@jcom.home.ne.jp
URL for Zettai-Shonen & Megalopolice: http://members.jcom.home.ne.jp/zettai-shonen
Blog: http://blog.zaq.ne.jp/beyondimagine/

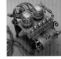

"The Japanese Mixism" (nixie wristwatch)
077p •W170 x D180 x H160 (mm) (W6.75 x D7.00 x H6.25 in.) •Grip, leather belt included / FRP, Brass, Copper wire, Beads, Nixie tube clock works / 2012 •Comments: I wanted to make this over the top of a nixie wristwatch. Besides the body, a battery for the circuit must be carried separately in a shoulder bag. Next time, I want to make it more compact. •For Sale

Katsutoshi Shirasuna

Born in Shizuoka. Modeling artist and mineral artist. After working in landscaping, Shirasuna started to make accessories in his early 20's. He spent time backpacking and making accessories, which he sold while traveling. In 2002, he started the handmade accessory brand, Hippie Style. With the beauty of bilateral symmetry and life forces in mind, he uses specially selected, one of a kind minerals, fossils, meteorites, etc., for his jewelry and objets. Also, he does woodcarving using a single piece of wood and makes musical instruments. He feels that all of his encounters with trees, minerals, metals, and people, are based on fate and he creates works that accentuates each individual's special qualities using various materials he has encountered through time.
Contact: Shirasuna Katsutoshi http://shrasuna-k.com/
Hippie Style Web Shop: http://www.hippie-style.com

"Kyusei-syu" (Salvation Species)
078p •W60 x D60 x H310 (mm) (W2.25 x D2.25 x H12.25 in.) / Walnuts, Copper, Brass, Glass, Himalayan crystal / 2012 •Comments: As a result of foolish fighting, 80% of the species on Earth went extinct. The surviving species now wait in hiding to pass their lives on to the next generation, all the while receiving the cleansing effects of the crystal. •For Sale

"Kyusei-syu" (Salvation Species)
078p •W60 x D60 x H205 (mm) (W2.25 x D2.25 x H8.00 in.) / Linden tree seeds, Copper, Iron, Glass, Himalayan crystal / 2012 •Comments: As a result of foolish fighting, 80% of the species on Earth went extinct. The surviving species now wait in hiding to pass their lives on to the next generation, all the while receiving the cleansing effects of the crystal. •For Sale

"Toki no Namioto" (Time Labyrinth Series)
078p •W35 x L65 (mm) (W1.50 x L2.50 in.) / Copper, Brass, Silver / 2012 •Comments: Pierce a hole in the human body to wear this piece. •For Sale

"Shu no Kigen ~ Minori" (Time Labyrinth Series) (Origin of Species ~ Harvest (Time Labyrinth Series))
078p •W20 x L270 (mm) (W0.75 x L10.50 in.) / Copper, Brass, Silver, Garnet •The root word garnet means seed in Latin. / 2010 •Comments: Everyone who makes a long and hard journey is a time traveler, in their own way. Since ancient times, they have prayed for the prosperity of descendants and then, they all wholeheartedly send those prayers to loved ones. •For Sale

"Shu no Hanei ~ Shinjitsu no Ai" (Time Labyrinth Series) (Glory of Species ~ True Love (Time Labyrinth Series))
078p •W30 x L255 (mm) (W1.25 x L10.00 in.) / Copper, Brass, Silver, Amethyst, Kyanite, Lapis Lazuli, Peridot, Double points crystal / 2010 •Comments: Since ancient times, people have picked up earth's beautiful pieces, held them up to the sky, and decorated their chests with those pieces. •For Sale

"Steamconga" (Hand Drum)
079p •W410 x D390 x H1130 (mm) (W16.25 x D15.25 x H44.50 in.) / Copper, Brass, Iron, Glass, Lens, Fluorite *Fluorite: A natural mineral that is fluorescent under ultraviolet light. / 2012 •Comments: A hand drum communication system. Using various rhythms you can communicate with the consciousness of people who are far away. Black lights are inside so that the fluorite packed inside will glow. •For Sale

"Kyumin no Kaijo (Hatsuga)" (Lifting the Dormant (Germination))
079p •W60 x D60 x H185 (mm) (W2.25 x D2.25 x H7.25 in.) / Copper, Brass, Iron, Glass, Dart, Plant / 2011 •Comments: When certain conditions are met, dormant seeds will be lifted. The seed either knows or feels the time. Either way it knows best. Plant a seed while you wish to lift the dormant (germination). •For Sale *Dart and plants are not included.

"Kakokara Kita Mirai no Sochi" (The Future Device Came from the Past)
079p •W100 x D100 x H235 (mm) (W4.00 x D4.00 x H9.25 in.) / Copper, Brass, Iron, Glass, Himalayan crystal *Himalayan crystal: Crystals produced from mines over 4000m in altitude in the Himalayan Mountains. / 2012 •Comments: Though its operation is unknown, this ancient device will definitely be needed in the future. Depending on its usage, this is likely a device that can be good or bad, so let's hope nobody misuses it. •For Sale

"Esper-Cross Lantern"
079p •W170 x D170 x H390 (mm) (W6.75 x D6.75 x H15.25 in.) / Copper, Brass, Iron, Water drop rainbow double points smoky crystal, fluorite *Double points crystal: Crystals that have grown at both ends so that both ends are sharp / 2012 •Comments: Human beings are constantly walking by feeling around in the dark. But, we sometimes feel the existence of a person of light at your feet. Even in this chaotic era, I want to live firmly feeling the light. And, one day, I wish to be the one who lights somebody's feet. •Not For Sale

Michihiro Matsuoka

Born in 1969 in Aichi prefecture. Since he was little he has been interested in nature and devices that have become obsolete. He finds his inspiration in childhood memories and experiences and then carries out his creations. Many of his pieces are works of art that include floating objects that merge animals and devices together. Even though his pieces are fictitious, his mysterious style of art makes it seem like they genuinely exist. Matsuoka primarily uses stone powder clay for his works and finishes them with acrylic paints. Besides solo exhibitions and events held in Japan, he has participated in solo/group exhibitions overseas in places such as San Diego, New York, and Columbus in the United States, Cologne in Germany, Hasselt in Belgium, Beijing in China, etc. His works of art have been permanently exhibited and put up for sale at GALLERY TATSUYA in Owariasahi, Aichi prefecture, ART RUSH in Shibuya, Tokyo, and ARTISHOXArtGallery in Hasselt, Belgium.

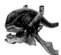

"Scull Ship"
080p ●W200 x D120 x H150 (mm) (W7.75 x D4.75 x H6.00 in.) / Polymer clay, Copper, Lead, Acrylic paint / 2012 ●Comments: Created a skull as being a motif. ●For Sale

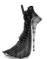

"High Heel Special Version"
080p ●W2200 x D580 x H450 (mm) (W86.50 x D23.00 x H17.75 in.) / Polymer clay, Copper, Lead, Acrylic paint / 2012 ●Comments: The motif is a high heel with a beautiful line and Steampunk style. Pull the handle at the center to tie the shoe. ●For Sale

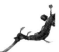

"Weedy sea-dragon"
081p ●W200 x D850 x H175 (mm) (W7.75 x D33.50 x H7.00 in.) / Polymer clay, Copper, Lead, Acrylic paint / 2012 ●Comments: The motif consists of a beautiful pacific seaweed pipefish that lives in Australia. ●For Sale

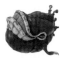

"Kujiragata Taiki Jokasen" (Whale-shaped Air Purifying Ship)
081p ●W500 x D470 x H450 (mm) (W19.75 x D18.50 x H17.75 in.) / Stone powder clay, Copper, Lead, Acrylic paint / 2012 ●Comments: An air purification ship that is used to purify pollutants in the air by way of the lip filter. When the level of contamination reaches five, it signals by blinking its red eyes. ●For Sale

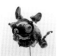

"French Bulldog"
081p ●W500 x D470 x H450 (mm) (W19.75 x D18.50 x H17.75 in.) / Resin, Lead, Copper, Acrylic paint / 2012 ●Comments: The motif here is a humorous French bulldog. His job is to deliver the mail. Since he delivers mail at his own pace, a delivery date cannot be specified. ●For Sale

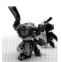

"Custom Rabbit"
082p ●W120 x D220 x H60 (mm) (W4.75 x D8.75 x H2.25 in.) / Eggcore Rabbit, Polymer clay, Brass, Lead, Acrylic paint / 2012 ●Comments: This is a custom made work using an Eggcore Rabbit toy, sold by a Chinese toy manufacturer called 909TOY. This work was displayed at the Custom Show held in Beijing. ●Not For Sale (909TOY Collection)

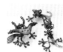

"Nyoro Nyoro"
082p ●W150 x D150 x H60 (mm) (W6.00 x D6.00 x H2.25 in.) / Stone powder clay, Brass, Lead, Acrylic paint / 2012 ●Comments: The motif is a gecko. ●For Sale

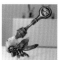

"TreeHopper"
082p ●W150 x D70 x H43 (mm) (W6.00 x D2.75 x H1.75 in.) / Polymer clay, Brass, Lead, Acrylic paint / 2012 ●Comments: The motif is a treehopper with an extraordinary shape. ●Not For Sale

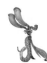

"PARADIGM SHIFT"
082p ●W520 x D580 x H550 (mm) (W20.50 x D23.00 x H21.50 in.) / Stone powder clay, Brass, Lead, Aluminum rod, Acrylic paint / 2012 ●Comments: The fusion of an elk, a sea horse, and fish. ●For Sale

"Time Machine"
082p ●W820 x D820 x H450 (mm) (W32.25 x D32.25 x H17.75 in.) / Polymer clay, Brass, Lead, Aluminum, Acrylic paint / 2012 ●Comments: This is a device that allows you to travel into the past by spinning it against the direction of the earth's rotation at high speed. Reversing the spin lets you travel to the future. When you actually attempt time travel, the key is to install this device precisely at the center of the axis of the earth. ●For Sale

"Horned Headband Special Edition"
082p ●W420 x D470 x H150 (mm) (W16.50 x D18.50 x H6.00 in.) / Stone powder clay, Brass, Lead, Acrylic paint / 2012 ●Comments: A customized collaborative work with ririco:ramu, a horned headband artist. Three different types are created: Red horn Dragon wing and Chimney. ●Not For Sale (ririco:ramu Collection)

SONIC

A Puppetoon artist and illustrator. Mainly using Stop-Go animation, Sonic is actively involved with various genres such as illustrations and graphic designs. Beginning with puppet-making, he now directs, writes scripts, and shoots for frame-by-frame recording, all by himself. He has great knowledge of motion pictures and foreign animation works. These influences make the style of his work very broad, from pop to dark. Currently, he works both domestically and internationally. His hobbies are watching movies and collecting Batman related items.
Contact: SONIC ONLINE http://sonic.the-ninja.jp/

"The Diver"
083p ●W160 x D100 x H210 (mm) (W6.25 x D4.00 x H8.25 in.) / Brass, Aluminum, Lumber, Polymer clay, Fabric / 2012 ●Comments: This diver does his best while working with Baron Steam on various assignments. Though it should be noted that he is very timid. This work is made as a Stop-Go animation puppet with moveable joints. ●Not For Sale

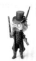

"Baron Steam"
083p ●W140 x D130 x H270 (mm) (W5.50 x D5.25 x H10.50 in.) / Brass, Aluminum, Polymer clay, Lumber, Plastic, Fabric, Synthetic leather / 2012 ●Comments: Baron Steam, who works hard night and day to protect his town from criminals. Though, it should be noted that he is very timid. This item is also made as a Stop-Go animation puppet with moveable joints. ●Not For Sale

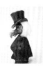

"Mr. Dodo"
083p ●W160 x D120 x H260 (mm) (W6.25 x D4.75 x H10.25 in.) / Brass, Aluminum, Polymer clay, Lumber, Fabric / 2012 ●Comments: A noble criminal who does evil while wearing the mask of a Dodo. Nobody knows his face. This item was also made as a Stop-Go animation puppet with moveable joints. ●Not For Sale

Keizo Hoshino

Born in Tokyo. After working at KUROKAWA Masayuki ARCHITECT STUDIO Mr. Hoshino began creating sculptures using metal. He twice received the Hands Mind Award from Tokyu Hands. Using copper and brass, these sculptures, which are handcrafted down to the last screw, are generally not for sale. These delicate sculptures can be seen at exhibitions and events where FLYING MEGALOPOLICE is a participant.
http://members.jcom.home.ne.jp/flying-megalopolis/flymega/hosinok/hosinok_t.htm

"Kinzokugyo 5" (Metal Fish 5)
086p ●W600 x D180 x H130 (mm) (W23.50 x D7.00 x H5.25 in.) / Brass, Copper, Spring / 1991 ●Comments: A metal fish belonging to the catfish family. Fish and insects are my favorite motif. Springs are installed inside of the fish so the fins, etc. can move. ●Not For Sale

"Kinzokugyo 3" (Metal Fish 3)
087p ●W430 x D190 x H120 (mm) (W17.00 x D7.50 x H4.75 in.) / Brass, Copper, Cogwheels / 1985 ●Comments: This one belongs to the scorpion fish family. It holds AA batteries inside its stomach and the cogwheels inside move. The cogwheels represent a heart. The work was awarded the Hands Mind Grand Award in 1985. ●Not For Sale

Mari Igarashi

Mari Igarashi is a writer, designer, Steampunker, and fan of peculiar places. She has a wide range of knowledge and hosts many websites and blogs. Steampunk *Daihyakka* is one of the most famous websites in the steampunk genre in Japan. She loves not only mechanical objects but also *Meiji* and *Taisho* era styles and Victorian objects. She is working at transforming her den into a *Wunderkammer* and steampunk-style wonderland. In this book, she introduces a part of that process (pp. 134 ~ 151). Contact: Steampunk Daihyakka http://steampunk.seesaa.net

"Bedroom"
088p ●Comments: Clean and warm off-white color was used as the predominant color for bedding, curtains, and canopies. Dark red for the niche cabinet and the bed liner. This is an antique style bedroom where you can enjoy the mismatch of skeletal specimens and feminine bisque dolls, flower pattern plates and vases.

"The sink and the vanity"
089p ●Comments: This is a vanity object that predominantly displays science items such as, lab equipment and a wall full of butterfly specimens. At night, turn on a green light, mad scientist style. It also serves practical uses. For example, you can use a test tube as a toothbrush holder, a beaker as a cup, and a flask as an oil container.

STEAMPUNK STYLE 2: Goggles, Gas Masks and Aviator Styles
by STEAMPUNK ORIENTAL LABORATORY
ISBN: 9781783294961

Published by Titan Books
A division of Titan Publishing Group Ltd.
144 Southwark Street
London
SE1 0UP

First Titan edition: October 2017
10 9 8 7 6 5 4 3 2 1

This book was first designed and published in Japan in 2012 by Graphic-sha Publishing Co., Ltd.
This English edition was published in 2017 by Titan Books, a division of Titan Publishing Group Ltd.

Original design and art direction:	Mitsugu Mizobata
Photographs:	Susumu Miyawaki, Hironobu Onodera, Yun Yuah,
Planning collaborator:	Keita Makuta
Hair styling and makeups:	Hiromi Igarashi
Styling:	Akemi Minagawa
Image processing and illustration for "how to" pages:	Rino Ogawa (Atelier Kochi)
Editing and proofreading:	Yuko Sasaki (Atelier Kochi), Maya Iwakawa (Graphic-sha Publishing Co., Ltd.)
Planning and editing:	Sahoko Hyakutake (Graphic-Sha Publishing Co., Ltd.)
English edition layout:	Shinichi Ishioka
English translation:	Kevin Willson
Production and project management:	Kumiko Sakamoto (Graphic-Sha Publishing Co., Ltd.)

Did you enjoy this book? We love to hear from our readers. Please email us at readerfeedback@titanemail.com or write to us at Reader Feedback at the above address.

To receive advance information, news, competitions, and exclusive offers online, please sign up for the Titan newsletter on our website: www.titanbooks.com

A CIP catalogue record for this title is available from the British Library.

Printed and bound in China.